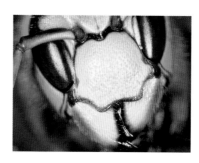

Small Things Big

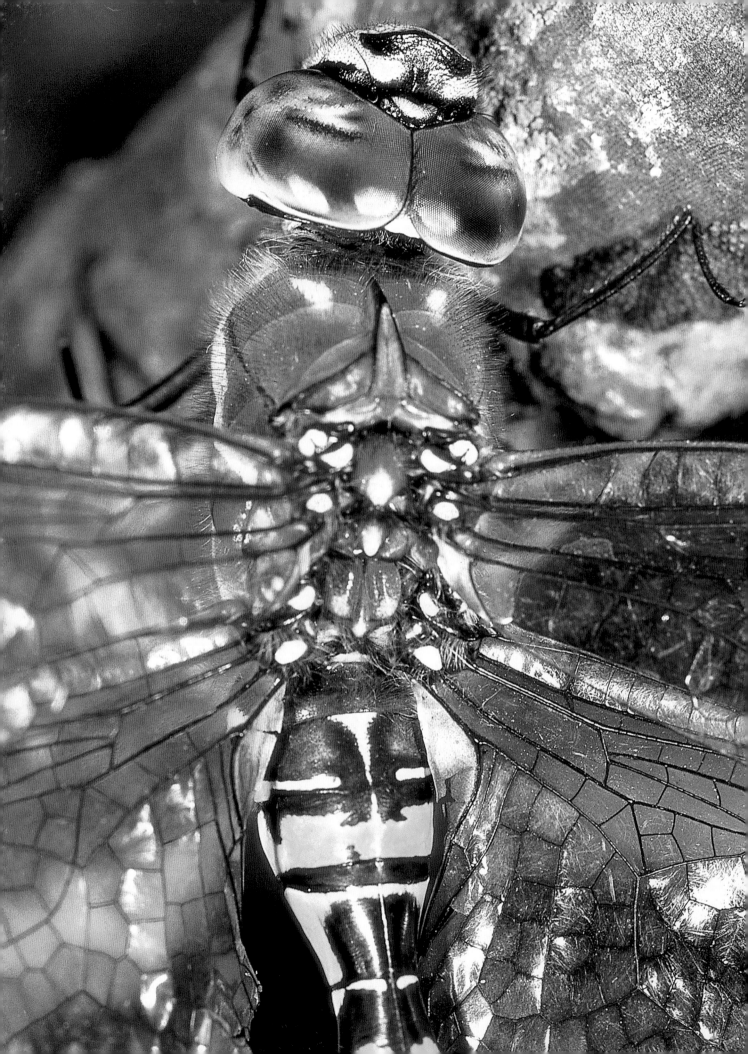

Small Things Big

Close-up and Macro Photography

Paul Harcourt Davies

David & Charles

A DAVID & CHARLES BOOK

First published in 2003 in the UK by
David & Charles
Brunel House
Newton Abbot
Devon

ISBN 0 7153 1688 5

Conceived, designed and produced by
Quarto Publishing plc
The Old Brewery
6 Blundell Street
London N7 9BH

QUAR.SMAL

Senior project editor: **Nadia Naqib**
Art editor: **Karla Jennings**
Copy editor: **Sarah Hoggett**
Designer: **James Lawrence**
Assistant art director: **Penny Cobb**
Illustrator: **Kuo Kang Chen**
Indexer: **Joan Dearnley**

Art director: **Moira Clinch**
Publisher: **Piers Spence**

Manufactured by Universal Graphics Pte Limited, Singapore
Printed by Midas Printing International Limited, China

9 8 7 6 5 4 3 2 1

Visit our website at www.davidandcharles.co.uk

David & Charles books are available from all good bookshops; alternatively you can contact our Orderline on (0)1626 334555 or write to us at FREEPOST EX2 110, David & Charles Direct, Newton Abbot, TQ12 4ZZ (no stamp required UK mainland).

Contents

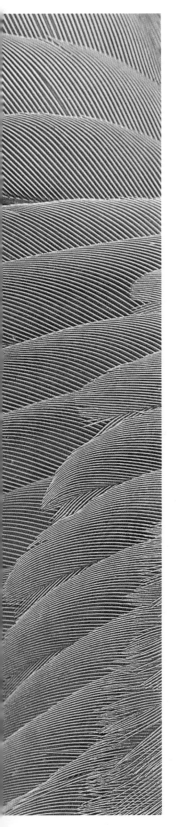

Introduction

I make no excuse for concentrating on close-ups of the natural world because it has been my passion since early childhood and I have never lost my sense of wonder for what lies just beyond the familiar. I realize now that there is a thread running through what has absorbed me over the years – and that thread is a deep love of pattern and symmetry in nature, both visual and mathematical.

Nature has an unlimited capacity to intrigue and delight – from the delicate whorls on a seashell to the spiralled tendrils of climbing plants or the hexagonal facets of an insect's eye. There are fascinating mechanisms to discover such as the hairs on stinging nettle leaves that act as 'hypodermic syringes', the pulsing cold-chemical light of fireflies or the insect-mimic bodies of some orchid flowers that, through heady scents, delude tiny wasps into copulating with them. The diversity in nature is astonishing and the SLR camera the ideal tool both for revealing and recording it.

When I began taking photographs, I quickly found that I had a means not just of recording details but also of conveying that beauty and fascination to other people by opening their eyes to details that would otherwise pass unnoticed. And I have always had the underlying belief, however naïve, that if people become more aware of the sheer wonder of natural forms, they might be that much more careful about protecting and preserving them.

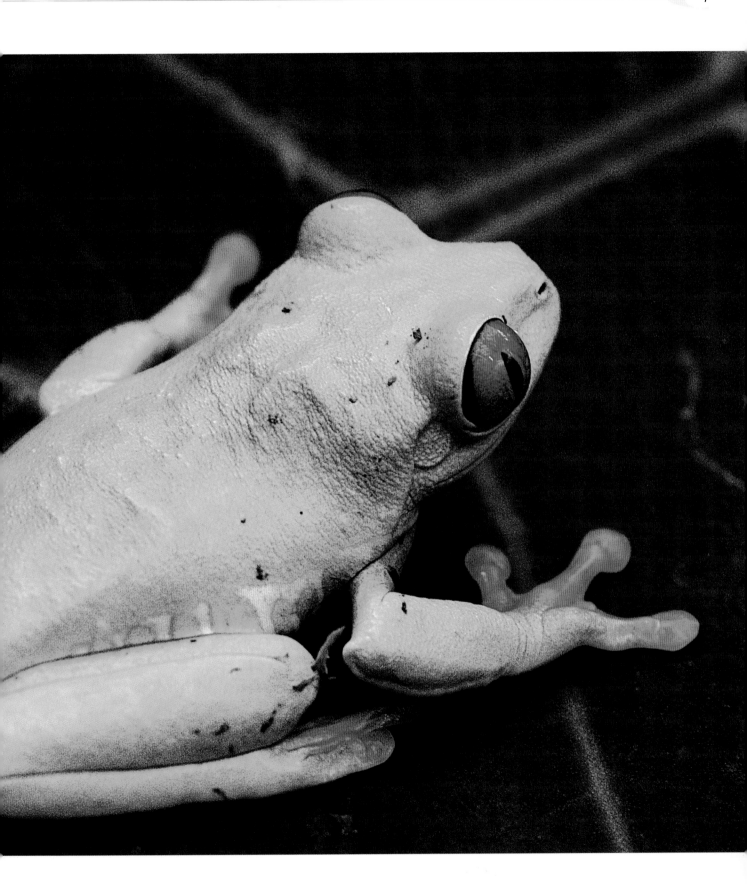

The key to creating great images is to learn to see and recognize opportunities – perhaps concentrating on small creatures or focusing on a limited area of a subject. You do not even need to travel to far-off lands, for so much that is near at hand is still terra incognita. Those ever-busy ants milking their greenfly on a nettle stem, the scales on a butterfly wing, the thorns on a rose bush – often the ordinary becomes extraordinary when it is magnified even slightly. Shapes, colours and patterns can create intriguing compositions: only your imagination sets the limits.

You don't even need complicated equipment to make your first forays into the close-up realm. Nowadays, the typical standard zoom lens (focal length 28–80mm) that comes with many an SLR camera lets you get close to your subject and begins to open up wide-ranging possibilities for photography. Of course, there are countless specialized gizmos and gadgets available for those who want to delve deeper into the subject – not to mention the possibilities of constructing your own close-up and macro equipment without breaking the bank.

There is no magic involved in the photography, for the basic techniques are easily mastered and modern equipment is superb.

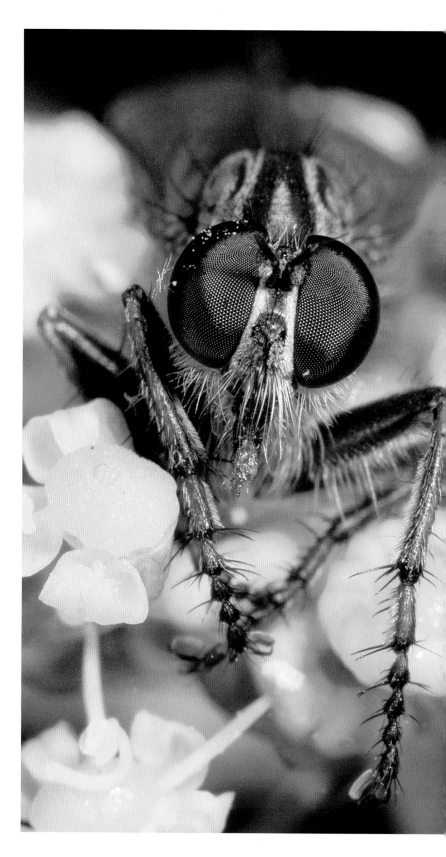

But let's start by defining exactly what we mean by 'macro' and 'close-up'. In this book, the terms arise time and time again, and people are often confused about how they should be applied.

Strictly speaking, the term 'close-up' embraces scales of reproduction from about 1/20 life-size to around half life-size – 1:2 on film. True macro photography applies over the range from life-size (1:1) to about x25 magnification, although the latter is way beyond what can be achieved with most equipment.

The first purpose-built macro lenses were specially corrected to deal with subjects close up; many produced half life-size unaided, but then used an extension tube to give life-size reproduction. Thus common usage has meant that 'macro' is the term used from about half life-size to higher magnifications and, to avoid confusion, this is the way the terms are used in this book.

Spending time with my own children as they grew up and with the children of friends made me realize that we all have an eye for detail when we are young and a magical sense of wonder that the business of life seems to hammer out of us. Hunting with a macro lens on the camera offers the ideal excuse for being

a child again – if you need it. Take time to look at the details around you, to see how the natural world hangs together at all levels and offers up myriad stories of lives different from ours.

As photographers, we all want to create pictures that have impact – the shots that elicit appreciative murmurs, maybe gasps of wonder from an audience. Many of us want to win prizes in clubs and competitions and perhaps get our work published in books and magazines. This book sets out to show you what is possible in the world of close-up and macro photography. There are no secrets, no exclusive information; the intention is to help you acquire the tools and skills and then get out there and make your own discoveries. In an uncertain world, looking closely at nature can restore a sense of calm and of what really matters; it has certainly worked for me. Through this book I hope that I can encourage you to go out and fuel that sense of wonder deep in all of us, for that hidden world is so close and so easy to access once you know how.

Paul Harcourt Davies

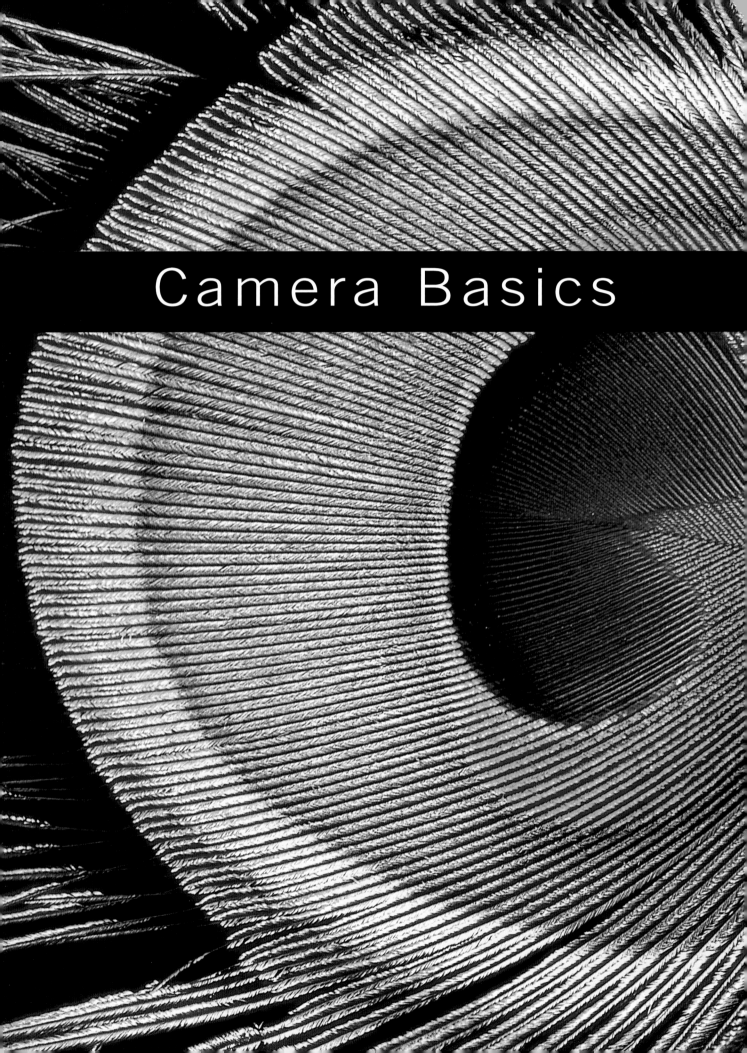

Camera Basics

Close-up photography, at whatever magnification scale, poses an endless number of challenges for you to achieve the pictures you want and do something different. It's very easy to be seduced by the manufacturers' advertising hype and convince yourself that your photography will improve immeasurably if you buy the very latest high-tech gizmos and gadgets. Of course, your work will never suffer from using high-quality equipment – though your bank balance might. Ultimately, the only real key to success is to understand what your equipment is capable of and take the time and trouble to learn how to use it to its full capacity.

This chapter looks at the various types of camera, lenses and lighting equipment available to you and explains the pros and cons of each in relation to close-up and macro photography, so that you can make an informed choice about what you really need. You may be pleasantly surprised to discover that you need less specialist equipment than you imagined. With a little ingenuity and basic practical skills, you can adapt existing equipment and improvise to make other pieces and set-ups to suit your own requirements.

35mm systems

There is a bewildering selection of cameras on the market – and the confusion increases when you see that many models, in various formats, feature a so-called 'close-up facility'. So, if you're looking for a new camera to use for taking close-ups, what kind of system is best? The good news is that modern engineering ensures that all brand-name camera systems can give you great results.

35MM COMPACT CAMERAS

Autofocus (AF) compact cameras with a close-up facility are a great way to start taking close-up shots, since you have everything you need in one unit. Their automatic exposure and focus help you to get good results, but you cannot get close enough to your subject to magnify it more than a quarter life-size or so on film.

APS CAMERAS

The Advanced Photo System (APS) is mostly used with compact cameras, and the limitations are the same as for the 35mm compact. When it comes to single-lens-reflex (SLR) cameras (see below), the APS film format is smaller than 35mm and is not capable of producing the detail of 35mm, so there is no advantage at all. If you have an APS SLR, you may still use its accessories until you decide to buy a 35mm film or digital body.

STAR CLOVER
(Trifolium stellatum)

The 'stars' on the clover seedhead are not obvious until you move in close, but, an SLR camera allows you to frame exactly what you want to appear on film.
📷 *Nikon F100, 60mm f/2.8 AF macro, 1/60 sec. at f/22, Fujichrome Velvia, SB29s macroflash*

FOXGLOVE
(Digitalis purpurea)

An SLR camera will encourage you to look at familiar objects such as foxglove flowers in a new light.
📷 *Nikon F100, 60mm f/2.8 AF macro, 1/60 sec. at f/16, Fujichrome Velvia, SB29s macroflash*

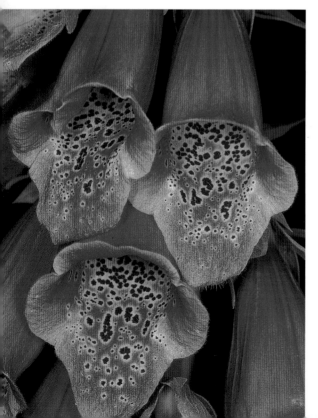

SLR CAMERAS

Most close-up and macro photography is done using 35mm SLR cameras. Compared with medium-format cameras, they are easier to handle, have a much wider range of accessories, are lower in price, and even the cheapest bodies come complete with autofocus and sophisticated metering. Even if your aim is to have your work published, you will find that 35mm transparencies taken on a fine-grain film stock such as Fujichrome Velvia can be enlarged to cover a double-page spread in a magazine or book.

The major benefit of an SLR camera is that it uses a mirror behind the lens to reflect light up through the pentaprism in the viewfinder, allowing you to see something exactly as it will appear on film. In close-up photography this takes the guesswork out of framing small subjects. In a rangefinder camera, the optical systems of viewfinder and camera lens are completely separate. Thus there is a slight difference between what the viewfinder shows and what the lens records. This is called 'parallax' and the effect becomes more pronounced the closer you get to your subject.

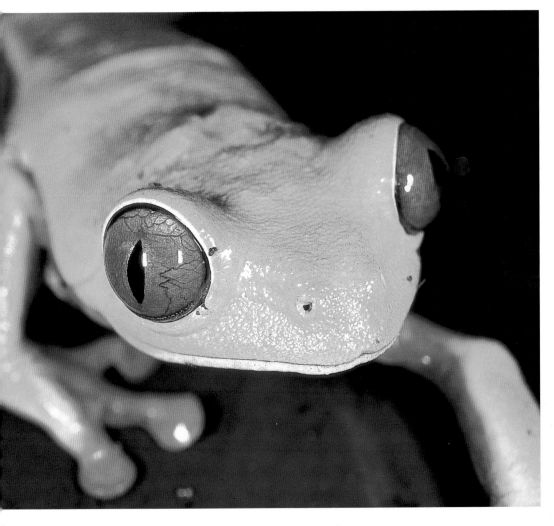

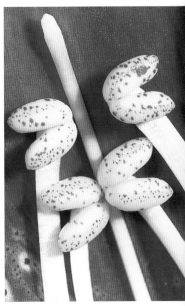

RED-EYED TREEFROG
(Agalychnis callidryas)

Being able to frame tightly while looking through the viewfinder of an SLR means you can exclude unwanted backgrounds. This treefrog was photographed in captivity, but the background gives nothing away.

📷 *Nikon D100, Sigma 180mm f/3.5 AF macro, 1/60 sec. at f/16, ISO 200, SB80-DX flash*

FOXGLOVE STAMENS
(Digitalis purpurea)

More accessories are available for SLR cameras than for any other type. This shot was taken using a x2 converter, which allows you to create images on film that are larger than life-size.

📷 *Nikon F4, Sigma 180mm f/3.5 AF macro plus x2 converter, 1/60 sec. at f/11, Fujichrome Velvia, SB29s macroflash*

INDIAN MOON MOTH LARVA
(Actias selene)

With fine-grain film and modern optics, you can capture an astonishing level of detail, right down to the fine hairs on tiny caterpillars.

📷 *Nikon F4, 105mm f/2.8 AF macro, 1/60 sec. at f/11, Fujichrome Velvia, SB29s macroflash*

BUYING A 35MM SLR SYSTEM

When it comes to quality, there is little difference between all the top brands – so ask fellow enthusiasts, read magazines and build up a picture of what will suit you. You may even look at what the professionals use – but remember that they are paying for reliability, and equipment that is built robustly tends to cost more.

If you buy a camera from a local camera shop it may cost more than from a large chain, but you will inevitably be talking to fellow enthusiasts who know what they are doing and can answer your questions. Never be afraid to buy second-hand equipment from reputable dealers, provided they offer a no-quibble guarantee, but be a little more circumspect with private sales and look for signs of knocks and heavy use.

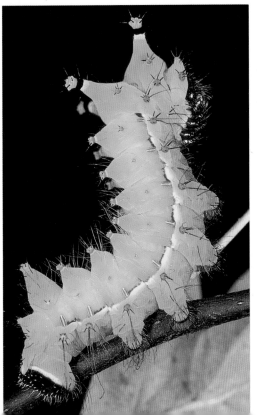

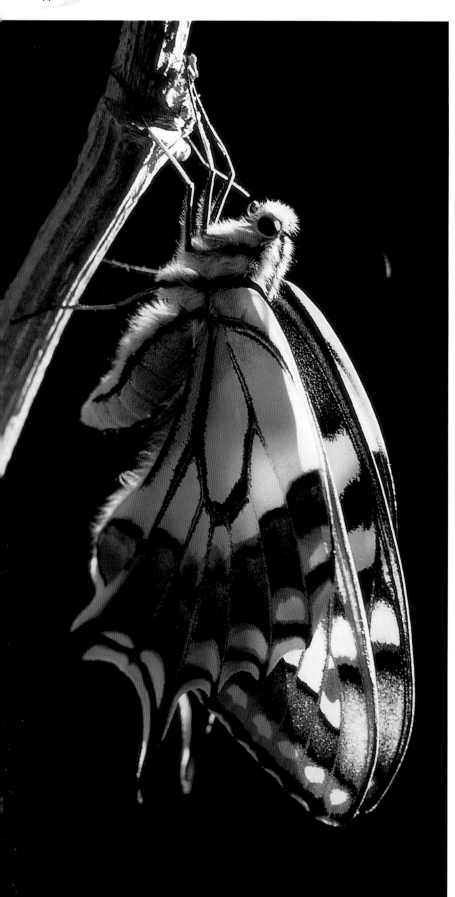

USEFUL FEATURES

Buying a camera system is an investment – it can prove expensive to change your mind later. In brochures and catalogues, the write-up on every camera boasts a range of seemingly essential attributes, making everything that went before obsolete. So, what features are genuinely useful in close-up and macro work?

AUTOFOCUS

In close-up and macro photography, autofocus (AF) is often a nuisance, because the focus mechanism 'hunts' at the slightest movement of either subject or camera. I always switch the autofocus off and focus manually when making the final adjustments. More recent camera models have fast-acting autofocus that can be switched to different areas of the screen to cope with off-centre compositions.

THROUGH-THE-LENS (TTL) METERING

Nowadays, TTL metering is so good that many photographers never use a hand-held meter. Many cameras offer several types of TTL metering such as spot, centre-weighted and matrix (see page 32). The important thing in practice is to recognize and compensate for those situations in which the meter might be fooled (see page 34).

PRECISE LIGHT METERING

By measuring the light coming through a camera lens, you can make exposures that are extremely accurate. This freshly emerged swallowtail (left) was backlit by the sun; to retain the 'glow', I slightly overexposed the shot. The dial on the camera top (above) allows fine adjustments to exposure; some cameras have a push button with a 'command' dial.
📷 *Nikon F100, 60mm f/2.8 AF macro, 1/15 sec. at f/22, Kodachrome 64*

DEPTH-OF-FIELD PREVIEW BUTTON

A depth-of-field preview button is a very useful feature for close-up (and landscape) work. This closes the lens diaphragm and, although the image gets darker, you can see how much is in focus front to back and adjust for shallow or maximum depth of field (see page 21).

INTERCHANGEABLE VIEWING SCREEN

A plain fine-ground-glass viewing screen, with or without a grid, works far better than the all-purpose screen that is supplied with many cameras. Screens that combine a central spot rangefinder surrounded by a coarse granular ring are hopeless with close-up photography, because you cannot tell the exact point of sharp focus. Many cameras allow you to change screens yourself, but if not a competent repairman might be able to replace the camera screen with one from an independent manufacturer.

MACRO LENSES

Does the system you are thinking of buying have its own range of macro lenses? Does the system allow you to use lenses by independent manufacturers? Independent companies such as Sigma make high-quality alternatives to the manufacturers' own, often high-priced ranges of lenses.

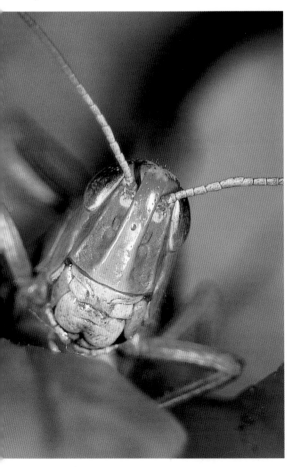

MIRROR LOCK-UP

The higher the magnification, the more the slightest movement can affect sharpness during a long exposure – even movement from the mirror as it flips up (mirror bounce). Modern 35mm SLR shutters are usually well damped, but some medium-format cameras shake with the 'thwack' of the mirror and focal plane shutter. A mirror lock-up facility fixes the mirror in the up position after you have focused and reduces vibration.

Many other features are useful and included in the specifications of many cameras:

Auto bracketing is useful with tricky exposures, although with practice you will learn what compensation to give. An exposure compensation dial (see page 32) lets you make slight changes for tricky subjects.

Of the program modes offered, aperture priority is the one you will use most, and to a lesser extent shutter priority and manual override. A camera's own programs rarely do all you want.

A built-in motor drive is essential when photographing insects, and built-in flash works well with moderate close-ups (up to about half life-size) as long as it is placed high enough on the camera to light the subject (see page 45).

LEAF PORTION

Autofocus is of limited use in close-up and macro work; with the leaf shown here, a slight movement in the breeze would send the system 'hunting' back and forth to find the sharpest focus.

📷 *Nikon F100, Sigma 180mm f/3.5 AF macro, 1/60 sec. at f/11, Fujichrome Velvia*

GRASSHOPPER FACE

When working with close-up subjects I usually work with open aperture because the image is bright and easier to focus: a preview button allows you to see the depth of field at any given aperture, so that you can then stop down or open up to get the effect you want. Here I wanted to make sure that the grasshopper's compound eyes were sharp.

📷 *Nikon F4, Sigma 180mm f/3.5 AF macro with x2 converter, 1/60 sec. at f/11, Fujichrome Velvia, SB29s macroflash*

Medium-format systems

Medium-format or 120 film has been around for a long time and is incredibly versatile. There are several formats (6 x 4.5cm, 6 x 6cm, 6 x 7cm, 6 x 8cm, 6 x 9cm and two 'landscape' formats of 6 x 12cm and 6 x 17cm). All use the same film width of 6 centimetres to give different numbers of transparencies per film. Surprisingly, the 6 x 9cm format has twice the area of 6 x 4.5cm and over six times that of a 35mm frame.

But before you invest a lot of money in a medium-format system, you need to think about the pros and cons. On the minus side, medium-format users are at a disadvantage compared to 35mm users when it comes to the variety of equipment. And a medium-format system costs far more.

However, there are strong points in favour of medium-format film and most of them derive from the larger film area: when you see medium-format transparencies alongside 35mm on a light box, there is no doubt which have the most immediate impact.

If you record the same scene on 35mm and medium-format film, the medium-format film has a much greater area of film and thus a higher level of detail is recorded. The larger film area also seems to allow a better handling of colour, with less tendency to 'burn out' or overexpose in bright areas and more detail retained in shadow areas.

A medium-format transparency is a better starting point than 35mm for creating images larger than about 20 x 30cm (8 x 12 in.). To create the same size of final

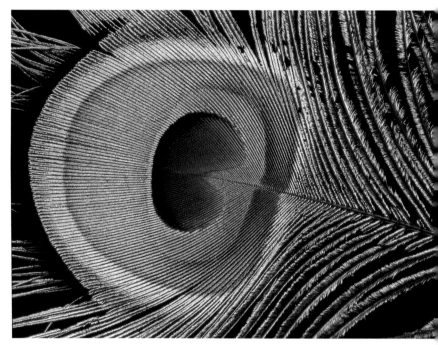

image, you enlarge fewer times and detail is retained without the grain structure becoming obvious. And the solid feel of medium-format equipment, combined with the high cost of film, mean that you tend to work harder for each shot.

But are there any advantages to using medium-format film for close-up and macro photography? The answer, of course, is that it depends what you want to achieve. Some medium-format models have a built-in focusing bellows that makes them suited to close-up work. The old Rollei SL 66 even allowed you to reverse its 80mm f/2.8 Zeiss Planar lens onto the built-in bellows for better performance close up. On this score, the Fuji GS 680 with bellows extension, rise and fall must be one of the most versatile cameras around.

As a user of 35mm, medium-format and digital cameras, I have learned that different systems suit different types of photographs. Whereas medium-format is my first choice for landscape work, I tend to take a lot more close-up and macro pictures on 35mm – and this is because of the depth of field.

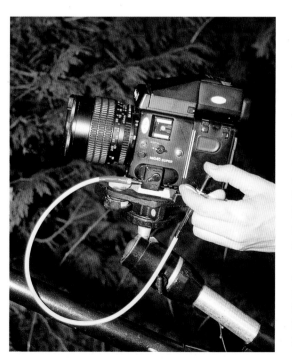

CLOSE-UPS WITH MEDIUM-FORMAT

The size and weight of medium-format equipment makes it impossible to hold for close-up work. For the peacock feather shot (above), I mounted the camera on a sturdy tripod and used a cable release to fire the shutter. The feather was taped to a board.

📷 *Mamiya 645 Super TL, Sigma 180mm f/3.5 AF macro with adapter and polarizing filter, 1/60 sec. at f/11, Fujichrome Velvia*

TREE SKELETON, OXFORDSHIRE, UK

A detail of a large subject, such as a tree, can still constitute a close-up. By isolating elements of the skeleton, the geometry of the tree becomes apparent. The rangefinder camera used to take this shot is lightweight, and there was no need to spoil our walk by carrying a heavy tripod: I simply leaned against the lower part of the tree to steady myself.

📷 *Mamiya 7 II, 43mm f/4, 1/60 sec. at f/11, Fujichrome Velvia*

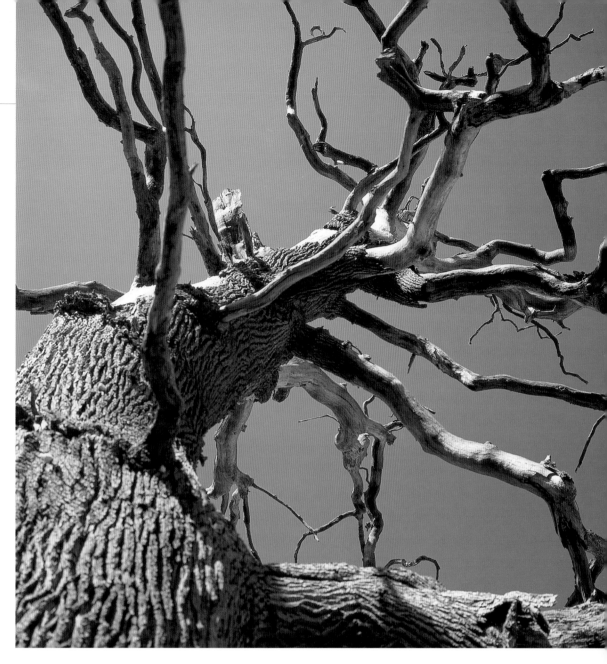

NATURAL SCULPTURE, GARGANO, ITALY

Designs are everywhere in nature, but the force of the sea on driftwood can produce astonishing 'sculptures'. An ultra-wide-angle lens captured and accentuated the shape of the log and yet at the same time set it in context on the empty beach.

📷 *Mamiya 7 II, 43mm f/4, 1/60 sec. at f/11, Fujichrome Velvia*

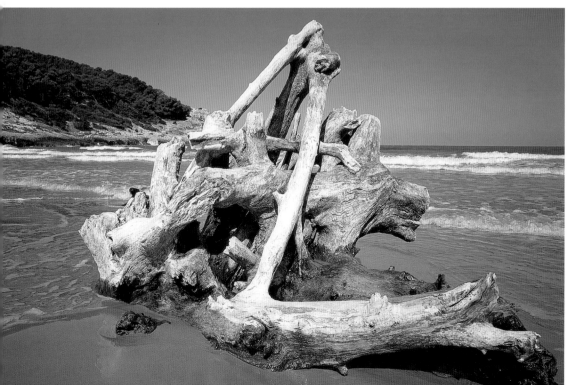

SPOLETO AND ITS POPPY FIELDS, ITALY

Some versatile medium-format systems allow you to create panoramic shots in the camera without cropping the image. The close-up foreground poppies lead the eye towards this lovely old town. The extent of the display depends on how the fields are cultivated – the following year there was only a handful of poppies.

📷 *Mamiya 7 II, 80mm f/4 with 35mm panoramic adapter, 1/60 sec. at f/11, Fujichrome Velvia*

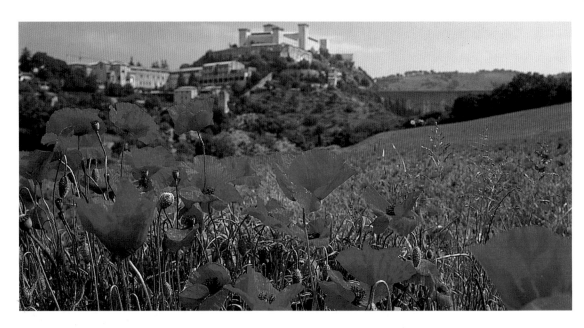

OLIVE GROVE WITH POPPIES, APULIA, ITALY

Rangefinder cameras have limited close-up potential, since the minimum focus is 1 metre – but they are ideal for displays of flowers. Here, the 6 x 7cm format captured every detail in the scene.

📷 *Mamiya 7 II, 43mm f/4, 1/60 sec. at f/11, Fujichrome Velvia*

THE MAGNIFICATION DILEMMA

We instinctively think that a wide-angle lens has more
depth of field than a telephoto – but this is only
because of the perspective and the fact that the wide-
angle seems to cram more in. If you use a wide-angle
lens, a macro lens and a telephoto lens and you
produce exactly the same-sized image of the same
subject in the viewfinder (the same on-film
magnification), then at whatever aperture you choose,
all three lenses have the same depth of field. Ultimately
it comes back to the way lenses build images and 'blur
circles' (see page 152).

For a given format, at a particular magnification
and aperture, the depth of
field is the same whatever
lens is used.

The great advantage
always claimed for
medium-format film is the
larger film area. If you fill
the frame of a 35mm and
a 6 x 4.5cm transparency
with, say, the face of a
bee, you will need
about three times the
magnification with the

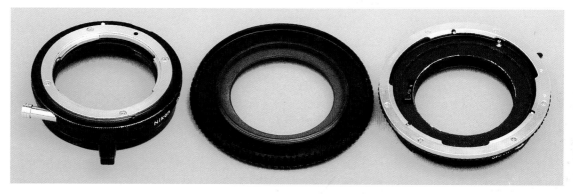

larger format in order to cover the same proportion of
the viewfinder. Higher magnification means less depth
of field – a precious commodity with close-up
photography.

So is it worth using medium-format film at all for
close-up work? My answer is yes, and in practice I use
it with flatter subjects such as leaves, coins and prints,
where depth of field is not so important. Here the larger
transparencies really score if my goal is to produce
large-scale prints for display. In the past, I tended to
use 35mm film rather than medium-format film when
depth of field was critical, but I now opt for high-
resolution 35mm digital (see page 90) because that
offers even better depth of field.

REPRODUCTION QUALITY

The differences between medium-format film and
35mm might seem obvious on a cursory glance at
transparencies, but when you make enlargements,
differences only become apparent with art prints of
about 20 x 30cm (8 x 12 in.) and larger. In reproduction
for magazines, however, those differences tend to
disappear, since each step of the reproduction process
loses definition and the final picture is made
up of dots. A 35mm shot will have the better depth
of field for exactly the same scene or subject at
the same aperture.

For those photographers who scan their films
for printing or take digital photographs, there are
extra issues of cost when it comes to weighing
up the advantages of larger files from medium-
format cameras.

ADAPTING 35MM LENSES FOR USE WITH MEDIUM-FORMAT CAMERAS

Although macro lenses designed especially for
medium-format cameras are prohibitively expensive,
in close-up and macro work, many lenses meant for
35mm can be pressed into use on a medium-format
camera if you want the larger transparency. You will
lose infinity focus and all meter coupling, so there is an
element of trial and error. I use all my 35mm macro
lenses (Nikon, Canon and Olympus) on a Mamiya 645
pro TL. When used close up (from about one-tenth life-
size), the image circle produced is more than enough
to cover the medium-format film.

To fit a Nikon or any other lens to another body
you will need an adaptor, because the bayonet fittings
are completely different. Mine are homemade (see
page 29). I use the manufacturer's own mounts
because they are properly machined for their cameras
and lenses, but you have to beware of fouling coupling
levers; separating the lens from the camera by means
of an extension tube helps to avoid this.

IMPROVIZED ADAPTORS – MIXING FORMATS

Lenses designed for 35mm
cameras can be adapted for
use with other formats; this
is what I did for the peacock
feather shot on page 16.
Here are two improvised
adaptors. One (top) is
complete (a Mamiya body
cap and a Nikon extension
tube) and the other (bottom)
is in parts (a reverse Nikon
camera mount, Mamiya
reversing ring and Mamiya
extension tube).

Lens basics

Every photographic lens is a compromise in which a designer has to try to eliminate lens defects or aberrations and produce the best possible specifications while keeping the price sensible.

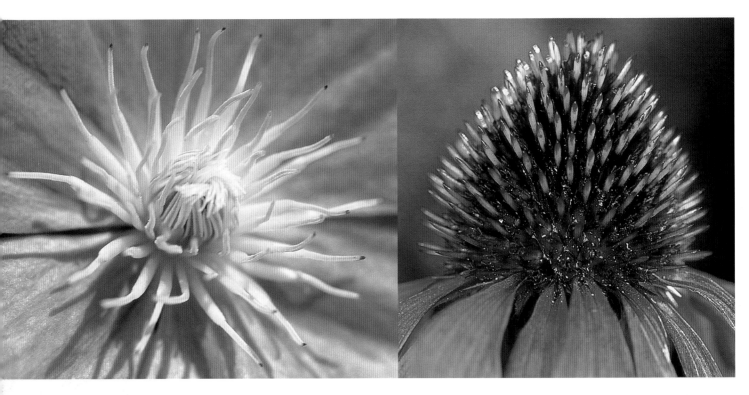

CONTROLLING DEPTH OF FIELD

The smaller the aperture, the greater the depth of field. The clematis flower (above) was taken at f/16; every detail is clear. The cone flower (above right) was shot at f/5.6 and depth of field is shallow.

 Nikon F4, 105mm f/2.8 AF macro, 1/60 sec., Fujichrome Velvia, SB29s macroflash

Modern lens designs created by tracing rays on a computer give a performance that would have been undreamed of a couple of decades ago. Lens tests claiming to discern slight differences on the basis of the way a lens performs on a test bench seem almost to invent differences, creating discrepancies from points on a graph. When used in the 'field' (the real test), those discrepancies seldom exist, for a host of things, such as wind and camera shake, tend to iron them out.

Resolution (see page 152) is not everything: a good lens design has a clever balance between resolution and contrast, and the ability to separate tones.

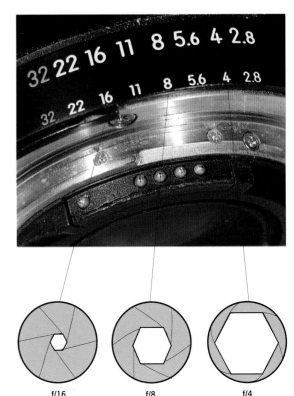

APERTURE AND DEPTH OF FIELD

In theory an image is assumed to be built from points of light, but in practice our eyes accept small circles of about 1/30mm ('blur circles' or 'circles of confusion') as being indistinguishable from points. The explanation of depth of field (see page 21) describes how light spreads out at either side of sharp focus; something still looks sharp as long as the light has not spread out too much. The smaller the aperture, the less the light spreads – and the greater the depth of field.

f/16 f/8 f/4

THE DIAPHRAGM AND F-NUMBERS

Every photographic lens has an iris diaphragm – a device that can be opened and closed (like the iris of the eye) to control the light through the lens. It is made from a set of interlocking metal blades controlled by a ring with a set of numbers on it that relate to the lens aperture – the hole at the centre of the diaphragm.

Lenses are marked with a series of numbers, or f-stops, which denote the size of the aperture and run in a series (see page 30). Confusingly, the higher the number the smaller the aperture. The amount of light passing through the aperture is doubled as a lens is 'opened up' by one stop and halved when it is 'stopped down' by the same amount. This is because the area of the aperture changes by a factor of two when you move from one f-number to the next.

The aperture size not only governs the amount of light entering the system, but it also affects the depth of field. This is the distance over which detail in front of and behind the plane of sharpest focus still appears to be in focus. The smaller the aperture, the greater the depth of field at a given magnification. In landscapes, the depth of field can be hundreds of metres but with close-ups we work with just a few millimetres or less. In theory, by using smaller apertures we can increase depth of field – but at very small apertures, a wave effect called diffraction begins to soften an image, as light spills around the edges of the diaphragm.

Some manufacturers state the number of diaphragm blades in their macro lenses. This might seem like a gimmick, but the aperture controls the shape of the tiny 'points' of light that make up the image. The closer these points are to circles, the better the image quality and the easier it is to detect sharp focus. The aperture becomes a polygon as it closes, with the same number of sides as the number of blades – so the more blades, the more circular the aperture.

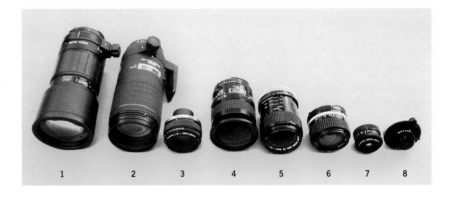

LENS TYPES

Each of these lenses has some degree of close focus.
1 300mm telephoto **5** 50mm macro
2 180mm telemacro **6** 28mm wide-angle
3 80mm bellows macro **7** 38mm belllows macro
4 60mm standard macro **8** 20mm bellows macro

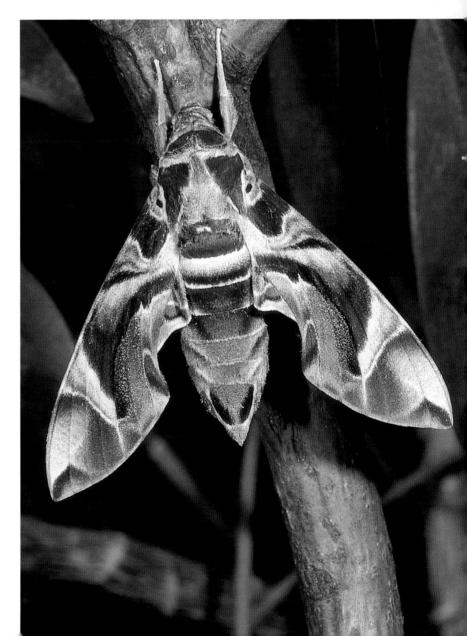

DEPTH OF FIELD LIMITS

With careful camera positioning, the oleander hawk moth is in perfect focus while the background is soft.

 Nikon F4, 105mm f/2.8 AF macro, 1/60 sec. at f/11, Fujichrome Velvia, SB29s macroflash

LENSES WITH CLOSE FOCUS

Several types of lens allow you to move in close on subjects even though they are not designed specifically for that purpose. Their close-focusing capability can be enhanced by using supplementary lenses that screw into the front filter thread of the lens or extension tubes that move the lens further away from the film. With both, the results are very good.

ZOOM LENSES

Many photographers make their first foray into close-up work with the so-called 'standard zoom', which has a focal length range of 28–80mm. In fact most zooms, whether they are in the wide-angle (15–35mm), standard (28–80mm), telephoto (70–300mm), or general-purpose 'wide to tele' range, offer some kind of close-focus facility.

 The best-quality zooms are easily as good as fixed-focal-length lenses and they have the advantage that you can zoom to frame a subject – but few of them allow you to get more than a quarter or one-third life-size images in close-focus mode without supplementary lenses (see page 68).

WIDE-ANGLE LENSES

Wide-angle lenses typically fall within the focal length range of 15mm (extreme) to 35mm (moderate) and many can focus close to a subject. Fixed-focus lenses perform better in this respect than their autofocus counterparts, because they have a longer focusing thread in the lens mount. Their handling of perspective means that you can focus on something in the foreground while still keeping the background in focus; this is a good way of setting your subject in a wider context (for example, a close-up of flowers that still shows something of their habitat).

MACRO LENSES

So-called macro lenses carry a higher price than general-purpose, fixed-focus lenses, but they are highly corrected and excellent for general work, too. Most modern models allow you to get a 1:1 reproduction scale (life-size) on 35mm film. A few medium-format lenses do the same, although most give half life-size, and you will need to use an extension tube to achieve 1:1. With a digital SLR and its built-in magnification factor, you can produce slightly more magnification from the same lens (see page 90).

MOSS CAMPION
(Silene acaulis)

With an ultra-wide-angle lens, small subjects can still be lost in the frame, even at the closest focus. This clump of alpine flowers (below) was about 30cm across – just large enough to dominate the foreground at a focusing distance of about 20cm.
📷 *Olympus OM2, 20mm f/3.5 with linear polarising filter, 1/60 sec. at f/11, Fujichrome Velvia*

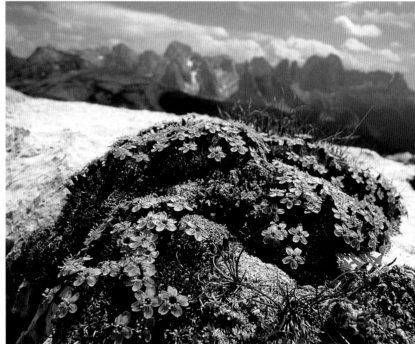

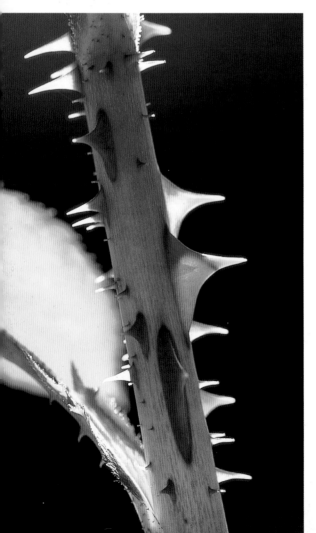

DOG ROSE
(Rosa carina)

A telephoto zoom lens with a useful close-focus setting isolated the rose stems and its thorns. They would have been well out of reach with any lens of a shorter focal length.
📷 *Nikon F4, Sigma 70–300mm f/4–5.6 AF apo macro zoom, 1/60 sec. at f/16, Fujichrome Velvia*

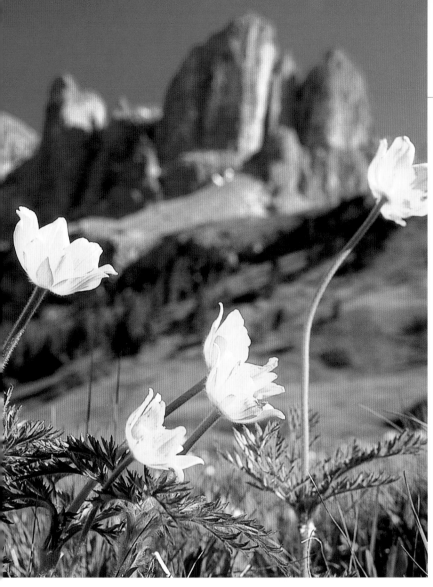

Most macro lenses offer autofocus – although this is a mixed blessing for, no matter how fast the motor is, these lenses still 'hunt' back and forth with the slightest movement of a subject. What no lens manufacturer tells you is that autofocus macro lenses achieve close focus by moving elements of the lens around, which reduces focal length – so, for example, a 105mm AF macro becomes an 80mm macro lens at 1:1.

Macro lenses come in three focal-length ranges:

Standard macro (50–60mm) The standard macro is ideal for flowers and subjects that will not fly away when you get too close. The front element tends to be deeply recessed; as a result, the lens front itself is just a few centimetres from the subject, which can be disturbing for live subjects.

Portrait macro (90–105mm) The portrait macro is often regarded as best for insects and small subjects that tend to be active. It enables you to work from slightly further away from your subject than a standard macro and, as a result, there is less likelihood of you scaring your subject into flying away.

Telephoto macro lenses (180–200mm) Telephoto macros tend to be both heavy and expensive. They produce a slightly flattened perspective compared with shorter-focal-length lenses and have a long working distance and so are ideal with shy subjects such as dragonflies and butterflies (see page 96).

YELLOW PASQUE FLOWER
(Pulsatilla sulphurea)

The close focus of a wide-angle lens allows you to set a foreground flower in the context of a mountainous background.
📷 *Nikon F4, 28mm f/2.8 with circular polarising filter, 1/30 sec. at f/11, Fujichrome Velvia*

COCKLEBUR
(Xanthium spinosum)

A 60mm 'standard' macro lens is ideal for flowers or fruits such as cockleburs. Static subjects are not disturbed by the closeness of the lens front.
📷 *Nikon F100, 60mm f/2.8 AF macro, 1/60 sec. at f/22, Fujichrome Velvia, SB29s macroflash*

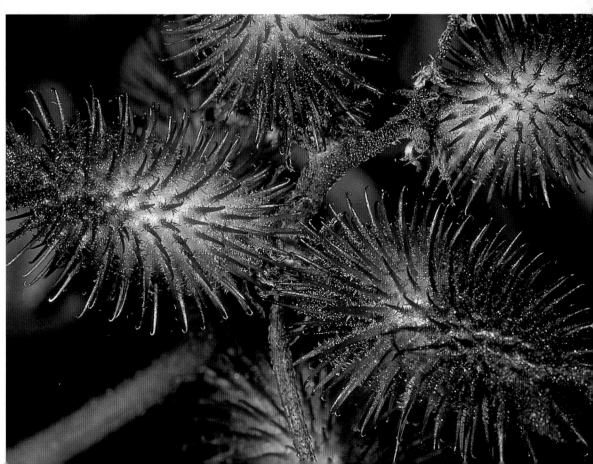

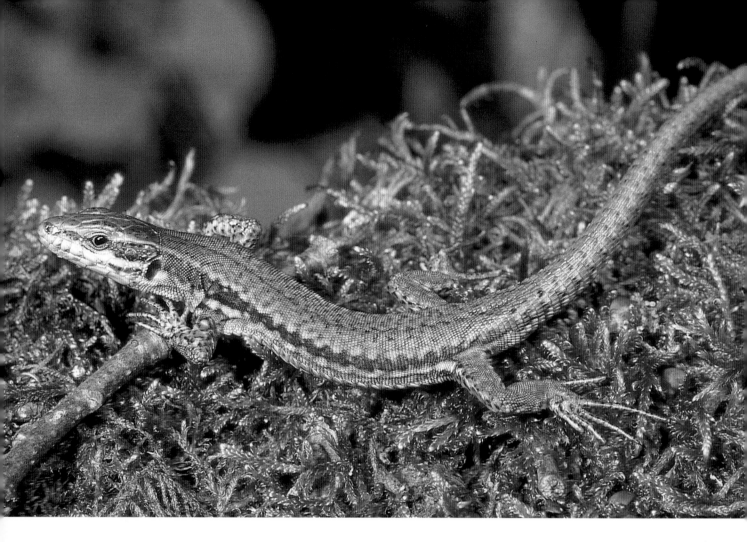

TELEPHOTO AND OTHER LENSES

Telephoto and other lenses, such as teleconverters and even enlarger lenses, can all be pressed into use to achieve excellent results in close-up photography. Although they are not specifically designed for close-up work, they have attributes that make them useful.

TELEPHOTO LENSES

Telephoto lenses are used to bring distant subjects closer. They also have the ability to condense perspective and to isolate distant subjects against a blurred background in a distinctive way that standard or wide-angle lenses cannot match.

In the search to produce compact lenses that are highly corrected, modern telephoto lenses focus by moving elements within the lens body without changing the overall lens length (internal focusing). Many of these telephoto lenses have a good close-focus capability, producing images of one-quarter or one-third life-size.

Extension tubes produce enlarged images by moving a lens farther away from the film (see page 72). An extension tube of about 25mm length is particularly useful with a telephoto lens, because it permits close focus at a working distance of 1 metre or more.

Modern telephoto lenses (and telephoto zooms) give very crisp results when compared with older designs, for they often use low-dispersion elements to give superb colour correction. Best known are the apochromatic (apo) lenses, which virtually abolish colour fringing – those rainbow colours at the edges of objects – and have better contrast than other telephoto designs.

SUPPLEMENTARY LENSES

Supplementary lenses are lens elements that screw into a lens filter ring on the front of your main lens. The main lens loses infinity focus when a supplementary lens is fitted, but you can move in closer without incurring the light loss associated with extension tubes and bellows.

TELEPHOTO LENS CLOSE-UPS

The close-focus possessed by many telephoto lenses is great for shy creatures. This sand lizard stayed still when it was about 1 metre away: using a 300mm telephoto with a built-in tripod mount (see below), I was able fill the frame.

📷 *Nikon F100, Sigma 300mm f/4 AF apo macro, 1/60 sec. at f/11, Fujichrome Velvia*

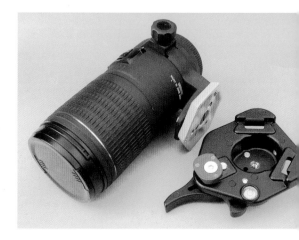

Simple supplementary lenses work well as long as you never open the lens wider than about f/8, since this restricts the rays that make up the image to those passing through the centre of the lens, reducing image softening through aberrations. The best results, however, are given by two-element lenses (see page 68).

TELECONVERTERS

Teleconverters are lenses that are typically used to increase focal length. For example, a x2 teleconverter changes a 300mm lens to a 600mm lens. Against them is the fact that they cut down the amount of light that reaches the film and effectively reduce the maximum aperture of the lens. An f/4 lens becomes the equivalent of f/8 when a x2 teleconverter is fitted. With a x1.4 converter you lose just a single stop.

Modern teleconverters are apochromatic and are often designed to work with particular lenses. In close-up work they act as magnification multipliers (see page 68). They work particularly well at small apertures.

OTHER LENSES

When working in the close-up realm, a bit of ingenuity allows you to use a range of lenses in ways for which they were not intended or in combinations that provide alternative ways of getting magnified images of high quality. Here is an overview of what you can use.

ENLARGER LENSES

Enlarger lenses can act as macro lenses at modest cost. They need to be reversed to make best use of the way the lenses have been designed (see page 70).

CINE LENSES

Lenses designed for 16mm cine cameras, reversed and used with adaptors, provide you with a means of investigating high magnifications up to x20 and more (see page 74).

35MM LENSES ON MEDIUM-FORMAT CAMERAS

Few people think of using 35mm lenses in this way, but when you are working at close quarters a 35mm macro lens can project an image circle large enough to cover a medium-format system, saving you the expense of buying macro lenses specifically designed for medium-format film.

SPECIAL-PURPOSE MACROS AND MACRO ZOOMS

The best known are the Zeiss Luminar lenses and Leitz Photars. Each lens is specially computed to cover a small magnification range (see page 74).

ATLAS MOTH
(Attacus atlas)

This moth was well out of reach, but a x2 teleconverter produced the equivalent of a 360mm macro, allowing me to fill the frame.
📷 *Nikon F4, Sigma 180mm f/3.5 AF macro plus x2 converter, 1/60 sec. at f/11, Fujichrome Velvia, SB29s macroflash*

BLUE WATER LILY
(Nymphaea caerulea)

The finest flowers on aquatic plants always seem to be too far away, but a x2 converter made it possible for me to take a close-up shot.
📷 *Nikon F100, Sigma 180mm f/3.5 AF macro plus x2 converter, 1/60 sec. at f/11, Fujichrome Velvia, SB24 fill flash*

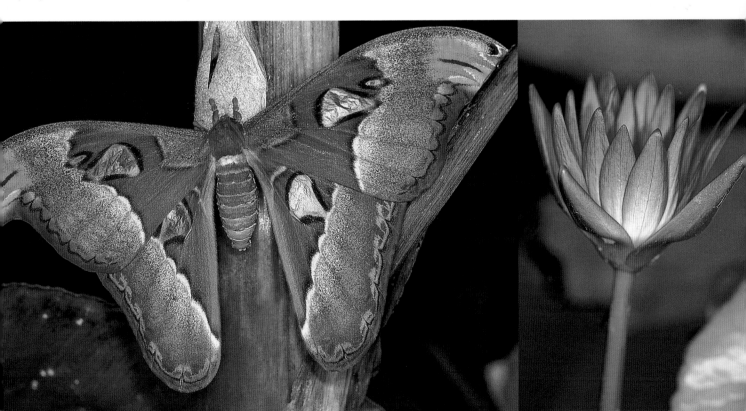

Optical accessories

Before macro lenses became widely available, many photographers used various types of optical accessories to obtain magnified images. There are several that are well worth considering.

VIEWFINDER AIDS

When working with close-up subjects, stopped-down lenses can make a viewfinder darken and sharp focus difficult to achieve because of the grainy appearance of the ground glass. Accessories are available to help overcome these problems.

INTERCHANGEABLE VIEWFINDER SCREENS

Ground-glass screens are not best suited to working with magnified images as, no matter how finely they are ground, their granular nature makes it hard for you to tell when you have achieved sharp focus. Some SLRs allow you to change screens yourself, while with others you will need an expert to do it for you. I prefer plain screens or one with a grid. For magnification greater than x4, some systems offer a screen with a clear central spot and cross wires. Focus is by 'no parallax': you move your head slightly and, when focus is exact, the cross wires and subject appear to move together with no separation.

EYEPIECE MAGNIFIER

An eyepiece magnifier enlarges the central portion of the viewfinder image, making it easier for you to achieve critical sharpness. Several systems also offer a

vertical magnifier for close-up work, which replaces the camera pentaprism altogether, but they are absurdly expensive.

Some people like right-angled magnifiers with 35mm cameras, as they fit into the eyepiece and provide a good way of getting pictures from low angles without becoming a contortionist.

DEATH'S HEAD HAWK MOTH LARVA
(Acherontia atropos)

Extension tubes boost the magnification of a macro lens. Here, over-filling the frame with the caterpillar's body produces a semi-abstract shot.

📷 *Nikon F100, 60mm f/2.8 AF macro with extension tubes, 1/60 sec. at f/22, Fujichrome Velvia, SB21B macroflash*

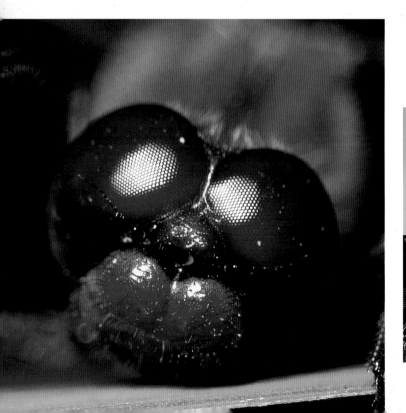

CRITICAL FOCUS

Even the finest focusing screens have a granular appearance that makes it hard to achieve critical sharpness, but using an eyepiece magnifier (left), which enlarges the central portion of the image, can help. The dragonfly (far left) was photographed at twice life-size magnification; an eyepiece magnifier enabled me to focus on the facets of its eye.

📷 *Nikon F4, Olympus 80mm f/4 macro on bellows, 1/60 sec. at f/22, Fujichrome Velvia, SB23 flash*

TOADSTOOLS

A 25mm extension tube improved the close focus of a telephoto zoom, allowing me to fill the frame.

📷 *Nikon F4, 105 mm f/2.8 AF macro with 25mm extension tube, 1/60 sec. at f/16, Fujichrome Velvia, SB29s macroflash*

EXTENSION TUBES AND BELLOWS

Extension tubes and bellows produce magnified images on film by adding space between the lens and the film so that light rays spread out more. Because of this, the light intensity (brightness) on film decreases, since less light reaches the area of exposed film.

This is sometimes described in terms of an effective aperture – on film, with a lens set at f/16 and used at 1:1, the intensity is the same as if the lens were closed down two stops to f/32. The table on page 155 gives the correction in stops for different magnifications.

You can calculate the magnification produced by a bellows or extension tubes by using a simple formula (see page 72).

Extension tubes are lightweight, but few enable you to retain any more of the camera functions than open aperture metering – you lose autofocus, for example.

These days, with most macro lenses going to 1:1 reproduction unaided, extension tubes are not as popular as they used to be. However, a single tube with a 300mm lens improves its close focus no end; a very thin tube with a wide-angle lens does the same, enabling you, for example, to get shots of plants in the foreground with scenery behind. Used with a macro lens, extension tubes enable you to produce images that are larger than life-size.

Essentially a bellows is a continuously variable extension tube mounted on a rail: front panel, back panel and the bellows as a whole can be moved, usually by rack and pinion. The camera and lens are attached via normal mounts or adaptors. In the field, most bellows are cumbersome (Novoflex are the exception), but they really come into their own in the table-top studio (see page 76), where they can be firmly fixed, creating an 'optical bench'.

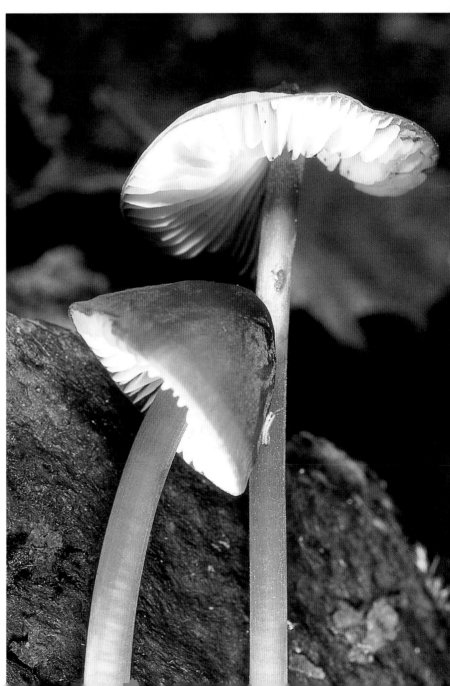

Mechanical accessories

Sometimes it seems that with close-up photography you can accumulate a great deal of hardware, particularly if you start adapting equipment for special purposes. But a few items are, in my opinion, essential.

TRIPOD

In the field, there is often no time to set up a tripod because your quarry is not going to wait around for you to do it. You can often improvize a 'tripod' by using a monopod and your legs – or simply support the camera by bracing it on a wall, by resting it on top of a bean bag sitting on rocks or on a photographer's rucksack. However, if you are using natural light with subjects that are going to stay put, a tripod is essential.

I use Benbo tripods, which have a central 'bent bolt' (hence the name) holding the legs and central column – a support designed for a World War I machine gun. They seem to have a will of their own; the secret is to hold the camera, loosen everything and let the unit settle with its legs splayed on whatever terrain you set it on, then tighten up. Benbo tripods are wonderfully versatile – but then, friends who use Gitzo and Manfrotto tripods say exactly the same.

Buy the very best you can afford: unless they are made from carbon fibre, lightweight is synonymous with flimsiness.

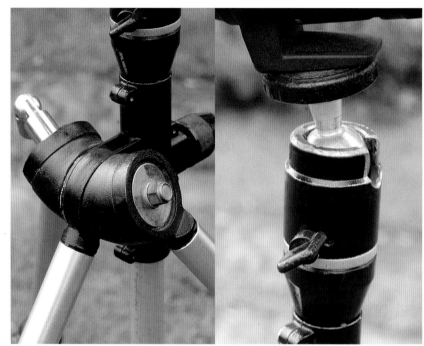

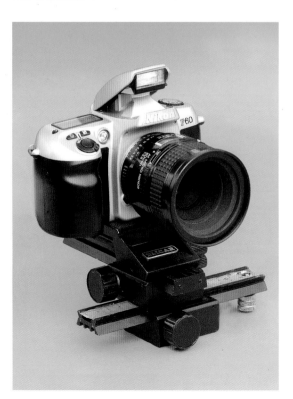

TRIPOD HEAD

Equally important is a tripod head. A pan-and-tilt head might suit video, but you are often better off with a ball-and-socket because of the ease with which you can turn the camera body through various angles to frame the subject. A built-in spirit level is useful for checking the horizon is straight if you also do landscape work. With any tripod and head, a quick-release mechanism saves a lot of time and bother and stops you being tempted to carry a camera fixed on top of the tripod. Camera screws can work loose – with predictable and disastrous consequences.

FOCUS SLIDE

The tiniest movement can send something out of focus when using magnifications higher than about x2. A focus slide – a camera platform that slides or has a rack-and-pinion gearing – helps you to focus smoothly. Manfrotto make an excellent screw-driven platform at a reasonable price that works with both 35mm and medium-format cameras.

TRIPOD USE

A good, sturdy tripod is one of the best investments you can make in your photography. I prefer the central bolt construction (above left), because it is so versatile on uneven terrain. For close-ups and low-angle tripod work, a ball-and-socket head (above right) is often more versatile than a pan-and-tilt one – particularly when cameras or lenses are fitted with a quick-release mount.

USING A FOCUS SLIDE

Most focus slides employ a single track with a rack-and-pinion adjustment: the one shown left also allows cross movement, which can make it easier to frame a subject.

ADAPTORS

Items like reversing rings or rings with twin male threads for screwing one lens reversed into the filter thread of another are useful and can be purchased as accessories. Some firms will machine adaptors for fitting lenses from one make to another. You can never guarantee infinity focus and coupling of things such as automatic diaphragm or metering. But if you are reasonably practical, you can make your own without having to be a precision engineer or using a lathe. Old filters, body caps, reversing rings and extension tubes found in the junk box of your local camera store can enable you to connect all sorts of things together. I have made adaptors that allow me to fit Nikon and Olympus lenses to my Mamiya camera, and reversing adaptors for awkward thread sizes from a pair of Cokin filter adaptors cemented back to back.

This is the principle: you use a mount to fit the lens you have (an old extension tube is ideal, since it already has a lens mount). The tube separates the lens from the camera body to stop any fouling of mechanisms. At the other end you will need to cement a lens mount to fit the camera body – an old reversing ring or a camera body cap with an aperture cut in it.

Unscrew the existing camera fitting from the extension tube, clean and lightly abrade both surfaces with fine emery cloth, clean with detergent to remove any grease and dry carefully. Now, have a dry run to make sure you can fit the mount to the extension tube before using a few drops of superglue (cyanoacrylate adhesive) to fix it firmly in place.

CABLE RELEASE

In order to avoid camera shake, get into the habit of using a cable release – manual or electronic. It is possible to use the self-timer switch on your camera, but Murphy's Law dictates that any butterfly will exit stage left just before the shutter fires.

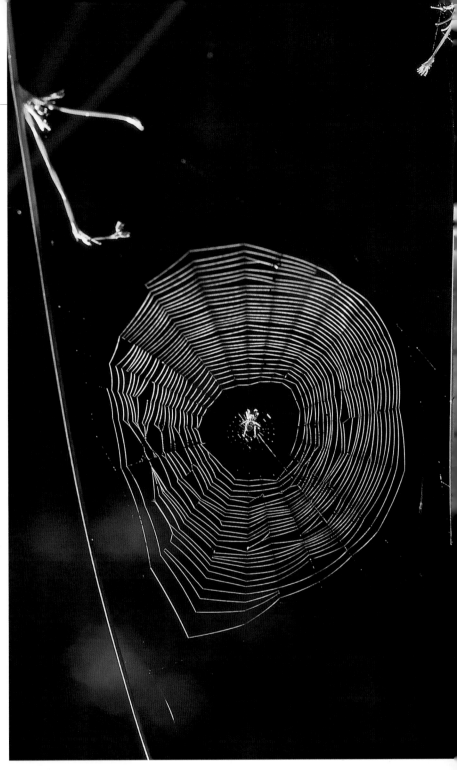

SPIDER WEB

To photograph this spider's web, back-lit with early morning light, I positioned two tripod legs on the ground and braced the third against a tree trunk.
📷 *Nikon F4, 105mm f/2.8 AF macro, 1/8 sec. at f/11, Fujichrome Velvia*

CLEMATIS SEEDHEADS

To capture fine detail on these clematis seedheads using daylight, I used a focus slide to move the whole camera precisely.
📷 *Nikon F4, 105mm f/2.8 AF macro, 1/60 sec. at f/16, Fujichrome Velvia, SB29s macroflash*

Exposure

At its simplest, a camera is just a light-tight box, with a lens that focuses an image on a sensitive surface such as a film or an array of light receptors. There is also some means of controlling exposure – the light energy that falls on the film or receptors. 'Correct' exposure results when the film reproduces tones accurately with the correct relative brightness after development.

ORIENTAL POPPY
(Papaver orientalis)

Poppies catch the slightest of breezes, so select a shutter speed to freeze movement, and let the camera set the aperture. When depth of field is important, use aperture priority and allow the camera to set the shutter speed.
📷 *Nikon F100, 60mm f/2.8 AF macro, 1/250 sec. at f/8, Fujichrome Velvia*

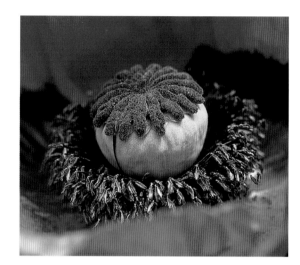

CONTROLLING EXPOSURE

GERBERA STAMENS
(Gerbera sp.)

When the exposure is correct for the film used, it shows both maximum detail and subtle differences in tone in even a uniformly coloured subject such as this gerbera daisy. Overexposed (burned-out) shots are harder to rescue than underexposed photos, which are dark but do contain detail.
📷 *Nikon F100, 60mm f/2.8 AF macro, 1/15 sec. at f/8, Fujichrome Velvia*

The amount of light that hits a film is controlled in two ways – by the size of the hole it passes through (the aperture) and by the time for which the film is exposed to light (the shutter speed).

Aperture sizes are indicated by a series of numbers – the f-stops engraved on a ring on the barrel of the lens (see page 114). When the ring is rotated, it moves a set of thin metal leaves – an iris diaphragm – to increase or decrease the size of the hole at the centre. The f-numbers run in a series of increments, each of which constitutes one 'stop':
1, 1.4, 2, 2.8, 4, 5.6, 8, 11, 16, 22, 32
decreasing aperture diameter ────────────➤

With large-format lenses, several extra values are included. These are: 45, 64, 90, 128.

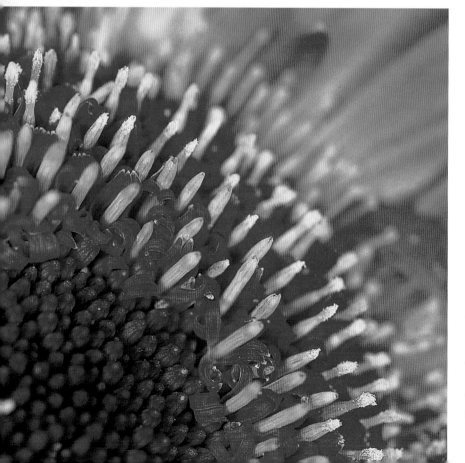

The larger the f-number, the smaller the diameter of the aperture. Moving from one number to the next (one stop) changes the area of the aperture by a factor of two: moving from f/11 to f/16, for example, halves the diameter of the aperture (or closes it by one stop), while moving from f/8 to f/5.6 doubles it (or opens it up by a stop). For colour transparency films a whole stop represents a coarse adjustment and many lenses come equipped with clicks at half stops: for larger formats they are at 1/3 stops (like an exposure compensation dial).

Shutter speeds are adjusted in multiples and fractions of a second: the shortest might be 1/8000 second and the longest can be minutes. Like f-stops, mechanical shutter speeds change by a factor of two from one setting to the next, but most 35mm shutters are now electronic and allow a range of intermediate speeds.

The shutter speed and the aperture need to be considered together as a means of controlling the exposure. Decrease the aperture by one stop and you must double the amount of time the shutter is open (and vice versa) for the same amount of light to reach the film. Suppose, for example, that an exposure meter reads 1/30 sec. at f/11: this will give an exposure in which the tones are correct, but the slow shutter speed means that a moving subject will appear blurred. If you

want to use a faster shutter speed to freeze movement (say, 1/125 sec.), then you need to alter the aperture to ensure that the same amount of light reaches the film and gives you the correct exposure. In this example, we have reduced the shutter speed by two stops, from 1/30 sec. to 1/125 sec., so you need to make a corresponding two-stop increase to the aperture – from f/11 to f/5.6.

EXPOSURE VALUE

Professional exposure meters generate an exposure value (EV) and sometimes exposure ranges are quoted in EV. In practice, a change of 1EV is the same as a one-stop change (the doubling or halving of the ISO speed, for example). 0EV is equivalent to an exposure of 1 sec. at f/1 for a film of ISO 100.

ROSE BUD *(Rosa sp.)*

Reliable TTL metering has meant the end of complicated calculations for close-up exposures. Modern meters cope accurately with daylight and flash, expecially when the subject dominates the field of view as this rose bud does.
📷 *Nikon F100, 105mm f/2.8 AF macro, 1/60 sec. at f/16, Fujichrome Velvia, SB29s macroflash*

PUSS MOTH *(Cerula vinula)*

The puss moth caterpillar and its surroundings are all neutral tones, so camera meters can be trusted to give the right exposure.
📷 *Nikon F801, 105mm f/2.8 AF macro, 1/60 sec. at f/22, Fujichrome Velvia, SB21B macroflash*

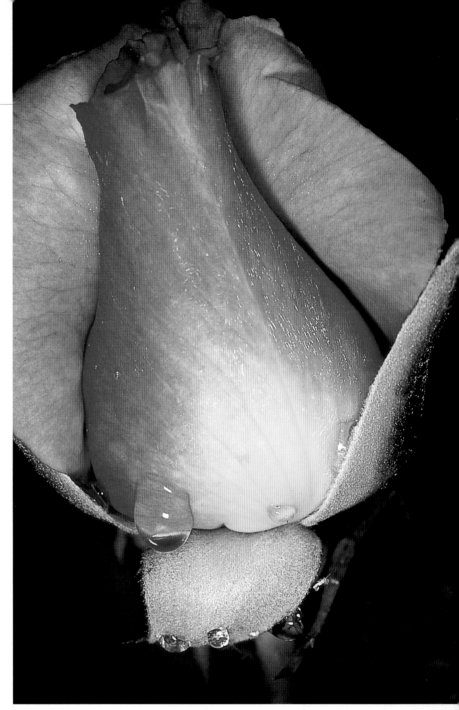

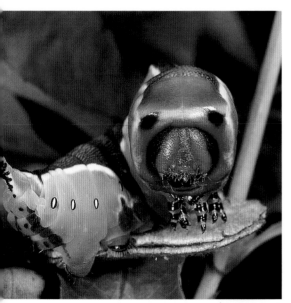

SPRING CROCUS
(Crocus vernus)

Highly reflective backgrounds, such as the limestone behind these crocuses, can fool an exposure meter into reading the overall scene as being light and underexposing to compensate the meter from neutral tones.
📷 *Nikon F4, 28mm f/2.8 with circular polarising filter, 1/30 sec. at f/11, Fujichrome Velvia*

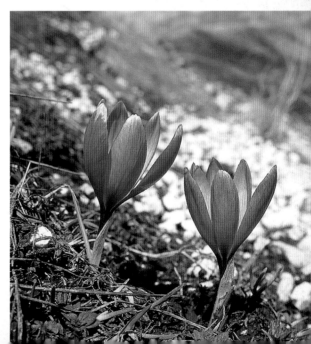

MAKING FINE ADJUSTMENTS

Modern exposure meters cope successfully with a wide range of subjects. For pinpoint accuracy I prefer to use the spot mode and make adjustments for bright and dull tones (see page 34). The camera's exposure compensation dial (right) allows this to be done precisely – most have 1/3 stop increments. The lawyer's wig fungus (bottom left) has lots of reflective spots and so I opted for 1/3 stop overexposure. The bracket fungus (bottom right) is mostly mid-tones and I left it to the camera's matrix meter to compute a weighted average.

📷 *Nikon F100, 60mm f/2.8 AF macro, 1/60 sec. at f/22, Fujichrome Velvia, SB29s macroflash*

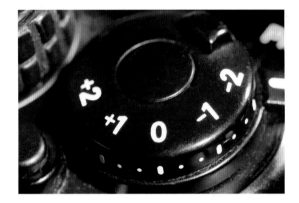

EXPOSURE MODES

Many cameras allow you to set the exposure system in a number of ways, or 'modes'. Manual exposure means that you set the shutter speeds and aperture yourself, according to a meter reading. With shutter priority, you choose a shutter speed (say, one fast enough to freeze action), and the camera then adjusts the aperture to suit varying light conditions. With aperture priority, you set an aperture to give the required depth of field, for instance, and the camera then sets the correct shutter speed. Program modes set both shutter speed and aperture for various situations: one program mode might be good for moving subjects, another for low light. Essentially the camera 'decides' by comparing readings of a scene with examples in its memory.

EXPOSURE METERS

All exposure meters contain a sensor that uses some light-sensitive property to determine the brightness (intensity) of light. Most meters now depend on a photodiode, but earlier models used cadmium sulphide, a photo-resistor or a selenium cell.

There are two kinds of exposure meter. Incident light meters are hand-held and are placed in the subject position. Light falls on a diffusing surface and the meters measure the light intensity directly. Reflected light meters measure light that is reflected back from the subject to the camera position; they are either hand-held and pointed at the subject or built in to the camera. They are all calibrated to deal with average reflectivity, or mid tones, and are designed on the assumption that every scene will contain an average tone (the 'standard' 18% reflectance grey card) and will be correctly exposed.

Modern electronic cameras have such sophisticated meters that we tend to rely on them far too much, not questioning the reading. If you understand how and what they measure, then you can make fine adjustments when necessary and greatly improve the success rating of your shots.

Exposure meters in modern cameras are ingeniously constructed and offer several metering patterns:

CENTRE-WEIGHTED METERS

Centre-weighted meters bias most of the reading of a scene to the centre of the frame, which is not ideal for anything that is off-centre or for small, bright subjects.

SPOT METERS

TTL spot meters select a very small area at the centre of the camera viewfinder or employ a small angle of view (typically 1°) in a hand-held meter. You can compare readings from different tones or lock in the

reading from a mid-tone using the auto exposure (AE) lock, so that the composition can be changed but the exposure kept. You have to be able to recognize the mid tone that you want or to be able to compensate if you meter from bright and dark tones. With experience, this becomes the most accurate method.

MATRIX METERS

Matrix meters can cope with scenes containing light and dark subjects, as well as intermediate tones. The viewfinder area is split into five or more segments and the camera then assesses the relative brightness of these segments and compares them with a huge range of scenes programmed into the camera's memory. This can be also coupled with data from the rangefinder in the camera's autofocus so that a camera 'knows' the reflectance of a grey object at that distance and can thus correct for any other tone. Matrix metering is now so good that it is almost foolproof, although it can still be deceived by extremes such as bright snow or the proverbial black cat in a coal cellar (see page 34).

TONAL RANGE

Ideally, your film should be able to capture the brightest parts of a scene without becoming washed out while still registering all the detail in shadow areas. This is a lot to ask when films may have to deal with a range of tones from pure white through various greys to featureless black and condense that into a spread of five to six stops. Digital SLRs can have a range of seven stops giving, in theory, better gradation of tones as well as allowing them to cope better with over- and underexposure (see page 91).

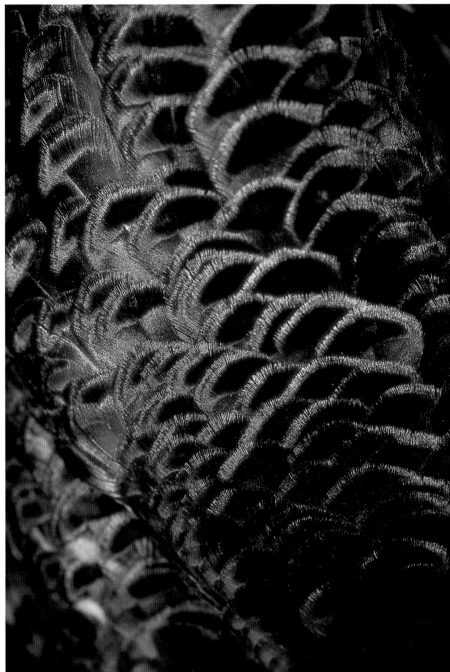

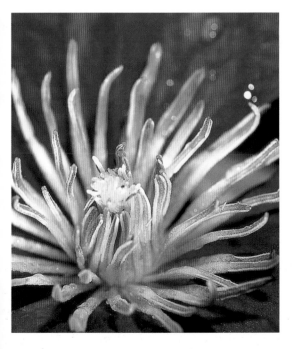

CLEMATIS FLOWER
(Clematis sp.)

Exposure readings of the yellow flower centre and purple surroundings differed by over a stop. The camera's matrix meter came up with an excellent compromise.

📷 *Nikon F100, 60mm f/2.8 AF macro, 1/60 sec. at f/22, Fujichrome Velvia, SB29s macroflash*

EDWARD'S PHEASANT FEATHERS
(Lophura edwardsi)

The dark feathers demand a film that can retain shadow detail. I underexposed by 1/3 stop and reduced the flash output to prevent overexposure.

📷 *Nikon F4, Sigma 180mm f/3.5 AF macro, 1/60 sec. at f/11, Fujichrome Velvia, SB29s macroflash*

PROBLEMATIC EXPOSURES

When confronted with subjects that reflect a lot of light – such as bright yellows and whites – a meter tends to register them as an 'average' tone of grey. This results in underexposure with dull yellows and white reproducing as a dull grey. Snow scenes are a classic example: so much light is reflected that the meter suggests a reading that will make everything appear dull. Similarly, dark subjects will be over-exposed as the meter tends to lighten them.

To get around this problem, you need to overexpose very bright subjects and underexpose very dark ones – but the question is, by how much? Matrix meters cope well, but for absolute accuracy I use spot metering.

Different meters behave in different ways, and it is worth making a note of how your camera copes in each of its metering modes by taking a range of exposures (bracketing) for about 1/3 and 2/3 stops either side of the camera's recommended exposure. The best way to handle this is to use a camera's exposure compensation dial, which is adjustable in increments of 1/3 stop. This gives a finer degree of control than using a lens that adjusts in half stops. Always remember to adjust the compensation dial back to zero after you have taken the shot, otherwise every later shot will be under- or overexposed.

In each case, let the subject dominate the viewfinder so that background does not interfere and confuse things. For the expense of a few frames – a roll at most – you will save yourself time and money later on.

My own tests have shown that the spot meter in one of my camera bodies needs +2/3 stop compensation when bright yellows, reds and other bright tones dominate and +1 1/3 stops to retain detail with white.

With practice, you can handle all exposures confidently by anticipating what the meter will do. You can happily meter from bright tones, knowing you have to adjust things slightly to get them to appear bright on film. I used to keep a small card listing the amount of correction needed for particular situations in the film holder on the back of an SLR until they become second nature.

THE SUNNY F/16 RULE

A colour film is constructed to give correct exposure when the sun is high in the sky in the northern hemisphere for a lens aperture set to f/16 and a shutter speed that is 1/film speed (the ISO rating). For instance, with an ISO 125 film at f/16, correct exposure is obtained at a shutter speed of 1/125 sec. For ISO 25, the shutter speed would be 1/25 sec.

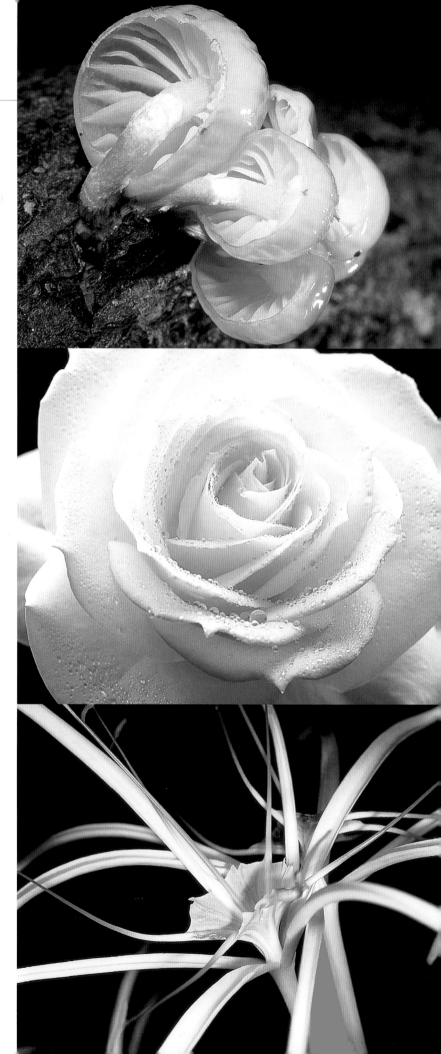

WHITE SUBJECTS

If your pictures of white subjects are consistently underexposed, it is time to take control. First, select a white subject and make some test shots. Then you can use the same exposures to get perfect results with every subject. I take a reading using the camera's built-in spot meter and overexpose by at least one stop. This method works with highly reflective subjects such as the fungi shown top left. It also retains shadow detail, as in the rose petals (centre left) and the stag beetle larva (right). It also copes with a white subject against a very dark background, as in the *Hymenocalis* shot (bottom left).

Nikon F100, 60mm f/2.8 AF macro, 1/60 sec. at f/16, Fujichrome Velvia, SB29s macroflash

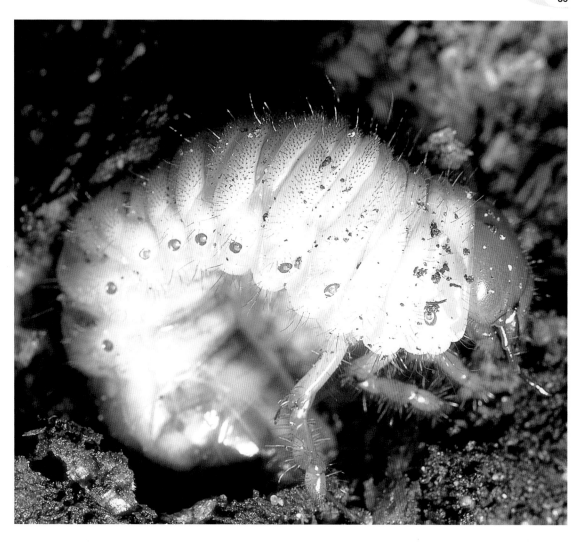

With some film speeds, however, you may need to make a slight adjustment, as there is no shutter speed that is identical to the ISO rating. For example, if you are using an ISO 50 film, there is no 1/50 sec. shutter speed. The nearest shutter speed to this is 1/60 sec., which means that your shot will be underexposed by about 1/3 stop. Use your camera's exposure compensation dial and all will be well. On several occasions I have sensed that a meter was not working properly and saved the day using this rule.

YELLOW BRAIN FUNGUS
(Tremella mesenterica)

Yellow subjects need slightly less exposure correction than white ones. In my determination to get the exposure right, I completely missed the tiny slug, feeding on the fungus.

Nikon F100, 105 mm f/2.8 AF macro, 1/60 sec. at f/16, Fujichrome Velvia, SB29s macroflash

Film

Your eye, a colour film and a digital camera all respond to the range of wavelengths in visible light in a slightly different way. Black-and-white film simply reproduces colours as tones, so that a mid-green and mid-red appear to be the same shade of grey.

BACKLIT SEEDHEADS
(Pulsatilla appennina)

In a backlit subject such as these seedheads, one might well want to hold detail in both the highlights and the shadows – but this is asking a great deal of any film. Only by knowing exactly what your chosen film can cope with will you get the best compromise. For this shot I used Fujichrome Velvia – a great favourite with many photographers because it handles a wide contrast range and exhibits very fine grain, capturing subtle detail in a scene.

📷 *Nikon F4, 24mm f/2.8 with circular polarising filter, 1/30 sec. f/11, Fujichrome Velvia*

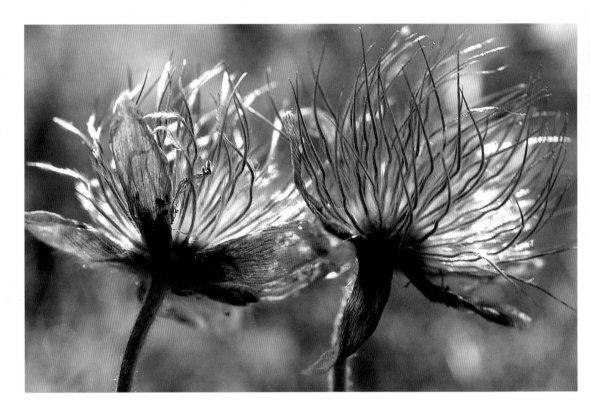

Colour perception varies between individuals, and human sensitivity to light peaks in the green region of the visible spectrum. We also have differing acceptance of colours – some people like their colours 'warm' and others 'cool'. Different films react differently, too. It is up to you, the photographer, to decide what you want in terms of sharpness and colour rendition from a film and to choose your film stock accordingly.

HOW FILM WORKS

The light-sensitive layers in both colour and monochrome films are formed from silver bromide (a silver halide) held in a gelatine substrate. Light energy disturbs the crystal lattice and produces the metallic silver to form the dark areas in monochrome films. These dark areas are bleached out in colour films and replaced by dye clouds. Groups of crystals clump together to form 'grains' – and this is what you see under high magnification when the image appears to break up.

GRAIN AND FILM SPEED

The grain is really clusters of silver halide (bromide and iodide) crystals – the faster the film, the larger the clusters. The individual silver halide crystals are much smaller – about 0.0002mm across. (Compare this with a pixel on a sensor, which is typically 0.009mm.)

The slower films (ISO 25, 50, 64 and even 100) have the finest grain and keenest sharpness and it is fine grain that enables a film to record and separate fine detail (its resolving power). Sharpness (see page 152) is a more complex issue; in fact, one film may have a lower resolving power than another but appear sharper. This is because it is better at handling contrast (or distinguishing between light and shade) – particularly at the edges of objects in an image. This property is known as the film's 'acutance'. When you process black-and-white film yourself, you can use different developers to control acutance, but with colour film consigned to a processing house you have no control: acutance is optimized by the film manufacturer.

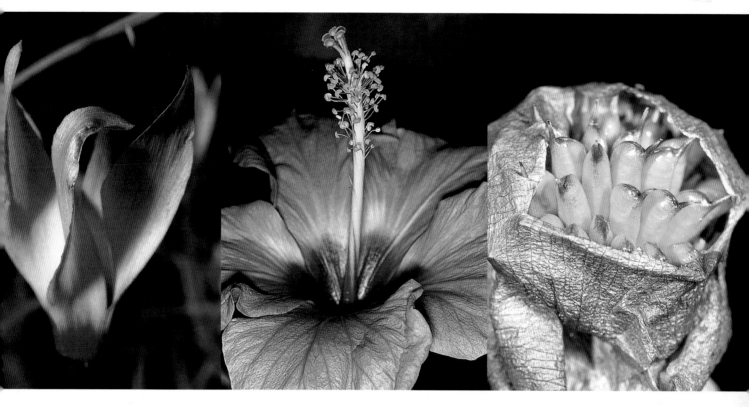

Slow films are the choice for most close-up and macro work, where it is essential to render fine detail sharply with maximum tonal range. Conversely, the medium (ISO 100–200) and faster films (ISO 400–1600) have more obvious grain structure and do not handle contrast so well, but both grain and poor contrast can be used creatively.

CONTRAST

Slow films are best at handling a wide range of light intensities in the same scene – the contrast. Typically, a colour film has to cover everything from deepest black to featureless white over a range of about five to six stops. A slow film will retain detail in shadow and highlight areas whereas with a fast film this is lost – the result is said to be 'contrasty'.

EXPOSURE LATITUDE

The latitude in exposure that a film can handle either side of the correct value, while still giving usable results, is known as its tolerance. The faster a film, the less tolerant it is, and images can appear burned out with even slight overexposure. When printing, negative films offer the highest tolerance. Black-and-white negative films allow you a couple of stops of tolerance, while the slower colour negative films allow a stop or so. However, even with the slowest films, the exposure latitude with transparency films is less than a stop.

CONTRAST AND DETAIL

The aim of most close-up and macro photography is to capture a full range of colours accurately, with as much detail as possible. Different films produce different results: the cyclamen (above left) was taken on Kodachrome 64, the hibiscus (above centre) on Fujichrome Provia, and the seedhead (above right) on Fujichrome Velvia. Each film is excellent and each has its devotees.
 Nikon F100, 60mm f/2.8 AF macro, 1/60 sec. at f/16, SB29s macroflash

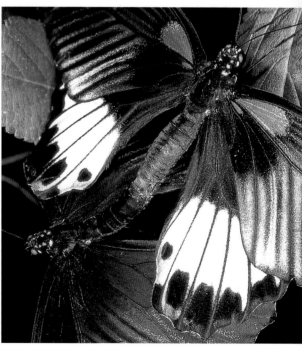

SWALLOWTAIL BUTTERFLIES MATING
(Papilio rumanzovia)

Recording shadow and highlight detail in both black and white is often beyond colour transparency films. I chose to focus on part of the wings making sure that detail was retained in the white areas.
Nikon F4, Sigma 180mm f/3.5 AF macro, 1/60 sec. at f/16, Fujichrome Velvia, SB29s macroflash

CHOICE OF FILM

First and foremost, your choice of film should be dictated by what pleases you, the photographer. Do you prefer black-and-white or colour? If colour, then do you like the convenience of negative films with prints and a greater exposure latitude, or do you want the accuracy and better tonal range of colour transparencies?

Choice can also be influenced by the potential uses you see for your work. If you intend to scan pictures to be printed on a digital printer, then it does not matter whether you start from transparency or negative material – a dedicated scanner will handle both.

If you aim to get your work published then transparency material is what the industry is geared to handle, since it produces far better colours and tonal range. Again, if you enjoy giving talks, transparencies are useful for projection.

MONOCHROME FILMS

Monochrome films tend to be neglected in close-up work, though they are unequalled for revealing texture, structure or tone where colour might be a distracting element. There is a choice of both negative or positive films: the latter are more expensive and come process paid, but the results are superb and you have the novelty of a black-and-white image for projection.

Some people work in colour but use the capabilities of computer manipulation to produce impressive monochrome prints (see page 140).

SPECIAL FILMS

Besides the usual negative and positive films readily available in your local store, there are films designed for special purposes – but many are of limited use in close-up and macro work.

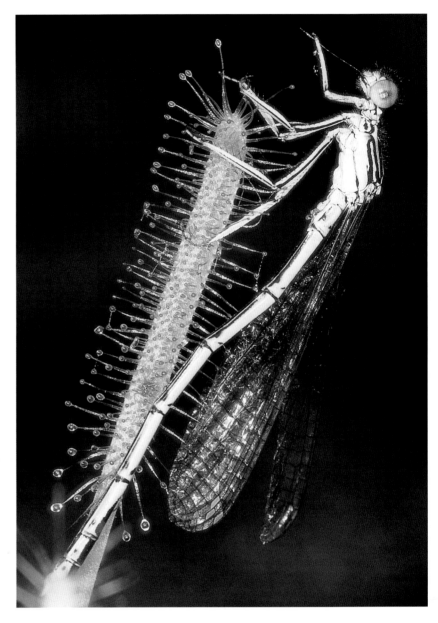

FILM VARIETY AND FORMAT

There is a great variety of film available in both medium-format and 35mm formats. Although it is not nearly as popular as colour, black-and-white film is ideal for exploiting pattern and texture. I was guilty of neglecting it until I discovered Agfa Scala monochrome transparency film. The damselfly (above) was found trapped by a sundew plant in a sphagnum bog.

📷 *Nikon F100, 105 mm f/2.8 AF macro, 1/250 sec. at f/22, Agfa Scala, SB29s macroflash*

FERN WITH SPORES

When shooting static subjects, such as these fern spores, I prefer to make duplicate slides by taking several shots in sequence.
📷 *Nikon F4, Sigma 180mm f/3.5 AF macro plus x2 converter, 1/60 sec. at f/16, Fujichrome Velvia, SB23 off-camera flash*

COPYING FILMS

Copying films are used for making duplicate transparencies. If you try to produce duplicates using your normal film and a slide copier, the results are inevitably too contrasty. You can give the film a short pre-exposure – about 6–7 stops underexposure – that reduces contrast, but copying films have a lower contrast built in and will do a better job.

INFRARED FILMS

Colour films such as Kodak's Ektachrome EIR and several black-and-white films are sensitive to green, red and near infrared light. They have to be stored carefully, loaded in total darkness, and not exposed to direct heat (because radiant heat is a form of infrared radiation). They produce interesting, often bizarre results with false colours. In close-up and macro work they are something for the occasional experiment.

FILM CARE

Heat and moisture are the enemies of films, both processed and unprocessed. Always try to buy your film from reliable sources and not from some street-corner booth in a hot country. When subjected to heat, the contrast ability of some films goes haywire. In tropical climates do not open film until necessary; after exposure, store it in a cool place in a sealed tin with silica gel to remove moisture. The gelatine in films acts as a marvellous culture medium for moulds.

X-RAYS AND FILM

Photographic magazines regularly publish articles on films and X-rays. Following the terrorist attacks of September 11, 2001, it has become harder and harder to get a hand search for film and to avoid X-ray machines. It is claimed that low-dosage machines at large airports do not affect slower films, but high-speed films that pass through several X-ray machines on internal flights stand a risk of damage, because the film receives an accumulated exposure to X-rays that makes it lose contrast. Always carry film in your hand luggage, as the powerful machines used to X-ray checked baggage can damage film.

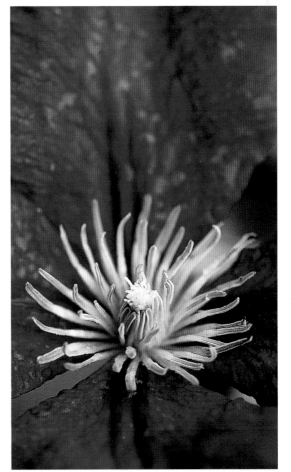

CLEMATIS CENTRE

This slide was showing the first signs of fungal threads which will eventually eat into the emulsion. I used a soft tissue, soaked in isopropanol and squeezed almost dry, to remove them.
📷 *Nikon F801, 60mm f/2.8 AF macro, 1/60 sec. at f/22, Fujichrome Velvia, SB21B macroflash*

Backgrounds

By choosing the right background, you can improve the overall impact of a picture immeasurably. With complicated backgrounds, such as a mass of twigs or small leaves, the viewer's eye begins to wander away from the main subject. A simple, unfussy background, on the other hand, can emphasize the main subject and make it appear to stand out.

TARANTULA SPIDER WITH ITS YOUNG
(Lycosa narbonense)

Neutral colours of foliage or of the earth and rocks make natural backgrounds that are pleasing to the eye. Many subjects such as this tarantula are coloured in the same way but fill-flash can emphasize whatever contrast difference there is.
📷 *Nikon F100, Sigma 180mm f/3.5 AF macro, 1/60 sec. at f/16, Fujichrome Velvia, SB25 fill flash*

A blurred background has the effect of emphasizing foreground sharpness. Although there are many problems to contend with in close-up and macro work, one great advantage is that blurred backgrounds are created as a matter of course because objects are thrown out of focus just a short distance from the subject. The longer the focal length of the lens, the more this effect is accentuated.

CHECKING FOR BACKGROUND CLUTTER

When photographing in glasshouses and other buildings, people often fail to see girders, pots and labels lurking in the background. Even in the foreground, grass blades can be interposed between your lens and the subject without you noticing. Unfortunately, as you stop down they become sharper and more noticeable. It is worth using the stop-down preview button before you take the shot to see if you have anything obtrusive in the background.

'NATURAL' BACKGROUNDS

If you are photographing plants or insects and other small animals up close in captivity, you can create a very pleasing 'natural' background by positioning a clump of wild grasses or other plants far enough behind your subject to produce a blur of colour when illuminated. Stones can also be effective behind close-up subjects, provided they fill the background in the viewfinder. Individual stones, particularly highly reflective

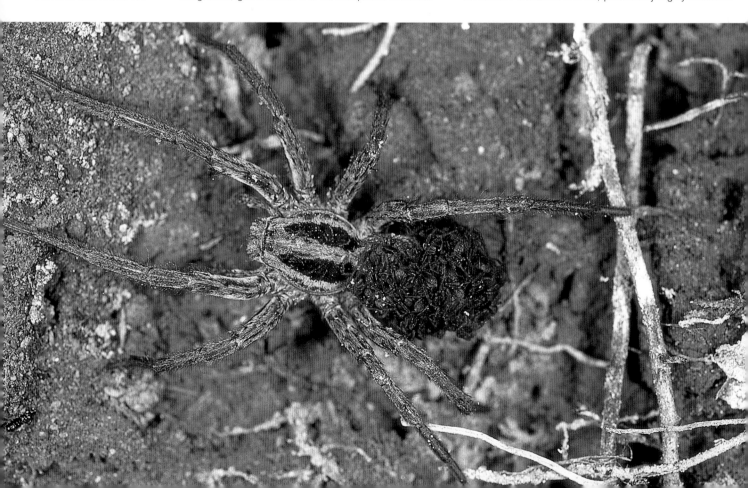

stones such as limestone and chalks, can appear as distracting bright blobs in pictures. The neutral tones of soils and pieces of bark make backgrounds that are easy on the eye when thrown out of focus.

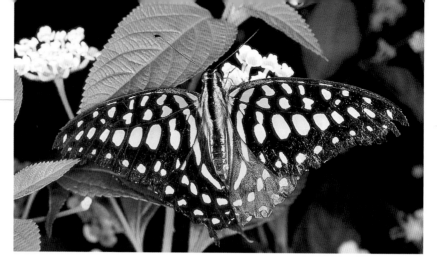

ARTIFICIAL BACKGROUNDS

Some people paint their own backgrounds – although the colours must be chosen carefully so that they do not draw attention away from the main subject. Natural tones such as greens and browns work well because they are 'neutral' colours. For pictures taken in an aquarium, a mixture of dark blues can work well. Single colours that do not occur in nature might look fine for a while but our ideas change and eventually you will feel those picture are unusable.

Other techniques for making your own backgrounds include photographing a background so that it is thrown out of focus and then scanning and printing it on a matt paper. You could also create a blur with a software package such as Adobe Photoshop and then print this, but creating any sort of artificial background demands a good eye for colour.

BLACK BACKGROUNDS

For 'art' shots, a black background can be extremely dramatic. Even better, incorporate some degree of backlighting that makes the edges of the subject glow and stand out against the black.

It is not always easy to get a true black background. Black velvet works well, but tends to pick up specks of dust and fluff; black flock paper is better, but it is a very scarce commodity these days. Painted matt black backgrounds can be surprisingly reflective, and black card is so reflective with flash that it comes out grey. I have used a (clean) black T-shirt as a background on many occasions to great effect.

GREEN TRIANGLE BUTTERFLY
(Graphium agammemnon)

Vegetation close to the subject helps break up the dark background inevitably created by flash fall-off. This butterfly was photographed in a butterfly house.
📷 *Nikon D100, Sigma 180mm f/3.5 AF macro, 1/125 sec. at f/16, ISO 200, SB80-DX flash*

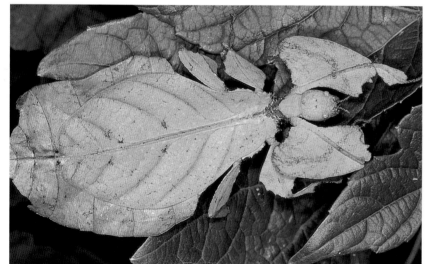

LEAF INSECT
(Phyllium crucifolium)

Camouflage depends on how well creatures blend with a background. In this shot of a leaf insect, my aim was to show the insect in detail, while retaining just enough background to illustrate camouflage.
📷 *Nikon F4, 105mm f/2.8 AF macro, 1/60 sec. at f/16, Fujichrome Velvia, SB21B macroflash*

WEEVIL FEEDING
(Liparus glabrirostris)

The mix of natural green leaf and black background has worked well to emphasize the weevil: the camera was positioned to show the holes created by the weevil feeding.
📷 *Nikon F4, 105mm f/2.8 AF macro, 1/60 sec. at f/16, Fujichrome Velvia, SB29s macroflash*

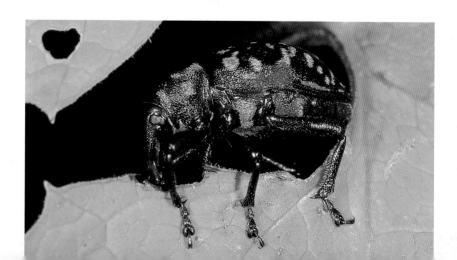

Flash

In close-up and macro photography, you need a light source that allows you to use small apertures and also obtain maximum depth of field. With a little practice, flash can become your ideal light source. Flash also has action-stopping speed (typically less than 1/1000 second) and thus largely eliminates problems associated with camera shake and subject movement.

THE SHORTCOMINGS OF FLASH

Some photographers maintain a resolute belief that flash is 'unnatural' and to be avoided at all costs. Their criticism centres around two things: harsh shadows and unwanted black backgrounds. In reality, however, you can control both.

HARSH SHADOWS

When a flash gun is held some distance from a subject, it acts as a point source, creating harsh shadows – like the midday sun in a cloudless sky. The solution is to use a single small flash close enough to the subject to act as a wall of light: shadows created by light from one part of a flash are softened by overspill from other parts. Alternatively, you can use a couple of flash guns – one as main light and another as a 'fill-in' to soften the shadows.

UNWANTED BLACK BACKGROUND

Black backgrounds are created as light falls off rapidly beyond the subject. By including something (leaves, twigs, stones) close enough to be illuminated by the flash, the background can be broken up. Alternatively you can illuminate the background by means of a TTL flashgun linked to the others. If the background is slightly less well illuminated than the subject – by a stop or so – then the subject is accentuated.

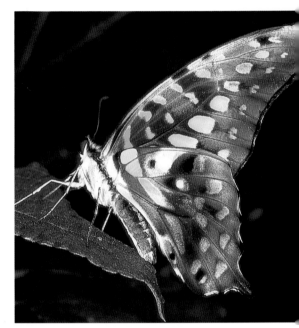

ON-CAMERA FLASH

An SLR camera's integral flash (below) can provide excellent close-up results provided the subject is neither too distant nor so close to the lens front that the flash misses it. The green triangle butterfly (right) was an opportune snapshot taken in a butterfly house, using just such an integral camera flash and a close-focus zoom. Beware, built-in flashes can quickly drain expensive camera batteries.
📷 *Nikon F60, 28–80mm AF zoom, 1/60 sec. at f/8, Fujichrome Velvia*

TYPES OF FLASH GUN

Flash guns are available in a number of types, all of which can be used in close-up photography – although some are more useful than others. TTL flash metering, an ingenious invention, has been around long enough to have become a feature of most cameras.

ON-CAMERA AND INTEGRAL FLASH

Many cameras now come complete with an integral pop-up flash on top of the camera. When these devices were first introduced, the flash guns sat so low on the pentaprism that the light would not clear the end of a macro lens, leaving the subject in shadow. In current cameras, many of these small tubes sit higher up and are very convenient for close-up work up to about half life-size. Small flash guns can be mounted on the hot shoe of most cameras and work in exactly the same way as an integral flash, although they are usually placed higher and are able to illuminate subjects nearer the lens.

GUIDE NUMBERS

Each flash gun comes with a series of guide numbers (GN) for different film speeds in both feet and metres. If you divide the guide number for your chosen film speed by the chosen aperture, you get the distance (in metres) from the subject at which the flash should be held. For example, with a GN of 32 at ISO 100, at f/16 the flash should be about 2 metres away. In practice, manufacturers' guide numbers seem wildly optimistic, as if they have been measured in rooms with white walls. You might also have to adjust the figures when a flash is used to the side of the camera because only a portion of the light that hits the subject is reflected back to the lens and for magnification. However, they do give you a useful starting point for your own tests.

SEPARATE FLASH

The position of the flash gun is important in lighting close-ups and any on-camera flash limits you; it is far better to use a connecting cable and hold a flash slightly to the side of the camera. A good starting position is around 15–20cm away and at 30–45° to the side to create lighting relief. In addition, raise the flash above the subject by the same angle to create a more natural direction for the light and the shadows created (see below).

A large 'hammerhead' flash gun, held further away, will illuminate both subject and background without overexposing the foreground, although it helps to diffuse the light to avoid harsh shadows. Some flash units already have an integral diffuser attachment for use with wide-angle lenses. This diffuser is also ideal for creating a diffuse source with close-up work when you use a single off-camera flash to light the subject.

MANUAL FLASH GUNS

Small manual flash guns can give good results, but you need to experiment to calibrate them. You can use a flash meter in the subject position, but you then have to correct the exposure if you know the magnification, using the magnification factor given in the table on page 155. A better solution is to fix the flash on a bracket. First run test exposures at f/8, f/11, f/16 and f/22 to see what lens aperture gives the correct exposure. If every shot is overexposed, repeat with the flash further away; if every shot is too dark, move closer. When you find the right combination of aperture and distance, make a reference mark on the lens barrel opposite the gun. Always keep the gun opposite this mark so that, as you increase magnification and move forward, the flash moves with the lens, which offsets the effect of less light reaching the film. You will find that dark subjects need slight overexposure (open up a half stop or so) and bright subjects need correspondingly less (so close down the aperture).

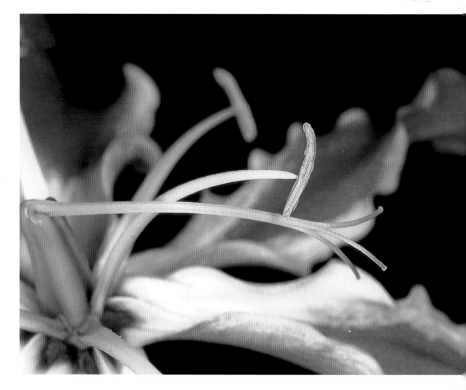

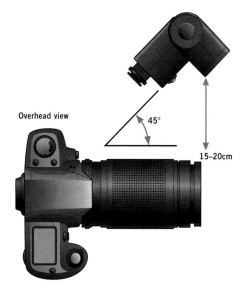

Overhead view 45° 15–20cm

FLASH POSITION

A good starting point is to hold the flash about 45 degrees to the side of the camera and 15–20cm away from it.

FLASHGUN ACCESSORIES

With a single TTL flash, use the integral diffuser or diffuser attachment (near left) and hold the flash close to the subject using a connector lead and adaptor (far left). The Gloriosa lily (above) was lit in this way, with a flash held slightly to the side.
📷 *Nikon F4, Sigma 180mm f/3.5 AF macro, 1/60 sec. at f/11, Fujichrome Velvia, SB23 flash with diffuser*

Flash units for macro work

Standard TTL flash guns can be used for close-up and macro work with excellent results. The secret, already mentioned but worth repeating, is to use them close to a subject so that they act like a wall of light (or an umbrella reflector used by portrait photographers) and don't produce hard shadows. The best results are often obtained by using their in-built diffusers, if they have them, meant to allow the unit to cover the area of a 24mm or wider-angle lens. This produces a softer light that is excellent for close-up use.

TAKING CONTROL

You can use any TTL flash system with confidence for close-up work as long as you recognize that some subjects might fool the meter – just as they do with visible light exposures. Luckily, matrix meters usually produce a result that is useable, if not perfect. Potential problems are dealt with on the next page. In practice, using flash is easy when you have run tests. You might find you have to dial in +2/3 stop overexposure for yellows and about + 1 1/3 stops for white to maintain the degree of underexposure needed to retain detail.

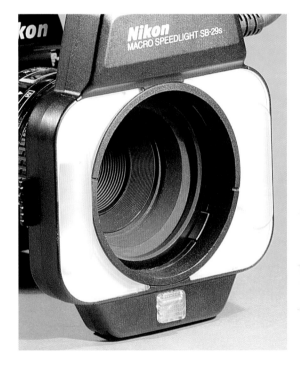

MACROFLASH UNITS

If macro work becomes your passion, there is a lot to be said for 'macroflash' units. These are specialist flash units in which the flash tubes and power unit are separate. The TTL power and control unit sits on the camera's hot shoe, like a flash gun, and the energy is shared between two flash tubes connected to the power unit by a cable.

TTL FLASH CONVENIENCE

A single flash can easily be held close to the camera (below). It works well but a dedicated macro flash unit (right) can provide balanced lighting in a compact package, fitting on a lens front with adaptor rings provided.

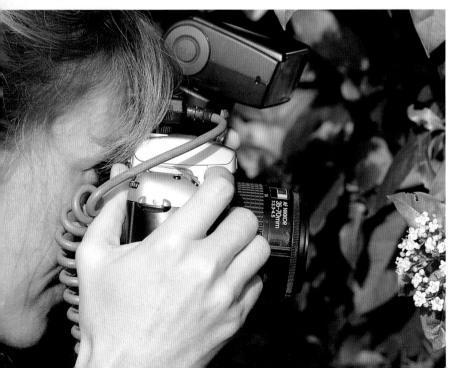

The advantages of macroflash units are their portability and the fact that they provide light close to a subject where it is needed. The first disadvantage is the price, especially since much of what they do can be done with small flash guns or with a homebuilt unit assembled from manufacturers' guns (see page 47). The second disadvantage, which is more of an aesthetic problem, is that twin flash tubes give twin highlights, which can look unnatural.

USING A MACROFLASH

The beauty of any macroflash system, ready-made or homebuilt, should be convenience – everything you want in one easy-to-use package. You set the aperture to f/16 or f/22, for example, to provide the requisite depth of field, the TTL exposure meter determines the flash exposure, and the film transport winds on film.

Set the aperture before you approach your subject and, with the autofocus switched off, use the focus mechanism to set the approximate magnification for

your subject (you can use your hand as the temporary subject). With practice you will learn how much to fill the frame – and you can fine-tune anyway. Focus by moving your whole body. When you are within range, with the subject the size you require in the viewfinder, gently rock forward until you reach the point of sharpest focus and then squeeze the shutter release. Then rock back slightly. This helps keep you relaxed, for if you are tense it will be a nightmare trying to hold the camera still. Always use a camera with a motor drive, because flailing fingers as you wind on will scare butterflies and other insects.

GHOSTING

One slight problem with all flash exposures is ghosting: if the shutter synchronization speed is too low, the flash exposure gives one image and subject movement creates another by natural light. You see two images, especially at the edges of the subject. The answer is to use a higher shutter sync speed – say 1/250 second.

CLOSE-UP FLASH POSITION

A diffused flash close to the subject provides a 'wall' of light that gives soft shadows and good modelling of shapes.

MIGRANT HAWKER DRAGONFLY
(Aeshna mixta)

This shy dragonfly was photographed towards evening, using a dedicated macroflash unit.
📷 *Nikon F100, Sigma 180mm f/3.5 AF macro, 1/60 sec. at f/16, Fujichrome Velvia, SB29s macroflash*

SPECULAR REFLECTION – 'HOTSPOTS'

Many beetles and other insects have highly reflective wing cases that create reflective 'hot spots' with flash. Don't waste money on buying a soft box for your flash – a piece of clean white tissue or tracing paper will diffuse the light and reduce specular reflection.

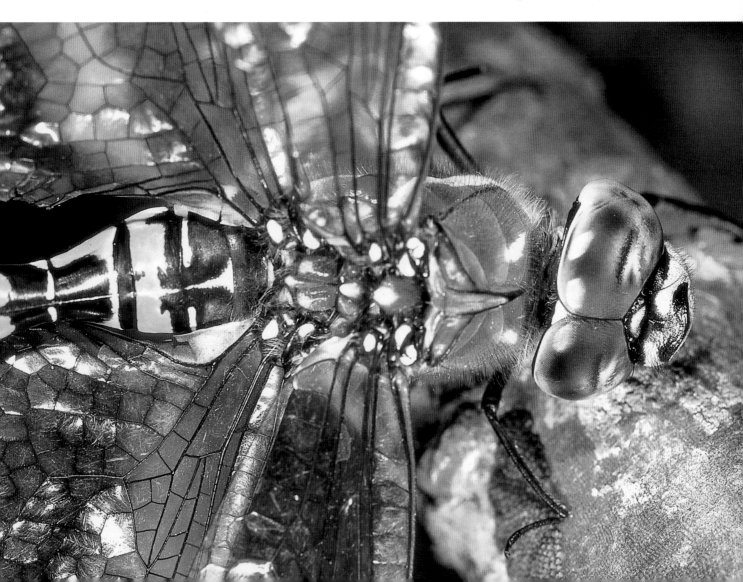

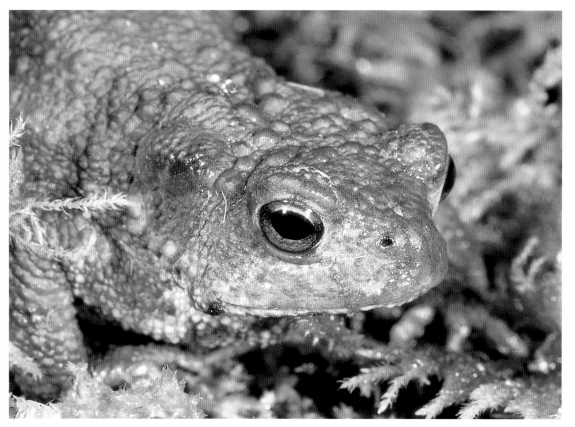

MODELLING CONTROL

Two guns or flash tubes, exactly the same distance from the subject, can produce a 'flat' lighting with soft shadows. Varying the lighting ratio (to about 1:4) with diffusers or flash position improves modelling – essential with a 'sculpted' subject such as the lily (below).
📷 Nikon F4, Sigma 180mm f/3.5 AF macro, 1/60 sec. at f/16, Fujichrome Velvia, SB29s macroflash

CHOOSING A FLASH

Anyone keen on electronics can, with care, demount a flash tube from a second-hand flash gun, mount it separately and link the tubes to the control unit by a coiled cable. But unless you really know what you are doing, never open one. Flash guns carry warnings about 'no user-serviceable parts inside' with good reason: their energy is stored in a capacitor, typically charged to about 450 volts, and a shock from that could prove lethal.

If you procure a set of manufacturers' brochures and look at the commercial flash units made with macro in mind, you might get the idea you could put one together on your own. And you would be right. Commercial units offer switchable lighting ratios and other inducements – but can they do anything that a piece of neutral density filter cannot?

Where most of these units fail is that, with longer lenses and slow films, they are underpowered – unless, that is, you are working at life-size magnification, close enough to the subject to illuminate it. You can open up the lens aperture and lose depth of field or use faster film and lose definition. With digital cameras set at a speed equivalent to ISO 200, this is not a problem, as long as your macroflash will work with them. Your options are to modify a ring flash, use a couple of connected flash guns or get the best out of a single flash unit.

RING FLASH

A ring flash has a circular flash tube that produces a shadowless light – ideal for illuminating cavities (they have been widely used in medical and dental work for oral photography). I have a strong personal aversion to ring flash, because it produces light of a flat quality. Both Sunpak and Vivitar make TTL ring flash units at a reasonable price, and you can modify them easily to get a much better quality of light, by using black tape to mask parts of the ring and leave clear windows on either side. In effect, this creates a twin flash that gives much better relief from the slight shadows produced.

MAKE YOUR OWN MACROFLASH

If you are reasonably practical, then the best way of obtaining a sensibly priced macroflash unit is to build your own. You need two identical small TTL flash guns and a bracket to mount them. There are quite a few good commercial brackets available or you could build one yourself, using wood, with an aluminium alloy strip for the supports. Flash gun holders from Hama or Kaiser are used to hold the guns to your frame but you have to use the manufacturer's own flash cables to connect them to the camera. The guns are on separate arms so that they can be set at different distances and angles from one another.

BEE ON PASSION FLOWER

A macroflash scores on portability and ease of use. I framed the bee quickly as it clambered onto the stamens.

📷 *Nikon F4, 105 mm f/2.8 AF macro, 1/60 sec. at f/16, Fujichrome Velvia, SB29s macroflash*

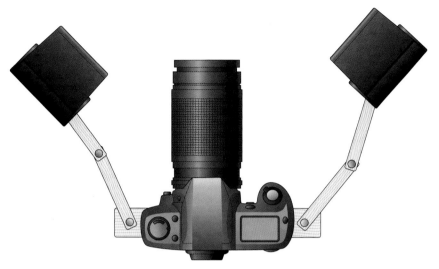

MACROFLASH UNIT

Keep your design compact, with short support arms. This will reduce weight and also the likelihood of cables and arms getting caught in vegetation as you pursue your quarry.

A homemade macroflash should allow you to set the guns further to the side of the camera lens, which can give you better modelling than you can achieve with commercial units. Always try to use the guns near your subject, for even with two guns there can be harsh shadows.

One way of controlling shadows is to vary the lighting ratio of the flash guns, just as in studio lighting set-ups. Use one gun to provide the main light and another as the fill-in. Either tape a x2 neutral density filter to the flash that you are using as the fill flash, or simply use it further away from the subject than the main gun.

CRYSTAL ANTHURIUM LEAF

A ring flash, masked to leave two clear flash 'sources' of different sizes, produced effective modelling on the veins of the leaf.

📷 *Nikon F4, 105 mm f/2.8 AF macro, 1/60 sec. at f/16, Fujichrome Velvia, ring flash*

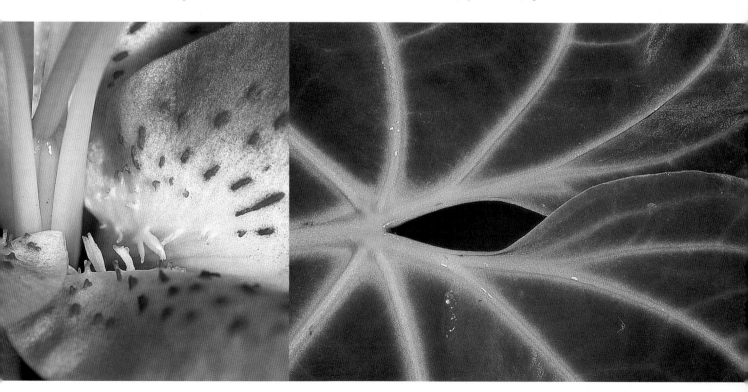

Incandescent lighting

Using incandescent lighting is a great way to learn your trade, because you can see how the subject looks as you move the lamps around and spot any 'hot spots' or spurious reflections. You can also use the lamps to photograph living material, provided they do not make them too hot – plants wilt quickly and insects keel over. (Lizards, on the other hand, love heat and tend to bask!)

For studio use, there are 'cool' lights available – but I tend to use small, inexpensive tungsten halogen desk lamps, which are fitted with a heat filter. They are surprisingly versatile and work marvellously with both film and digital cameras (see page 91). With film, you might find you need filters when the film is not balanced for the colour temperature of the light source (see page 52): a tungsten halogen lamp, for example, has a slightly higher colour temperature than a household lamp with a tungsten filament and so is slightly 'bluer'. With digital cameras, the ability to adjust the white point (see page 87) means that there is no need to use filters to remove unwanted colour casts and you can adjust things until the image on the monitor looks exactly as you want it to be.

The beauty of tungsten lights is that you can see the effect of lamp position directly. This helps to eliminate some of the things that catch you unawares in close-up flash photography, such as the tendency to produce twin highlights with reflective leaf surfaces or

with insect wing cases: with tungsten lamps you simply move or diffuse one of them until you see a single highlight. Again, diffusing light through screens of white tissue or tracing paper will eliminate hot spots (specular reflections).

For highly reflective subjects, you can borrow techniques from advertising and product photography. The traditional method of photographing shiny objects, such as silverware or glass, is to surround them with a lighting tent. This is basically a cone of translucent material that you illuminate from the outside with a hole in the side for the camera.

FILM STOCK FOR TUNGSTEN LIGHTING

Daylight films are balanced for a colour temperature of 5500K (see page 49) – a light source that is 'bluer' than an incandescent light bulb (3500K) – and if you use daylight film under tungsten lighting, you get a

DESK LAMPS IN THE STUDIO

Small tungsten halogen lamps (below left) make cheap and effective lights for the close-up studio – especially those fitted with a glass heat filter. It is a simple matter to photograph these sloe berries (below right) with a set-up like this and to control shadows and highlights by moving the lamps.

📷 *Nikon F100, Sigma 180mm f/3.5 AF macro, 1/15 sec. at f/11, Fujichrome 64T, two desk lamps*

FIBRE OPTICS

Fibre-optic 'goosenecks' (right) provide cool, intense light, which is ideal when using high magnifications in the studio. They can be arranged to direct light onto a subject from above or from behind, as was done with the shot of tartaric acid crystals (below) allowed to form on a glass slide from a drop of saturated solution.

📷 *Nikon F4, Olympus 80mm f/4 macro on bellows, 1/4 sec. at f/11, Fujichrome 64T, twin-fibre optic lamps*

pronounced colour cast. The choice is to use either daylight film with a suitable filter (a blue 80B) or a film designed for the purpose. The major manufacturers produce E6 counterparts to their daylight films that are every bit as fine-grained and contrast-rich and produce lovely saturated transparencies. Some people claim that if you use halogen lamps, you need a light orange warming filter to remove the slight bluish cast, but I have never found this necessary.

FIBRE-OPTIC LIGHTS

For photographs at magnifications larger than life-size, you need very bright lights because you are using small apertures to cope with limited depth of field. Normal tungsten lamps produce far too much heat to be used close to a subject. A convenient alternative is to use lighting units with fibre-optic 'goosenecks', which are used in laboratories where stereo microscopes are in use. The fibre optics conduct light from the source situated in the power unit – a tungsten halogen bulb, like those used for projecting transparencies – to exactly where you want it on the subject, producing intense, 'cool' light on small areas. Single or paired goosenecks filled with bundles of optical fibres have a small lens at the far end to direct light to where you want it. These units can be purchased from microscope suppliers.

ISLAND SNAPDRAGON
(Galvesia speciosa)

House plants can be photographed using indoor lighting as long as you have a film balanced for artificial light or change the white-point setting with a digital camera to incandescent. A mix of light sources – daylight and artificial – works only if one or the other dominates and the appropriate film is used.

📷 *Nikon F100, 105 mm f/2.8 AF macro, 1/15 sec. at f/16, Fujichrome 64T, two desk lamps*

Techniques

Many of the methods used in close-up nature photography depend both on the nature of the subject and on the level of magnification you want to achieve. A convenient way of listing techniques is to look at the different magnifications and to consider how, in practice, you can achieve them.

This chapter begins by looking at how you can use general-purpose lenses to create eye-catching and imaginative close-ups, and ends by showing how you can turn your camera into a low-powered microscope, or 'macroscope'. Along the way, you will discover how to get the best out of a whole range of specialist close-up and macro equipment, from supplementary lenses and extension tubes to fibre-optic lights.

The range of possible subjects is so diverse and intriguing that only your imagination imposes limits. As your interest, and mastery of basic skills grows, you will see myriad opportunities to create stunning images in places you might never previously have noticed.

Natural light

It is a truism to say that light is essential to photography, since the word photography literally means 'writing or drawing with light'. Most important to us as photographers is the way in which we can use the quality and direction of light to create the pictures we want.

THE QUALITY OF LIGHT

The same subject can appear warm or cool, depending on what is called the 'quality' of light. At either end of the day, daylight has a higher proportion of red and yellow light frequencies, which add a warmth that many people find particularly pleasing in photographs. Conversely, the bluer the light (such as just after dawn), the 'cooler' it feels.

The concept of colour temperature quantifies these feelings of warmth or coolness and can also be used with artificial light sources (see page 48). It is a useful concept in any branch of photography. Colour temperature is based on the fact that any very hot object (for example, a lamp filament or the sun) emits continuous visible radiation. If it is hot enough, it glows red, white, and eventually bluish-white.

COLOUR TEMPERATURE

This table shows the filters that you can use with daylight film for a range of different lighting conditions. Some of the filters absorb light so the exposure has to be increased by the amount shown.

LIGHTING DIRECTION AND CONDITIONS

The way light hits a subject, the direction from which it comes and the angle it makes with the surface all contribute to the way your subject looks on film. If an object is lit from the front (frontal lighting) and light hits the surface straight on (at 90°) it will look 'flat'. When light comes from the side (say at 30–50°), it creates shadows that enhance three-dimensionality and, in particular, shows up fine detail by creating small surface shadows. Light from behind a subject (backlighting) picks out detail at the edges of that subject, such as hairs on plants or insects. It is a good way of lighting translucent objects.

With natural light, the time of day (and also time of year) influence lighting angle and direction. In late afternoon and early morning (or all day in winter in the northern hemisphere), the sun is lower in the sky than it is at midday. The resulting shadows produce modelling, or relief, and make your subject look three-dimensional.

In close-up work, relief is important because it enhances sharpness (see page 152): many close-ups

SAFFRON CROCUS
(Crocus sativus)

The warmth of afternoon light emphasizes the orange crocus stigmas from which the spice saffron is created. This plant was grown from bulbs in a pot and photographed in a conservatory.
📷 *Nikon F4, Sigma 180mm f/3.5 AF macro plus x2 multiplier, 1/15 sec. at f/11, Fujichrome Velvia*

FILTERS FOR USE WITH DAYLIGHT FILM

Light source	Colour temperature (K)	Conversion filter for daylight-balanced film	Exposure increase in stops
Clear blue sky	10,000–15,000	85B orange	2/3
Open shade in summer sun	7,500	81B or 81C warm-up	1/3
Overcast sky	6,000–8,000	81C warm-up	1/3
Sun overhead at noon	6,500	81C warm-up	1/3
Average daylight from four hours after sunrise to four hours before sunset	5,500	none	none
Electronic flash	5,500	none	none
Early morning or late afternoon	4,000	82C blue	2/3
Tungsten photo pearl	3,400	80B blue	1 2/3
Quartz halogen bulbs	3,200–3,400	80A blue	2
Tungsten photoflood	3,000–3,200	80A blue	2
Household lamp (100W)	2,900	80A + 82C blue	2 2/3

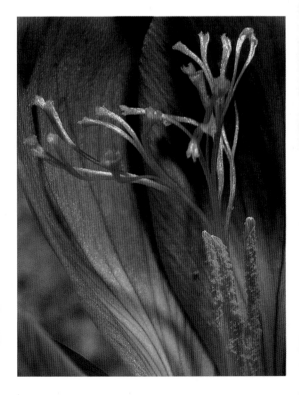

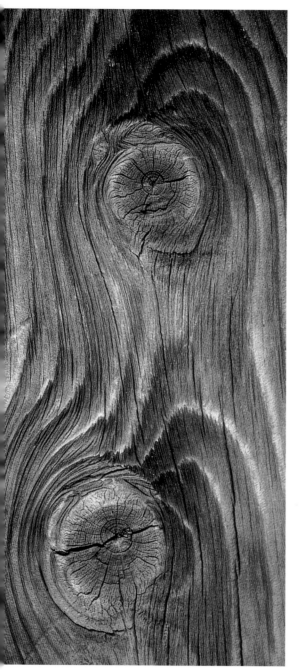

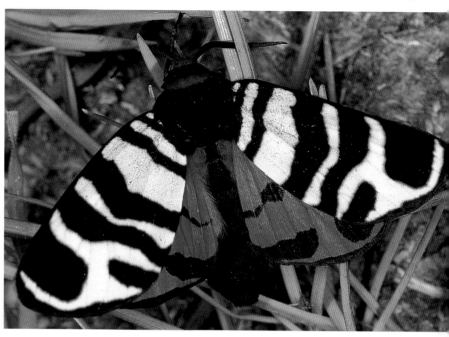

TIGER MOTH
(Ambiota festiva)

A lightly clouded sky produced diffuse light that was ideal for capturing the richness of contrasting colours in this freshly emerged tiger moth. Bright sunlight would have burned out highlights.
📷 *Nikon F801, 105mm f/2.8 AF macro, 1/30 sec. at f/11, Fujichrome Velvia*

DIFFUSE LIGHT

Light clouds act as giant reflectors to turn the sky into a diffuse or 'broad source' of light, thereby creating softer shadows and a contrast range that film can handle. In bright conditions, when you want to reduce the contrast range in a scene, you can use a portable lighting tent to diffuse the light. When you are photographing in bright sunlight, take along a large reflector, such as the collapsible type made by Lastolite; it is a boon for throwing light into shadow areas. The effect of such a reflector is obvious as you angle the disk, and miniature versions are available for close-up photography.

HARSH LIGHT

The midday sun in a cloudless summer sky is a 'point source' that creates harsh lighting in which the difference between illuminated and shadow areas is often impossible for film to handle. There is also a lack of relief because of the direction of the light. Avoid harsh light conditions for close-up photography work if at all possible.

RAINY DAYS

On rainy, dull days, it is tempting to stay indoors – but flower colours almost sing out on slow films such as Fujichrome Velvia. Some flower blues often reproduce poorly on film. Although we see flowers such as gentians and morning glories as blue, they can also reflect invisible radiation – both infrared and ultraviolet—that affects film and produces a purplish colour cast. It is often better to photograph blues on dull or rainy days, when a fine mist of droplets in the atmosphere filters out the invisible wavelengths.

EMPHASIZING WARMTH

Weathering had sculpted the grain of a beam in a ruined alpine chalet. It was late afternoon as we came down the mountain – the low angle of light created relief and the higher proportion of red and yellow light emphasized the 'warmth' of the tones.
📷 *Nikon F100, 28mm f/2.8 with circular polarizing filter, 1/30 sec. at f/11, Fujichrome Velvia*

are let down not by the lens or the film, but by indifferent lighting. For example, late-afternoon light from a sun low in the sky is perfect for close-ups of crustose lichens – those plants that adorn rocks by the sea and in mountains – as well as for snapping still-life studies of shells on sand or shingle.

If your pictures look 'flat', then you need to pay attention to the direction of the light. To learn about the effects of lighting direction, experiment with a pair of tungsten lamps, moving them nearer and then farther away from the subject, and positioning them in front of the subject and then to the side, to see how their position affects what you see through the viewfinder.

Filters

There are times when lighting conditions are not ideal for taking photographs: on a dull day, for example, colours lack warmth, while on a sunny day there may be strong reflections from water or leaves. Used sensibly, filters can make a great difference to the end result. The filters that might find a use in close-up work fall into three categories: colour correction and compensation filters, skylight and UV filters, and polarising filters. There are also vast numbers of so-called creative filters, to which most wildlife photographers rightly have a strong aversion.

COLOUR CORRECTION FILTERS

Unless you insist on using film balanced for daylight with tungsten sources and vice versa, the most useful colour correction filters are warm-ups. These are labelled 81A, 81B and 81C in order of increasing density (see page 52). They have a yellow/orange tint and produce the effect of the afternoon sun when the ambient light is cold (bluish). Less often used are blue filters in the 82 series that are used in the late afternoon to produce a cooler light.

SKYLIGHT AND UV FILTERS

Skylight filters emulate a skylight cast and filter out ultraviolet light in high mountain areas. They make little difference to the colour balance and many photographers use them to protect their lenses. UV filters are useful in mountain areas for removing a bluish cast to pictures.

POLARISING FILTERS

Polarising filters are the one type of filter I would never be without. They allow you to intensify the blue of a sky (they work best when used with the sun at about 90°

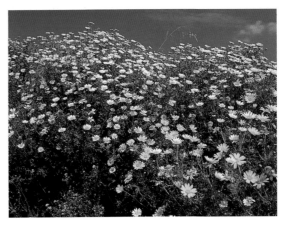

to the subject), reduce surface reflections from flowers and leafy shrubs in large areas of the frame and intensify colours as a result, and reduce surface reflections from water even rendering it transparent.

There are two sorts of polarising filters – linear and circular. You cannot use a linear polariser with an auto-focus lens, as the autofocus system works by detecting what are called phase differences (slight shifts) between a light wave and its reflection from the object you are

POLARISED SKIES

A polarising filter is a standard accessory for all my landscape shots in which flowers dominate the foreground. Rotating the ring on this filter allows you to control the intensity of a blue sky when you are facing away from the sun.

📷 *Nikon F4, 24mm f/2.8 AF with circular polarising filter, 1/60 sec. at f/11, Fujichrome Velvia*

POLARISED LIGHT

Polarised light is created in ways that involve either the reflection or scattering of light waves. For example, light is part-polarised when it is reflected from a non-metallic surface such as water. The scattering of light in a blue sky also results in the sky being part-polarised.

Light travels through space in straight lines: there are electric and magnetic fields associated with visible light (and all other forms of electromagnetic radiation) and these fields vibrate in a plane at right angles to the direction of light travel. A polarising filter acts like a grid, only allowing light to pass through in one of these directions; it cuts out all light at right angles to this direction and partially allows other light through in directions between these two. You can see the effect by crossing two sets of polaroid sunglasses.

Electric fields Polariser Crossed polariser

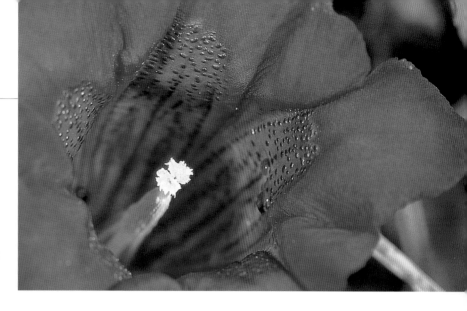

photographing. Circular polarisers have an extra coating layer one-quarter of a wavelength thick that changes the phase. If you have both manual and autofocus lenses, it is best to standardize on circular polarisers that work with both. A useful combination is B. 'Moose' Peterson's Moose filter, which allies a polariser with a warm-up filter. Polarising filters also work well in the studio with tungsten lamps, and with flash heads with in-built tungsten modelling lamps to cut out surface reflections – provided they are not from metal surfaces, where a polariser has no effect.

SUNFLOWER
(Helianthus annuus)

A polarising filter intensifies blue skies and cuts reflections from both flowers and leaves, which improves the richness of their colours. Overpolarising, however, can almost blacken skies.

📷 *Mamiya 645 Super TL, 45mm f/4 with linear polarising filter, 1/30 sec. at f/11, Fujichrome Velvia*

TRUMPET GENTIAN
(Gentiana acaulis)

Some blues are notoriously difficult to capture on film (see page 34). In mountains, I wait for overcast conditions and always use a UV filter, since the bluish cast produced by these rays is more noticeable at high altitudes.

📷 *Nikon F4, 60mm f/2.8 AF macro with circular polarising and UV filters, 1/15 sec. at f/11, Fujichrome Velvia*

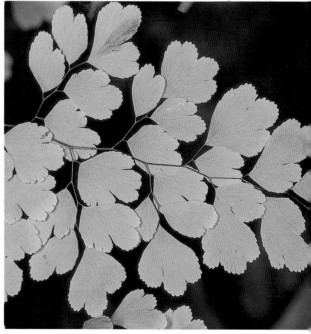

MAIDENHAIR FERN *(Asplenium adiantum)*

Leaf surfaces can be very reflective. A polarising filter reduces this effect, making colours appear more intense and slightly warmer.

📷 *Nikon F4, 60mm f/2.8 AF macro with circular polarising filter, 1/60 sec. at f/11, Fujichrome Velvia*

Backlighting and lighting the background

Most of the time we use frontal lighting to illuminate a subject, but there are times when lighting a subject from behind (backlighting) or lighting the background separately can add a great deal to a picture.

CREATING A GLOW

Backlighting translucent flowers – especially poppies – makes them glow. Shoot when the sun is low in the sky.

📷 *Nikon F4, 24mm f/2.8 AF macro with circular polarising filter, 1/30 sec. at f/11, Fujichrome Velvia*

BACKLIGHTING

Flowers are often translucent, and so poppies, tulips and many flowers with globular shapes can be made to glow when the light comes from behind. With backlighting you can pick out tiny hairs on stem edges, reveal the veins in translucent leaves and even create silhouettes. A degree of backlighting also works well with insects – particularly white or yellow butterflies, since their wings are often translucent and the net of veins shows against the light.

In the studio, it is easy to create backlighting by positioning an extra lamp behind your subject. It is not so easy with flash on film, unless you set the guns beforehand and run tests. With a digital camera it is a matter of setting the white point to incandescent light or flash and then trying it until it looks perfect.

Early morning and late afternoon, when the sun is low in the sky and light appears to come through your subject, are ideal for backlit pictures. However, you need to take care when using a wide-angle lens, even when the sun is not in the frame, as rays from the edges of the lens can become reflected internally from lens surfaces and create flare spots that soften the final image. Using a suitable lens hood will stop this; in a

pinch, you could even hold your hand just out of view to shield the lens from the sun.

To work out the correct exposure for a backlit subject, take a meter reading from the area around it: if you take a direct reading from a subject such as a glowing poppy, for example, your shot will be overexposed and the flower will look dull red in colour. By taking the reading from the surroundings, the subject itself will be slightly overexposed and will appear to glow.

LIGHTING THE BACKGROUND – MIXING DAYLIGHT AND FLASH

Flash and daylight can often be mixed to good effect, particularly when daylight provides the background lighting. This mix can be used to create natural backgrounds in a close-up shot and to avoid an unnaturally dark background where it is not wanted.

FILL-IN FLASH

Many photographers use fill-in flash as a burst of light to add detail to shadows. Flash guns are often highly sophisticated and allow you to adopt a fill-in mode. The camera's meter reads the ambient light and the flash is

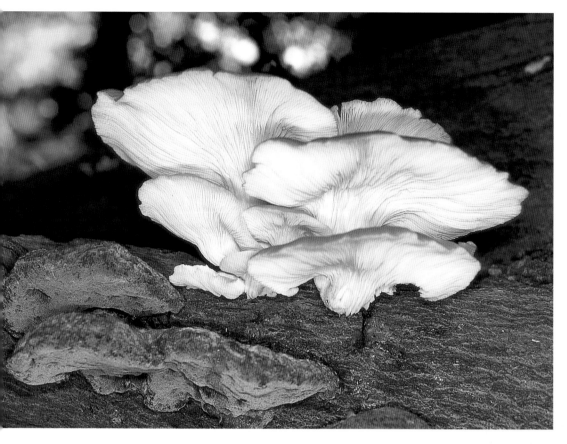

BRANCHED OYSTER FUNGUS
(Pleurotus cornucopiae)

The subtle tones of fungi are best caught with natural light but many of them grow in the dark recesses of woodland. Here the camera's TTL flash provided the main light. The shutter speed was reduced to expose the background with natural light.
📷 *Nikon F100, 60mm f/2.8 AF macro, 1/4 sec. at f/16, Fujichrome Velvia, SB29s macroflash*

WATER AVENS
(Geum reptans)

A mix of backlighting and frontal lighting works well for flowering plants. Here flash has provided the main frontal source, but backlighting picks out all the tiny hairs on the stems and the flower.
📷 *Nikon F100, 60mm f/2.8 AF macro, 1/30 sec. at f/16, Fujichrome Velvia, SB29s macroflash*

added at a lower level – a stop or two below that set on the flash. Such fill-in flash works well with close-up subjects when you are working in rather dull daylight conditions but need the 'punch' that a short burst of flash gives to the colours.

SYNCHRO-SUNLIGHT SHOOTING

In shady situations such as woodlands, when there is still enough natural light coming through trees to illuminate the background, it is often easier to use the flash as the main source. Fungi, in particular, never look their best when flash is the only light source and in close-ups, especially with wide-angle lenses, this mixture of light sources creates sharp, well-lit results. The effect looks natural, and I often use this technique with pictures of insects or flowers.

No sophisticated calculations or flash control are needed. First, set the aperture to give the depth of field you want and set the shutter speed manually (below the flash sync speed) to underexpose the background by a stop or so. The camera's TTL meter exposes for the foreground subject, but the shutter remains open long enough to expose the background, although it will be slightly darker than the foreground. A diffuser or a soft box will give a better quality of light to the subject. The air must be still in order to avoid getting 'ghost' images (see page 45) due to slight movements of the subject while the shutter is open.

BACK OR FRONTAL LIGHTING?

The autumn colours of these *Cotinus* leaves provide an ideal comparison for the difference between backlighting (far left) and frontal lighting (left). Back-lighting works much better here: it emphasizes the richness of the leaf colours and makes the leaf veins appear more prominent, creating a pattern that adds interest to the picture.
📷 *Nikon F100, Sigma 180mm f/3.5 AF macro, Fujichrome Velvia. Exposure: 1/60 sec. at f/11 (far left), 1/30 sec. at f/11 (left)*

Using a wide-angle lens

If I had to choose just one lens to carry on a hike, it would be my 28mm f/2.8 wide-angle lens (or its equivalent in 6 x 4.5cm format, a 45mm wide-angle). Not only does this lens provide a pleasing perspective for general views but you can achieve one-quarter life-size magnification with the subject just 14cm from the film plane. This is ideal for close-up shots in which you want you set a foreground subject in the context of its background.

CLOSE FOCUS WITH A WIDE-ANGLE LENS

A wide-angle lens is ideal for hand-held close-ups up to about one-quarter life-size magnification. The coverage allows you to include the background and establish the subject in a habitat.

With wide-angle lenses, the features nearest the lens – such as a nose in a portrait – become slightly distorted. Used with discretion, this distortion can become an effective compositional tool. Flowers, for instance, exaggerated in this way in close-up look particularly effective, perhaps because they are the things we notice when looking at plants and the result is closer to what we feel we see (see page 114).

FOCUSING RANGE

On the whole, manual-focus wide-angle lenses have a much better close focus than most of their autofocus equivalents because they have a longer built-in focusing thread. Only one manufacturer – Sigma – has addressed this, giving its autofocus wide-angle lenses a close-focus capability, too.

With some wide-angle lenses it is possible to improve the close-focus capability by fitting extension tubes (see page 72), which enable a lens to literally focus more closely and provide a magnified image. Some 35mm manufacturers make a very thin extension tube (5–7mm) that allows close focus on the foreground with the background visible, too.

FOCAL LENGTH RANGE

As lens designs become more sophisticated and low-density glass and aspherical elements allow wider apertures, extreme wide-angle lenses (those with a focal length of 24mm or less) have become more and more popular. However, the most useful focal lengths of wide angles for close-up work are 28mm and 24mm lenses in 35mm photography and their equivalents in larger formats, since they allow you to get close without distortion of the image.

Wide-angle lenses can also be reversed on a bellows to provide magnification of several times life-size (see page 70). This is the method that Nikon, for example, has always suggested with its bellows.

Most current models of digital SLR have an array of sensors smaller than the 35mm frame format, and this provides an effective change in focal length anywhere from 1.4 to 1.7 times, depending on the

model. This turns a 20mm extreme wide-angle into a 28mm or 35mm lens respectively. Thus to provide the expected angle of coverage necessitates a lens of shorter focal length and these are now commonplace – where a 16mm lens on a digital camera becomes the equivalent of a 24mm lens.

PRACTICALITIES

To achieve the depth of field that gives impact to pictures taken with wide-angle lenses, you often need to use slow, fine-grain films and apertures of f/16 or smaller. As the consequence is slow shutter speeds, a tripod is essential, along with a cable release to avoid any camera shake. You don't always have to carry lots of equipment, though – it is surprising how useful rocks or camera bags can be as supports when you want to minimize luggage. A stop-down lever closes the diaphragm to the taking aperture and allows you to make sure that the frame is in focus to infinity (see page 15).

WIDE-ANGLE LENSES: MEDIUM-FORMAT EQUIVALENTS					
35mm format (Angle of view)	35mm (62°)	28mm (74°)	24mm (84°)	20mm (94°)	18mm (100°)
6 x 4.5cm	55mm (65°)	45mm (76°)		35mm (90°)	
6 x 6cm		50mm (75°)	40mm (88°)	38mm (90°)	
6 x 7cm	75mm (61°)	55mm (78°)	45mm (89°)		
5 x 4 in.	90mm (58°)	65mm (76°)			

In each format, the nearest practical equivalent lens is listed and its angle of view is given in brackets.

ALPINE CHOUGHS

Alpine choughs around a mountain refuge in the Dolomite mountains recognize visitors as a potential food source, and strategically placed peanuts bring them within camera range. The picture on the left was taken with the 28mm end of a zoom lens and the one on the right with a 24mm lens.

📷 *Nikon F100, polarising and UV filters, 1/125 sec. at f/8, Fujichrome Velvia*

Using zoom lenses

Nowadays, the zoom lenses that many of us regularly use are every bit as sharp as their fixed focal length equivalents. They also embrace a wide range of magnifications so that, instead of carrying three different lenses around with you, you can take a single 70–300mm zoom.

GREEN CRESTED BASILISK
(Basilucus plumifrons)

A telephoto zoom is ideal for shy subjects such as this basilisk (below), as you can change the magnification from one camera position, getting whole subjects and even portrait shots. With fixed-focus lenses you move to do this, which can frighten the subject.
📷 *Nikon F4, Sigma 70–300mm f/3.5 apo AF zoom, 1/60 sec. at f/11, Fujichrome Velvia, SB24 flash*

The beauty of a good zoom lens is that it allows you to stay in one place and adjust the framing to suit the composition you want. You can take a range of shots that show the subject at every magnification stage, from shots that establish it in its surroundings to ones in which it fills and over-fills the frame. Zooms are incredible compositional tools.

A zoom lens operates by having groups of lenses that move as you zoom. With early zooms, a happy accident in lens design meant that locking one lens group gave a close-focus facility. The manufacturers

provided a locking ring and stamped 'macro' on the label – a marketing ploy rather than a true macro lens. With more modern lenses using low-dispersion glass elements, this close-focus facility is carefully built into lens design and it works extremely well.

THE POWER OF A ZOOM

A 5x zoom does not give you a magnification of five times life-size; this factor applies to its range of focal lengths from short end to long end. Let's take an

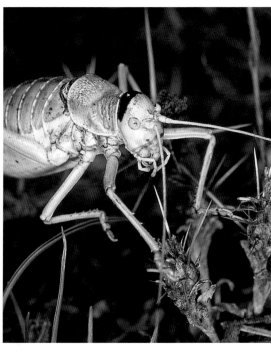

PALE WART BITER
(Decticus albifrons)

This cricket was surprisingly active as it made its way over dry, thorny ground. A telephoto zoom lens allowed me to keep it in frame without crawling along the ground in pursuit.
📷 *Nikon F4, Sigma 70–300mm f/3.5 apo AF zoom, 1/125 sec. at f/8, Fujichrome Velvia*

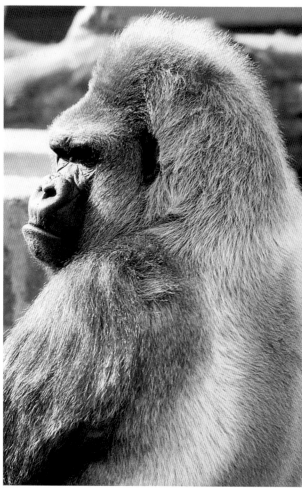

GORILLA MALE

This picture convinced me of the value of zooms in framing subjects to eliminate background. It was taken with my first zoom nearly two decades ago; my small, irreverent children christened the shot 'Daddy'.

📷 *Nikon F3, 80–210mm f/2.8 AF zoom, 1/60 sec. at f/11, Kodachrome 64*

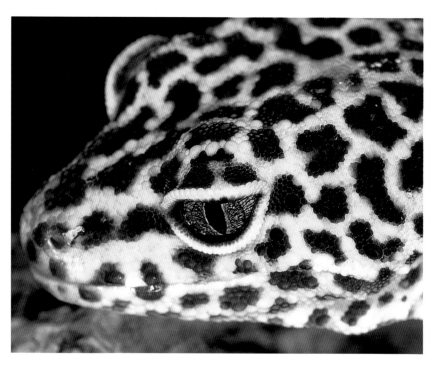

LEOPARD GECKO
(Eublepharius macularius)

This leopard gecko was photographed with a telephoto zoom fitted with a supplementary lens. This gives dramatically improved close focus, even allowing life-size images on film with extremely good definition.

📷 *Nikon F4, Sigma 70–300mm f/4–5.6 AF apo macro, zoom 1/60 sec. at f/16, Fujichrome Velvia*

example. Suppose the widest focal length of a particular lens is 24mm: if it's a 5x zoom, then the longest focal length will be 5 x 24 = 120mm. Effectively, at the long end of the lens's range, a subject is five times larger in the viewfinder than it is at the short end.

A 10x zoom covering a range from ultra-wide-angle to medium-telephoto – say 24–240mm – looks like an attractive proposition on the face of it because it saves carrying a lot of separate lenses, but such a lens tends not to have a useful close focus. To achieve this range, the design will have to be a compromise since there are so many lens corrections to build in. You get what you pay for: the best wide-range zooms are excellent but they're also expensive.

MACRO ZOOMS – LENSES DESIGNED FOR CLOSE FOCUS

Some lenses are carefully designed to exploit their close-focus capabilities. These are billed as macro zoom lenses. They focus all the way from infinity and are as highly corrected for close-up work as fixed focal length macro lenses. Nikon, for example, manufactures a macro zoom (70–180mm f/4.5–5.6) that effectively

provides you with a range of macro lenses in one package; in effect, you can change your distance from a subject and keep the same magnification.

MACRO ZOOM OR ZOOM MACRO?

A zoom lens that has an infinity focus can be a macro zoom, but the confusing term 'zoom macro' gets applied to lenses that are just designed to work at close quarters and are incapable of focusing on distant objects. Both Canon and Minolta manufacture these, as do some microscope manufacturers (see page 75).

TRIPOD COLLARS

When buying a zoom to use for close-up work, look for one that has a built-in tripod collar. This is a ring that fits around the lens and has a tripod screw mount on it. With any heavy lens, there is great strain on a camera's lens mount when a camera is supported at its body. The tripod collar allows you to support the camera and its lens near its centre of gravity and there is also less chance of vibration. It is possible to buy 'universal' tripod collars or get one custom-made from a specialist camera engineer.

Using a standard macro lens

A standard macro lens typically has a focal length of between 50mm and 60mm, with a maximum aperture of f/2.8. It is ideal for flowers and for anything where the proximity of the lens front will not scare the subject. In practice, since the front element tends to be deeply recessed, it places the lens front just less than 10cm away from the subject.

These lenses also function better with macroflash units than other macro lenses, since the lamps are closer to the subject, becoming broad sources and eliminating harsh shadows (see page 44). In addition, the light comes in from an angle of around 40°, which creates good modelling: the closer the flash tubes are to the lens axis, the 'flatter' the lighting appears.

FOCUSING

When you first use a macro lens, you may find that it is not easy to focus. Every time you adjust the focusing ring slightly, you alter the physical length of the lens and the front element gets nearer the subject. Then, to refocus, you have to move the lens and camera as a unit. This happens with other lenses too, but the tiny lens extension is negligible compared with the distance from the subject, in a landscape, for example. At close quarters, however, it does become significant.

RUSSULA FUNGUS
(Russula densifolia)

In dark woods, a standard macro is my lens of choice when photographing small fungi such as *Russula*: it is portable, quick and convenient to use with a macroflash, and I like the perspective.

📷 *Nikon F4, 60 mm f/2.8 AF macro, 1/60 sec. at f/16, Fujichrome Velvia, SB29s macroflash*

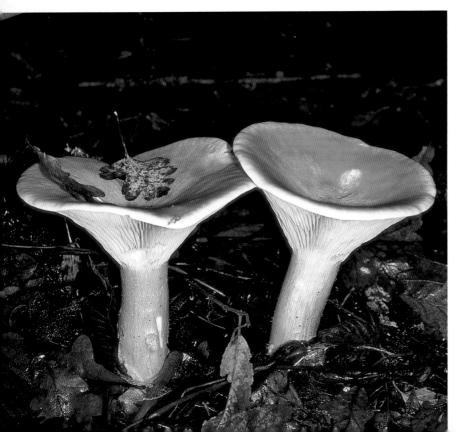

ROSE THORNS
(Rosa canina)

Even thorns on a rose bush look good in close-up. A camera plus standard macro and macroflash can be carried in a small camera bag ready to 'point and shoot': ironically, the results often seem better than those that have involved a lot of preparation.

📷 *Nikon F4, 60mm f/2.8 AF macro, 1/15 sec. at f/16, Fujichrome Velvia, SB29s macroflash*

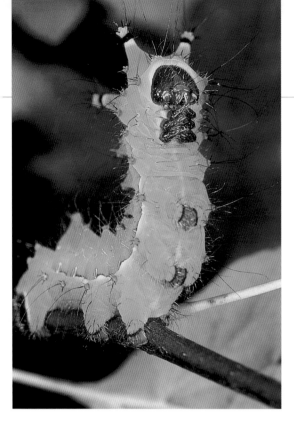

INDIAN MOON MOTH LARVA *(Actias selene)*

When animal subjects are not likely to leap away or fly off, the perspective afforded by a standard macro lens makes it a great choice for whole subject shots. Here, the larva made a half-hearted warning display and then went back to feeding.

📷 *Nikon F4, 60mm f/2.8 AF macro, 1/60 sec. at f/16, Fujichrome Velvia, SB29S macroflash*

ALPINE SNOWBELL
(Soldanella alpina)

On mountain walks I travel light with one camera body, a standard macro lens and a wide-angle lens with close focus. Bracing my body and the camera against rocks makes it possible to capture flowers such as this alpine snowbell near the ground.

📷 *Nikon F100, 60mm f/2.8 AF macro, 1/15 sec. at f/16, Fujichrome Velvia*

You might find that using a focusing slide attached to a tripod is useful. The camera sits on this and can be finely adjusted to get sharp focus. With active subjects, too much fiddling scares them away. If you refine this technique and use a macroflash, you can become independent of a tripod or slow shutter speeds (see page 44).

MAKING THE BEST OF DEPTH OF FIELD

Your joy at capturing a butterfly with spread wings can be short lived when you see that everything is pin sharp except one wing tip. After that you cannot ignore it – and it is the sort of thing that 'helpful' friends always seem to notice.

Try to imagine that your subject, however three-dimensional it is, lies in a single plane. With butterflies, for instance, the plane is formed by the open wings. The film back of the camera must be parallel to this plane, so that everything in view appears in focus. If the wings and camera back are at an angle to each other, some parts will be nearer to the lens than others and risk being out of focus.

With subjects that are not flat, you have to make a choice about what you want to be in focus and select a 'plane' that allows this to happen. This is one situation where a depth-of-field preview button is a great help – it allows you to see what happens as you stop down.

So long as things such as eyes and eye-spots are in sharp focus, both you and your audience will accept a lot more in the frame that is not. The viewer is drawn to these as a point of contact; if they are blurred, the shot will never look right.

VIEWING THE SUBJECT

The image formed by the camera lens on film is inverted – the pentaprism in the viewfinder system lets you see it the right way up. Sometimes you have to look at camera and subject from the side to make sure subject plane and film plane are as near parallel as possible.

Using a portrait macro lens

When a limited budget forces you to make a choice between the different macro lenses, then a 'portrait' macro, with a focal length of 90–105mm, is a good, general-purpose lens. As a high-quality optic, it also functions superbly as a portrait lens, producing the slightly flattened perspective that has made ordinary lenses of this focal length a favourite with portrait photographers.

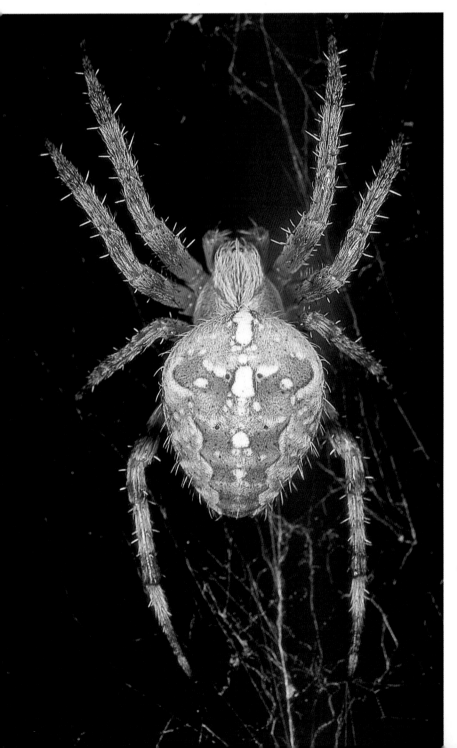

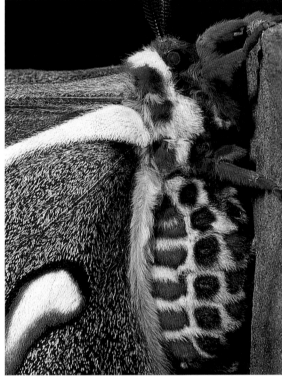

GARDEN SPIDER
(Araneus diadematus)

A portrait macro lens affords a greater working distance than a standard macro, making it useful for active subjects – although true arachnophobes might find that even a telephoto macro does not put them far enough away.
📷 *Nikon F4, 105mm f/2.8 AF macro, 1/60 sec. at f/16, Fujichrome Velvia, SB21B macroflash*

ROBIN MOTH
(Hyalophora cecropia)

The larger moths and butterflies often hang for some time after emergence to inflate their wings with body fluids and let them dry. A macro lens in the 90–105mm range is useful, as they can become perturbed if you approach too closely.
📷 *Nikon F4, 105mm f/2.8 AF macro, 1/60 sec. at f/16, Fujichrome Velvia, SB21B macroflash*

Portrait macros also work well with macroflash set-ups, which the longer focal length macros do not. Unfortunately, with slower films (ISO 50 and 64), these units tend to be underpowered and cannot give enough light to illuminate a subject if you are using small apertures outside a magnification range from half life-size to life-size.

Portrait macros are ideal for use with digital bodies where you have a few stops extra to play with and an in-built magnification factor that permits a greater depth of field than you would expect (see page 155).

For 35mm, the portrait macro is my preferred lens for a wide range of subjects that are capable of flying away. The working distance is not as generous as that of a longer lens, but the lens is easier to hold – particularly with a macroflash, where you do not need a tripod since the flash makes the exposure. It comes as a surprise to many people that at 1:1 you are not quite as far away from your subject as you thought. An older manual 105mm lens will put you further from your subject than an AF version, because most macros focus internally to some extent. This creates a magnified image through decrease of focal length.

As with the shorter 50 and 60mm macros, the easiest way to focus is to set the magnification you want and then 'fall forward'.

BUYING A PORTRAIT MACRO LENS

Some of the independents such as Sigma, Tamron and Elicar produce excellent lenses that easily compare with those from camera manufacturers' ranges. If prices seem too high, then do not neglect the second-hand market where macro lenses are always available, particularly in the portrait range. Be careful to examine the front lens surface for small scratches – these produce flare, whereas a small coating mark will not. With a manual-focus lens, stiffness in the focus can be remedied by having the lens serviced and lubricated; with an autofocus lens, stiffness might indicate that the lens has been dropped.

MACRO LENSES FOR MEDIUM-FORMAT CAMERAS

Medium-format camera users have a choice of macro lenses of focal lengths between 80 and 120mm (rough equivalents of the 50mm and 90mm macro lenses in 35mm). There are no independent lens makers in this field. However, if you use both 35mm and medium-format film, you will find that you can adapt your 35mm lenses for use with the larger format, as many 35mm designs can cover a much larger film than the 35mm frame when used in close-up mode (see page 19).

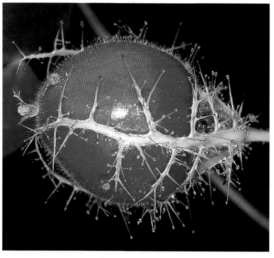

FOETID PASSION FLOWER – FRUIT
(Passiflora foetida)

It might just be a personal whim, but I feel the slight flattening of perspective that you get with a portrait macro works well with rounded fruits. Here it captured the peculiar feathery bracts surrounding the fruit.
📷 *Nikon F801, 105mm f/2.8 AF macro, 1/60 sec. at f/16, Fujichrome Velvia, SB29s macroflash*

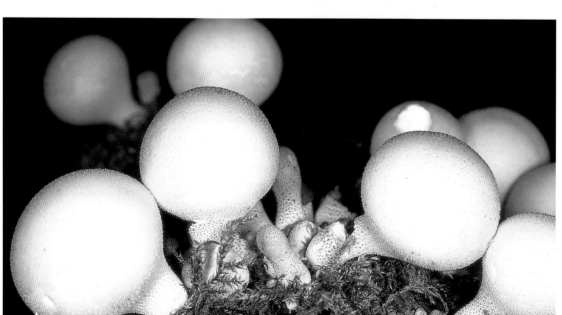

PUFFBALL FUNGI
(Vascellum pratense)

If you must choose just one macro lens then the portrait macro is the one to go for: it can capture fungi like these puffballs as well as a macro of shorter focal length and is much more versatile with small creatures.
📷 *Nikon F4, 105 mm f/2.8 AF macro, 1/60. sec. at f/11, Fujichrome Velvia, SB21B macroflash*

Using telephoto macro lenses

Telephoto macro lenses are produced in focal lengths of 180mm and 200mm. They tend to be expensive, but they are very substantially built and have some qualities that make them ideally suited to wildlife subjects. The first is that extra distance between you and shy subjects such as small animals and larger insects: at one-third life-size, for example, you are about 70cm away.

Any telephoto lens tends to flatten perspective, and the effect is more pronounced the longer the focal length. With a long focus lens, because of position and angle of view, the background appears to be thrown out of focus even a short distance behind the main subject. With a telephoto macro, the perspective produces a result that is pleasing to the eye, and a softly blurred background is a distinct aid to achieving a sharply focused subject.

Telephoto macros are heavyweights and need to be used on a tripod – which is never easy with macro subjects. But two things facilitate this. First, they all seem to have internal focusing, so you can get critical sharpness just by rotating the lens barrel and without having to move the lens plus camera. Second, because you are further away from your subject, you have a better chance of adjusting your tripod without scaring off your quarry.

MATCHED MULTIPLIERS

Those manufacturers who produce lenses in this range also tend to have x1.4 and x2 multipliers that are optically matched to the lenses. A 180mm macro plus its x2 converter becomes, in effect, a 360mm unit that focuses to twice life-size – and gives superb results. In addition, at any magnification it will be twice as far from the subject as it would be if the macro alone were used – but it will still give the same magnification.

USING A TELEPHOTO MACRO WITH MACROFLASH

If you try to use a slow film and a macroflash unit, you simply will not have enough power to illuminate subjects at small apertures with these lenses. The solution is to make your own unit with more powerful flash guns (see page 44), or to use a wider aperture with a consequent decrease in depth of field. With digital SLRs that have a minimum sensitivity equivalent to ISO 200, you have, in effect, an extra two stops to play with.

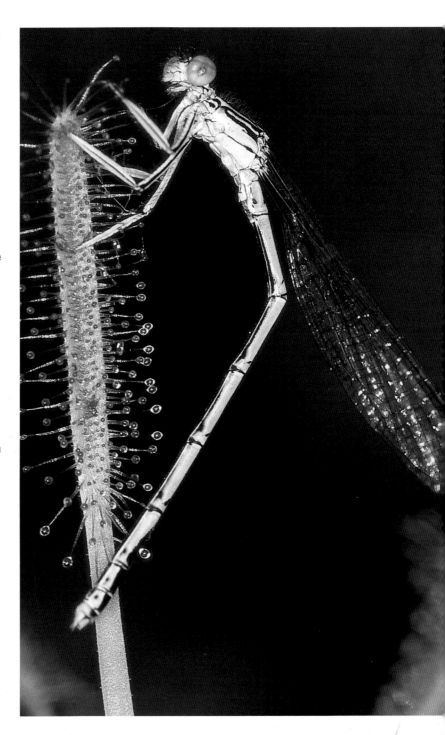

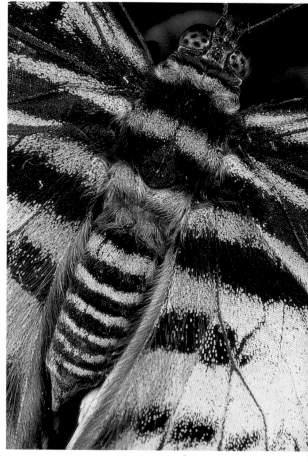

SMALL ANIMALS AND SHY SUBJECTS

For photographing larger insects and small animals, a lens like this, or a close-focusing telephoto (or even a telephoto plus extension tube), places you outside the 'circle of fear' or 'circle of awareness' that many creatures have. Snakes, frogs, many dragonflies, and butterflies can all be photographed from a distance of 1 metre or more if you use a matched multiplier, and will be seemingly oblivious of your presence.

CARE OF LONG LENSES

Telephoto macro lenses have large-diameter front elements – typically 72mm – which makes filters proportionally more expensive (especially polarisers) and the lens front element that much easier to scratch. Make sure you have a proper lens cloth to clean your lens and wipe away any condensation. No matter how soft that T-shirt seems, it can harbour grit – and the lens elements that some of these lenses use are made from soft glasses that are easily damaged.

WHITE LEGGED DAMSELFLY
(Platycnemis pennipes)

The insect was caught on a sundew leaf: you can often find insects freshly caught in the early morning. It was out of reach in a sphagnum bog, and a telephoto macro was the ideal lens to use.
📷 *Nikon F100, Sigma 180mm f/3.5 AF macro, 1/60 sec. at f/11, Fujichrome Velvia, SB29s macroflash*

CLIPPER BUTTERFLY DETAIL

After photographing a whole insect, I often fit a converter and capture patterns and shapes at the higher magnification (above).
📷 *Nikon D100, Sigma 180mm f/3.5 AF macro plus x2 converter, 1/125 sec. at f/16, ISO 200, SB80-DX flash*

CLIPPER BUTTERFLY
(Parthenos sylvia)

The telephoto macro is my usual choice for large, active butterflies (left), since you can fill the frame from over 1 metre away – and more if, as in this case, you use a digital camera with a x1.5 body magnification factor.
📷 *Nikon D100, Sigma 180mm f/3.5 AF macro, 1/125 sec. at f/16, ISO 200 equivalent film speed, SB80-DX flash*

Supplementary lenses and converters

You can change the magnifying power of a camera's lens by adding other lenses: such supplementary lenses are screwed into the front filter ring of a camera lens and a teleconverter, or multiplier, is attached to the rear of the lens. They provide a small, but useful, boost in terms of magnification.

SUPPLEMENTARY LENSES

A supplementary lens is often a good way of getting greater magnification: when one is attached to a prime lens, the focal length of the lens combination is decreased, enabling the combination to focus more closely. Supplementary lenses are also convenient: they are lightweight and easily portable, no light is lost in use (unlike extension tubes), all lens functions such as open-aperture metering and autofocus are retained and a high-quality image is the result.

One of the drawbacks of using a supplementary lens is that the main lens's ability to focus on infinity is lost. In addition, when inexpensive, single-element supplementary lenses are used at wide apertures, defects such as chromatic and spherical aberration arise; the first creates colour fringes at object edges and the second softens the image. Nikon, Canon, Hoya and some other manufacturers produce two-element achromatic lenses that eliminate chromatic aberration: to reduce spherical aberration, use the main lens at apertures of less than f/8.

Sigma has long used the two-element supplementary lens (they call it an auxiliary macro lens, or aml) as a way of getting 1:1 reproduction with their zoom lenses. Olympus also had a highly corrected

FITTING A SUPPLEMENTARY LENS

A couple of supplementary lenses and a standard 28–80mm zoom (below) create a useful, portable outfit for close-up work in a hothouse or botanical garden. This combination produced the picture of the warty anthurium lily (left).

📷 *Nikon F100, 28–80mm f/3.5 AF zoom with supplementary lens, 1/60 sec. at f/11, Fujichrome Velvia, SB29s macroflash*

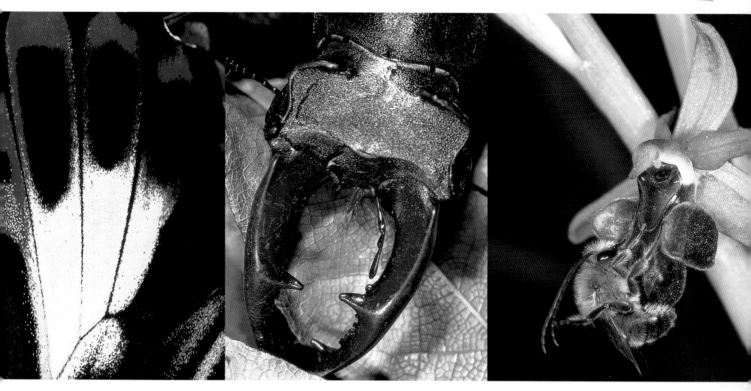

supplementary lens that screwed into the front of their 80mm f/4 macro to produce a 2x lens head. The same principle is widely used in low-power microscopy – particularly with stereo microscopes – to extend the magnification range of the instruments. Zeiss provided a turret of four supplementaries with their legendary Tessovar lens (see page 75), a specialist zoom macro lens, in order to give different magnification ranges up to a maximum magnification of about x12.

USING THE NUMBERS

Supplementary lens power is measured in a unit familiar from an optician's prescriptions – diopters. In fact, some people actually refer to supplementary lenses themselves as 'diopters'. They are just like spectacle lenses for long sight – convex meniscus lenses that are thicker at the centre than at the edges. Supplementary lenses are commonly available in 1, 2 and 3 diopter strengths.

To work out the power of any lens in diopters, find the reciprocal of its focal length in metres. For example, for a 50mm lens (0.05m), the power is:

$$\frac{1}{0.05} = 20\ D$$

Or, divide 1000 by the focal length in millimetres. To work out the magnification you will get when you add a diopter (supplementary lens) to a prime lens, divide the focal length of the prime lens in millimetres by the focal length of the diopter in millimetres. The same formula is used with coupled lenses (see page 70). For example, a 2D lens has a focal length of 500mm; used with a 100mm lens, you would get a magnification of 100/500 = 1/5 or x0.2 life-size.

Finally, if you are given a supplementary lens and know its power in diopters, you can find its focal length in millimetres: just divide 1000 by the power.

You can combine several supplementary lenses to produce a more powerful combination just by screwing them together. To find the strength of the combination, add their powers in diopters together.

TELECONVERTERS

In landscape and wildlife photography, you might use a teleconverter to double the focal length of your prime lens. When you use a teleconverter with a macro lens for close-up and macro work, however, it acts as a magnification multiplier (see page 68).

Teleconverters perform particularly well as multipliers, since the small apertures mean you utilize those rays nearest the lens centre – where the device is best corrected. I often use a 180mm macro lens with a x2 matched multiplier and find that a 105mm macro gets a useful boost from a x1.4 model. There is always a loss of light when using multipliers: you lose one stop with a x1.4 teleconverter and two stops with a x2. The best teleconverters (called matched multipliers) are designed to work with a small range of lens focal lengths. They are expensive because they have been computed to minimize aberration by matching the optics of the multiplier to the lens in use.

SWALLOWTAIL WING
(Papilio rumanzovia)

With a x2 converter you can overfill the frame and create abstracts (above, far left).
📷 *Nikon F4, 105mm f/2.8 AF macro with x2 converter, 1/60 sec. at f/16, Fujichrome Velvia, SB29s macroflash*

STAG BEETLE ANTLERS
(Lucanus cervus)

I used a x1.4 converter to boost the magnification a little: there is only one stop loss in light.
📷 *Nikon F4, 105mm f/2.8 AF macro plus x1.4 converter, 1/60 sec. at f/11, Fujichrome Velvia, SB29s macroflash*

BEE ON ORCHID
(Ophrys mammosa)

I have a passion for orchids and a research interest in pollination. A converter helps when the subject is not easily accessible.
📷 *Nikon F4, 105 mm f/2.8 AF macro with x1.4 converter, 1/60 sec. at f/16, Fujichrome Velvia, SB29s macroflash*

Reversing and coupling lenses

When a lens is designed, lens corrections are computed to allow for the fact that the subject is much bigger than its image size on film. In close-up and macro photography, however, the situation is reversed and, particularly with older fixed-focus lenses, you can get sharper images by mounting a lens back to front. You can do this effectively with standard 50mm lenses and wide-angles such as 35mm and 28mm: wider lenses give higher magnification but usually produce vignetting – the cutting-off of light from the image edges. Reversing a telephoto lens would involve using unrealistic bellows extensions to get magnified images.

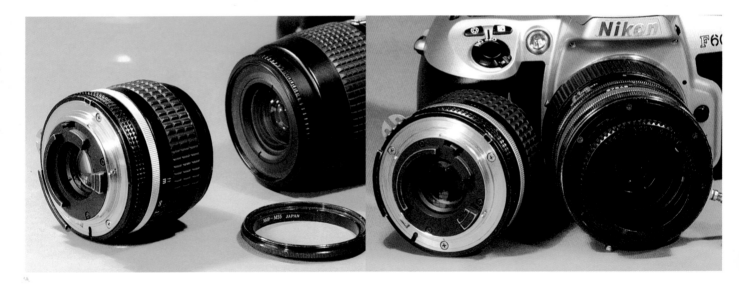

Even macro lenses benefit from being reversed, particularly the older manual-focus lenses that were optimized for one-tenth life-size magnification. You see a visible difference when these lenses are reversed (either on extension tubes or on bellows) from magnifications of about x2 upwards. With modern lenses, where special lens groups correct for close focus, the difference is not as marked.

All you need to reverse a lens is a reversing ring – an adaptor that screws into the lens filter thread and has a bayonet (or screw) mount to an extension tube.

A reversed lens loses all functions such as full-aperture metering and autofocus, and some lenses need an adaptor to keep the diaphragm open. A lens hood made by removing the centre of a rear lens cap cuts reflections from metal parts of the rear lens mount that might create flare.

Though you might not associate them with close-up work, old 16mm cine lenses (25mm and 12.5mm) and enlarger lenses make really excellent macro lenses

when used in reverse, especially for higher magnifications (see page 74).

REVERSING ZOOM LENSES

A medium-range zoom, such as a 28–80mm, can be used in reverse (usually with an extension tube between lens and body) and become a zoom macro lens, giving several times life-size magnification depending upon the extension tube. Any subject will be very close to the lens element when it is focused.

COUPLING

A very useful way of obtaining magnified images in the field at little expense is to reverse one lens on the front of another. The principle is the same as using supplementary lenses, but this time the supplementary is a superbly corrected camera lens. You use a commercial adaptor that has two 'male' threads, joining

REVERSING A LENS

When a lens is reversed, reflections from the shiny parts of its mount can create flare in your pictures. Here a 'z-ring' has been fitted; this is operated by a double cable release. It allows you to focus at open aperture and then stop down as you take the picture. There is also a lens hood made from a rear lens cap with its centre removed.

the lenses by their filter rings. Alternatively, you can cement two adaptor rings of different thread size from the Cokin or similar filter range.

The lens to be reversed is used at full aperture. All the functions of the lens coupled to the camera are retained and no light is lost by the system – unlike extension tubes and bellows.

To work out the magnification, divide the focal length of the prime lens (attached to the camera) by the focal length of the coupled lens. Suppose, for example, you have a 200mm lens on the camera and you reverse a 50mm lens on to its front:

$$\frac{200}{50} = 4$$

The wider the aperture of the coupled lens the better, since it allows more light through. The front lens diameter of both lenses should be similar, as this helps to prevent vignetting. Standard 50mm lenses work wonderfully well with 135mm, 200mm and even zoom lenses. Lenses such as 24mm and 28mm wide-angles can also be used, but the result is rather like looking down a microscope with a circular tube. However, the centre of the image will be very sharp.

Even the slightest movement can blur the image and so I often clamp the camera and lens, and move the subject in order to focus.

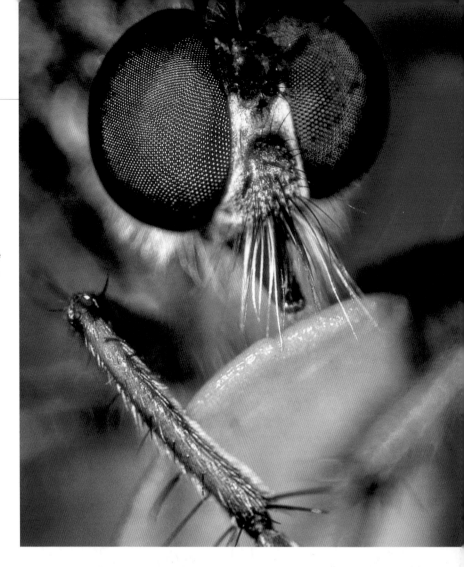

FLY'S EYES

Magnifications over x4 are impractical in the field, where the slightest movement destroys sharp focus. For this shot I reversed a 50mm lens on a 180mm telephoto (180/50 = 3.6 times magnification).
📷 *Nikon F4, Sigma 180mm f/3.5 AF macro with Canon FD 50mm f/1.8, 1/60 sec. at f/11, Fujichrome Velvia, single SB23 flash*

SPIDER WRAPPING HOVERFLY

I still use the first macro lens that I bought over twenty years ago (a Canon FD 50mm f/3.5). I usually reverse it on an extension tube, where it gives x2.5 magnification – ideal for capturing this spider as it embalmed its living prey.
📷 *Nikon F4, 50mm f/3.5 Canon FD macro reversed, 1/60 sec. at f/16, Fujichrome Velvia, single SB23 flash*

Extension tubes and bellows

Both extension tubes and bellows are used to separate the lens from the camera: the greater the separation, the more the rays of light spread and the higher the magnification on film. The advantage of extension tubes is their low price and easy portability; bellows allow you a continuous range of magnifications and precise focusing.

MAGNIFICATION

To work out magnification with bellows or extension tubes you need a simple formula:

$$\text{Magnification} = \frac{\text{Extension}}{\text{Focal length of lens used}}$$

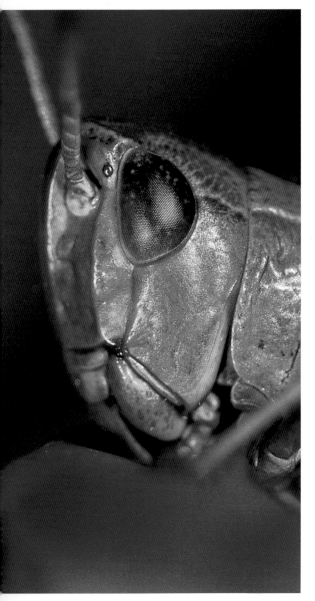

The drawback of adding extension tubes is that light intensity always drops as light spreads over a greater area. For example, to get life-size images with a given lens you have to add extension equal to its focal length – this is equivalent to losing two stops of light. At higher magnifications light intensity drops rapidly, making images difficult to see and to focus. You can use TTL flash to make exposures and lamps with heat filters to give enough light to focus or make exposures with tungsten-balanced film (see page 76).

EXTENSION TUBES

An extension tube is a ring, blackened inside and out to cut down reflection, with a lens mount on one end and a mount to fit the camera body on the other. The tubes usually come in sets of three and can be combined to give various degrees of magnification.

Some extension tubes are able to preserve both open-aperture metering and autofocus with lenses. In the field I tend to use extension tubes singly – one with a zoom or a telephoto gives a useful close focus. My experience is that you always have the wrong combination of tubes when you need them in a hurry.

USING A BELLOWS

A bellows unit looks complicated at first sight, but it is far easier to use in a fixed assembly in a studio. Below is a 20mm macro lens fixed via a home-made adaptor; it has an 'rms' (Royal Microscopical Society, London) standard microscope thread fitted to a Nikon extension tube. There is a focus adjustment on the front standard and on the main rail that gives precise focus to subjects such as the eyes of the grasshopper, shown left.
📷 *Nikon F4, Olympus 80mm f/4 macro plus bellows, 1/60 sec. at f/16, Fujichrome Velvia, SB21B macroflash*

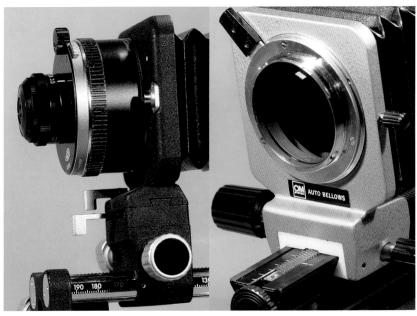

BELLOWS

A bellows is, in effect, a variable extension tube. It consists of two metal plates ('standards') with a lens mount on the front plate and a camera body mount on the rear plate. The plates are connected by a concertina-type bellows and fixed to a precision machine rail. For focusing, you can move the standards and the whole rail by means of rack-and-pinion screws.

Large-format and some medium-format cameras have a built-in bellows that also permits some of the traditional-view camera movements, such as rise and fall of front and back, and the tilt of the lens board and film holders. Some 35mm bellows allow the same, but control is very critical – although the results are good when dealing with subjects in different planes.

Bellows are excellent in a home studio, as you can fix them firmly and achieve exactly the scale of magnification you want. They offer a means of using bodies and lenses from different manufacturers, so long as you do not mind losing automatic metering and having to make or buy adaptors. I use mine with various lenses – including microscope lenses on one end and Nikon bodies on the other. The system uses TTL flash and works very well.

FOCUSING A BELLOWS

To get a sharp image in the camera viewfinder, you can adjust most bellows by moving the front lens panel, the rear camera mount part or the whole bellows since all of them have rack-and-pinion adjustment. However, the tiniest movement of the lens sends a subject out of focus, while moving the whole thing is both cumbersome and quickly reveals any imperfection in the focus mechanism.

The best method is to adjust the bellows length to give the reproduction scale you want and then focus as best you can by moving the bellows unit on its rack and pinion. Finally, fine focus by moving the back, since this gives much more latitude at higher magnification.

Alternatively, with practice, you can focus surprisingly finely by moving the subject with one or both hands while looking through the bellows.

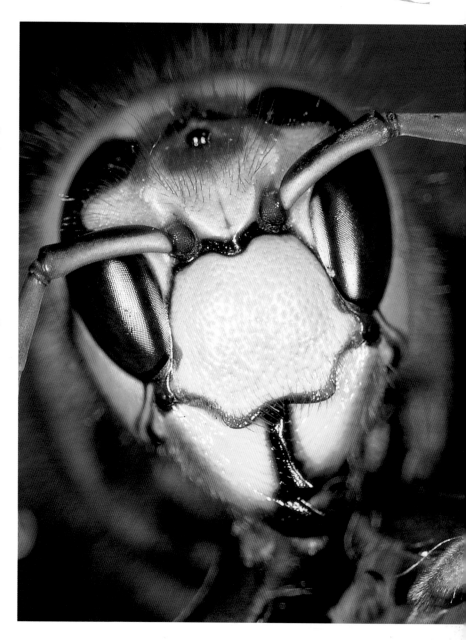

HORNET *(Vespa crabro)*

Hornets do not usually stay still for long! I placed this one on a twig and moved the twig in front of the bellows to focus the image.

📷 *Nikon F4, Olympus 80mm f/4 macro plus bellows, 1/60 sec. at f/16, Fujichrome Velvia, SB21B macroflash*

BELLOW MOVEMENTS – TILT AND SHIFT

Although this belongs in the realms of view cameras (large-format cameras taking sheet film and having a ground-glass back for focusing), there are principles governing the use of bellows and tilt-and-shift lenses that apply to medium and 35mm formats. Regardless of how you move the back and the lens board, the lines drawn through their planes have to meet at a point with the subject plane, as shown right – the Scheimpflug rule. In this way, objects A, B and C would be in sharp focus.

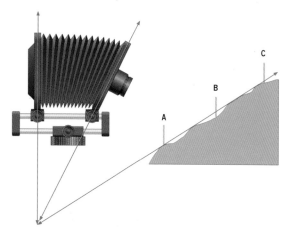

Special lenses

Special-purpose macro lenses – sometimes called 'true' macros – are usually designed to give working distances greater than you would get from reversed lenses. Unlike the general-purpose macro lenses described on pages 62–67, each lens is corrected for a given range of magnification and is designed to give optimal performance in that range.

POPPY SEED PODS
(Papaver orientalis)

A poppy seed head acts as a 'pepper pot', scattering tiny seeds as it is shaken by the wind or crushed underfoot. Being able to magnify the subject (in this instance by over ten times) with a bellows macro lens (right) reveals the details of the holes but creates an abstract image: few people would be able to identify the subject.
📷 *Nikon F4, Canon 20mm f/3.5 macro plus bellows, 1/60 sec. at f/8, Fujichrome Velvia, single SB23 flash*

Lenses such as the Leitz Photars and Zeiss Luminars represent the ultimate in optical quality. Furthermore, they cover an image circle so that they can be used in 35mm and medium formats. My macro lens heads – Olympus 80mm f/4 and 38mm f/4.5 and a Canon 20mm f/3.5 – are designed ostensibly for 35mm format, but I can go way beyond life-size on medium format by using a simple adaptor.

These lenses are optimized for the following magnification ranges on bellows:

80mm f/4	x0.5–2
38mm f/3.5	x1.7–6.7
20mm f/3.5	x4.2–16

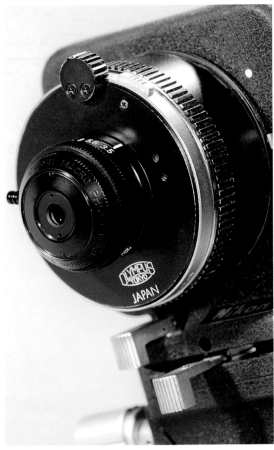

Other 'true' macros show similar specific ranges of magnification at which they work best.

If you want the ultimate in quality, then these lenses will give it; they are super sharp and superbly corrected. Luminars and Photars give the largest working distance, but are highly expensive even secondhand; the Olympus and Canon lenses have smaller working distances, but are optically every bit as good and are reasonably easy to find secondhand.

WORKING ON A BUDGET

There are less expensive alternatives to these specialist optics that produce excellent results for occasional use – provided you do not enlarge prints too much, for then the limitations become apparent.

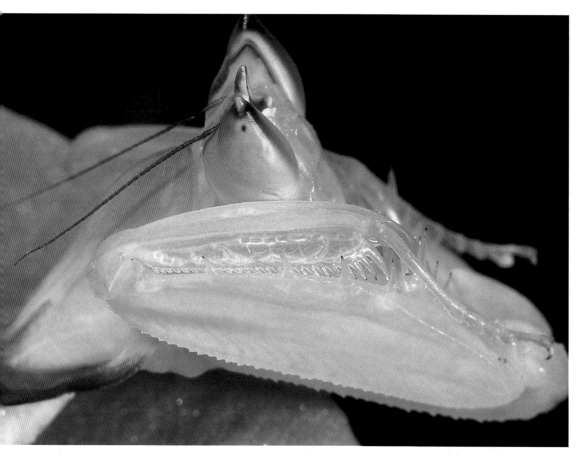

A box of four lenses (below) sits next to my optical bench, allowing biting sharpness over a range of magnifications from half life-size to x16 (with a digital body this is nearly x25). The orchid mantis (*Hymenopus coronatus*) shown on the left – perhaps my favourite of all insects – was taken at three times life-size.

📷 *Nikon F4, Olympus 80mm f/4 macro plus bellows, 1/60 sec. at f/16, Fujichrome Velvia, SB29s macroflash*

CINE LENSES

Lenses such as the 25mm and 12.5mm Switar lenses made for 16mm cine cameras are available second-hand and make highly corrected 'macros' when reversed. You have to use a little ingenuity in mounting them, but you can fabricate adaptors using mounts from an old filter or have them made.

Do not be tempted to shut these lenses down to marked apertures of f/22, because in use the effective aperture due to extension will be much smaller – f/128, for example – and diffraction will soften the image. It is a question of trial and error but a useful guide for any reversed lens is to look at the table on page 155 for the magnification in use and the number of stops correction this represents. Open up by this number of stops from f/22 marked on the lens.

MACRO ZOOMS

The way in which a mid-range zoom can be reversed to become a macro zoom has already been mentioned (see page 70). Usually, zooms are not parfocal, which means you have to adjust focus as you zoom. In practice, this does not make a great difference with close-up subjects, since you almost always have to tweak the focus before taking the picture.

The Canon (MP-E65 f/2.8) and Minolta (3x–1x) are lenses specifically classed as zoom macros in their lists.

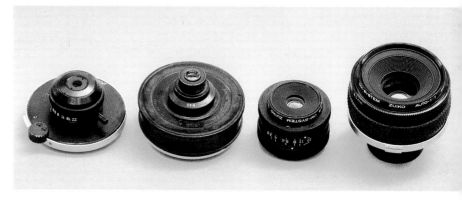

They are not straightforward pieces of equipment, but they are optically very good and just take time to master. As you are working with a tiny depth of field, the slightest movement sends things out of focus so they need to be well supported.

TESSOVARS

In the 1960s Carl Zeiss produced a beautifully made zoom lens – the Tessovar – that was specially corrected for macro work up to about x12. It carried a turret of four supplementary lenses to cope with four separate magnification and working distance ranges. Supplied with a periscopic attachment for viewing and a massive stand, it is still a superb piece of equipment.

An optical bench

At anything above a few times life-size magnification, vibration can be the single greatest barrier to achieving a biting sharpness. Depth of field is tiny, even at the smallest apertures – at x3 and f/16, for example, it is just under half a millimetre.

Pieces of equipment that seem to be smooth and rigid in normal use begin to show their imperfections. As you tighten a bellows with locking screws to get rigidity, the focus shifts a tiny bit. What feels like great engineering at low magnifications is simply not good enough when you want to do some precise work.

What you need is an optical bench – at its simplest, something that fixes camera and subject together. Your bench can be a steel or aluminum bar on which the camera is mounted on a focus slide or bellows to allow you to adjust its position. The subject is also mounted on the bar – again on a focus slide.

MAKING AN OPTICAL BENCH

You can build something that gives excellent results from secondhand equipment such as focus slides, microscope substages and other bits such as scissor jacks. (These are very useful for dealing with large subjects, such as a plant in a pot.)

I have never worked to any particular design since possibilities suggest themselves depending on what is available – from cast-offs from a metal supplier to an old lathe bed. For high-magnification cine work, where

there is greater chance of vibration, heavy construction is essential to give absolute rigidity.

The bench rail you choose must be as flat and straight as possible. Support it on a stand or a table using heavy marine plywood pieces, so that it does not flex when it is loaded. All holes you drill must be vertical, so use a drill stand or attachment that permits this and tap any threads with the utmost care. Always use accurate engineers' squares to make sure that any stage you fix to the bench is vertical – otherwise you will never be able to keep anything flat in focus over the whole of the viewfinder.

Such practical projects are not to everyone's liking, but you learn a great deal about what it takes to get great images in a process of trial and error. You will never get the perfect system, because you will inevitably think of improvements. But when you have a vibration-free system that enables you to get critical sharpness, it is extremely satisfying.

CRITICAL FOCUSING

By the time a camera is fixed to a bellows, it can be so cumbersome that it is easier to move the subject to

OPTICAL BENCH CONSTRUCTION

A solid base is first constructed from 3.8cm square aluminium alloy with sides of 5 x 1.5cm alloy to create a channel. Bellows and focus mounts are fixed to the 3.8cm square section, and slide in this position before being clamped down. The camera is fitted to bellows – the specimen stages are from old microscope parts and focus slides. Either or both can provide focus movement and hold subjects. Your metal supplier can saw alloy bar to length for a small cost – all you need is the ability to drill accurately, to tap screw heads and bolt the assembly together.

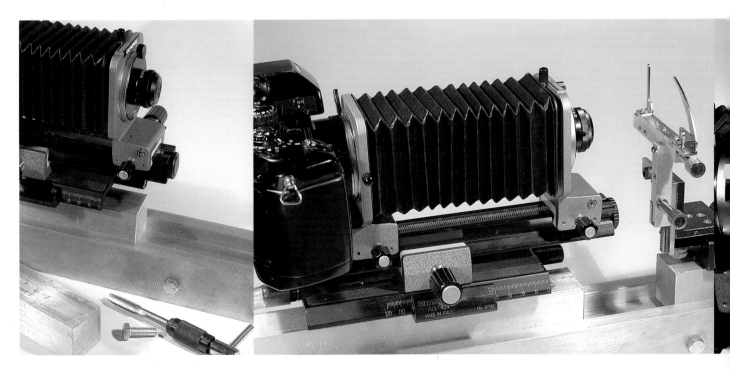

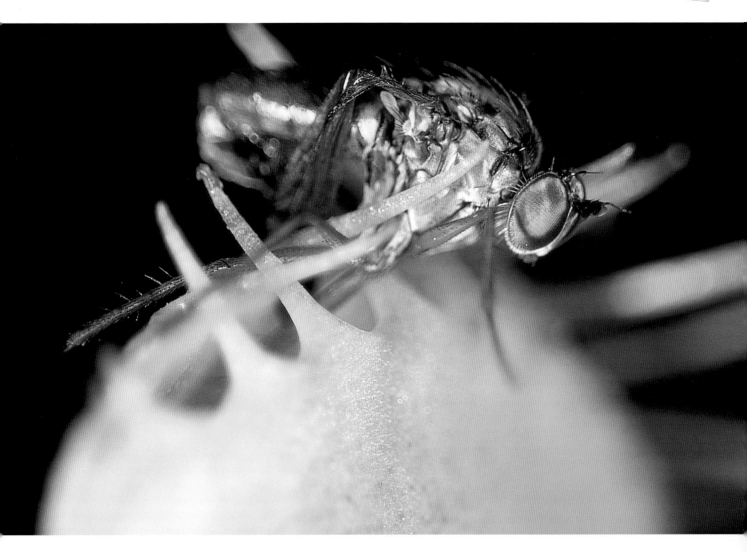

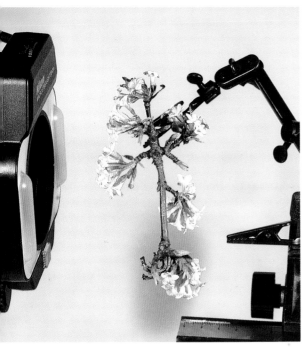

frame the shot and for fine focus on a 'subject stage' – just as one does with modern microscopes. I have made subject stages by using a focusing stage adapted from a microscope's moveable stage or employed a focusing slide made by Manfrotto that operates on a screw thread: one turn advances it 1mm or so, allowing quite precise control. Using an engineer's square, you can fix a stage (just a flat metal or MDF plate) so that it is perpendicular to the focus slide and square to the lens axis. Subjects can be attached with tape, rubber bands or blue tack. Insects can be placed on twigs and held in this way.

VENUS FLYTRAP IN ACTION

I wanted to capture the rainbow-coloured eyes of the tiny fly emerging from a Venus flytrap. Magnification was x10; the easiest way to focus was to move the plant and insect on a finely geared focus slide.

Nikon F4, Canon 20mm f/3.5 macro plus bellows, 1/60 sec. at f/5.6, Fujichrome Velvia, single SB23 flash

The macroscope

Some microscope manufacturers, namely Meiji and Wild (now part of Leitz), produce zoom 'macroscopes'. Their lenses can be purchased separately and used on optical benches or in home-built units. The Leitz unit has, perhaps, a very slight edge in optical quality, but it costs several times as much as the Meiji lens. In fact, used with a digital camera and then tweaked at the print or screen stage with suitable software (Adobe Photoshop's Unsharp Mask, for example), you will see no recognizable difference between the two.

Many binocular stereo microscopes can be equipped with trinocular heads, which permit photography over a range of magnifications, from the macro level to realms of photomicroscopy using supplementary lenses.

To all intents and purposes, a macroscope looks like a binocular stereo microscope, but it has a single main light path and the binocular head is fitted for viewing convenience. There is no need for the intermediate stereo part of the optical system and the fact that there are fewer lenses tends to mean better final optical quality.

There is nothing about these units that cannot be achieved using a home-built set-up: mine is an old microscope stand plus Olympus bellows and an

assortment of macro lenses and microscope objective lenses, some nearly 100 years old. The benefit is the convenience of having everything set up in one unit when you find something you want to photograph.

Some of these macroscope lenses do not have iris diaphragms, but already possess a very small aperture. As a result, depth of field is about as good as you might get without any deterioration due to diffraction at the magnification used.

If you do purchase a lens designed for a macroscope, then it is probably built to be corrected with 'infinity optics' – a standard adopted some years ago in the microscope world. In this case, using the zoom lens with an extension tube and camera might not fill the frame. Thus the image has to be expanded using a projection eyepiece (photo-eyepiece) or relay lens, in much the same way as a teleconverter diverges rays from the rear of a lens and makes them spread out. It is important to talk with your microscope supplier and look at catalogues to see what parts are used before you start to build your own system.

LIGHTING

You can light macroscope subjects with desk lamps or flash. Alternatively, fibre-optic lights can be used both for focusing and picture taking (see page 49). These have the advantage of providing bright, cool light either from the front or from behind a translucent specimen.

DARK FIELD ILLUMINATION

Subjects can be lit dramatically against a dark background using dark field illumination, a technique originally developed by Victorian microscopists. The technique works, with dramatic results, with any subject that is translucent, such as plant sections and small aquatic creatures.

At its simplest, it involves positioning a black (or coloured) disk beyond a subject, so that it just fills the viewfinder, with the light source behind this (or slightly

DARK FIELD ILLUMINATION

This mode of illumination is great for translucent subjects such as *Gorgonia*, a horny coral. Paired desk lamps, flash guns, or a twin fibre-optic source will produce dark field illumination

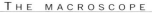 *Nikon D100, Canon 20mm f/3.5 macro plus bellows, 1/4 sec. at f/5.6, twin-fibre optic lamps*

WING SPOT (Morpho peleides)

A purpose-built rig such as a macroscope is highly convenient and quick to use for shots that would otherwise take a long time to create. Butterfly wings, for example, sit flat on the stage and allow corner-to-corner sharpness.

 Nikon F4 with Olympus 38mm f/3.5 macro plus bellows, 1/60 sec. at f/8, Fujichrome Velvia, Single SB23 flash

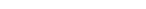

to the side) so that oblique light rays spill around the disk's edge and illuminate the subject against a dark or coloured background.

In the home studio at the macro level, a couple of halogen lamps work beautifully at magnifications of up to x20 and more, as the accompanying photographs and diagram show. I tend to use a digital camera so that I can quickly see the results and make adjustments (see page 82).

Camera lens Subject Glass Dark field stop Flash

(see page 82)

TECHNICAL NOTE

The lamps (flash guns in diagram) are placed out of the field of view. A circle of black felt or similar provides the background; this could be a translucent-coloured disk, illuminated from behind to produce Rheiberg illumination.

Digital Photography

There is no doubt that the digital revolution is in full swing. Many photographers have chosen to invest fully in the technology, from camera to printer; others shoot on conventional film and print digitally; and many more people are waiting on the sidelines to see where the technology is going and whether prices will fall.

Digital cameras, scanners and printers allow you full control of all aspects of the photographic process. The immediacy of digital photography is a tremendous boon: pictures that can only be achieved by a certain amount of experimentation can be viewed instantly and adjustments made without lengthy waits for processing.

Whenever the memory card is filled, simply download the images to a computer of some sort. This technology is changing all the time, with larger capacity memory cards and faster download connections introduced frequently as the market demands them.

Many people have bought a basic digital camera for snapshot purposes, but what are the possibilities with more sophisticated instruments when it comes to close-up and macro photography? The answer is that digital cameras allow approaches you could not have considered before. Digital SLRs are wonderful creative tools, both in the field and in the home studio.

Digital cameras

Digital cameras fall into several distinct price brackets, which relate directly to the number of pixels possessed by the sensor. The greater the number of pixels, the higher the image quality – and the closer the result to that which you would expect from film.

BALD EAGLE
(Haliaetus leucocephalus)

The penetrating gaze of this bald eagle was captured using a digital camera with a 6.3-megapixel sensor array. The picture is a portion of the image obtained.
📷 *Nikon D100, Sigma 180mm f/3.5 apo macro with x2 converter, 1/3 sec. at f/8, ISO 200*

PUMA
(Felis concolor)

Using a digital camera enabled me to 'warm' the light without using filters and adjust the 'speed' without having to change to a different film stock.
📷 *Nikon D100, Sigma 180mm f/3.5 apo macro with x2 converter, 1/3 sec. at f/8, ISO 200*

BASIC DIGITAL CAMERAS

Cameras that generate images of 640 x 480 pixels (0.3 megapixels) or 1024 x 768 pixels (0.8 megapixels) are ideal if you just want images for e-mail or Web use or to output at a small size. These cameras come in a variety of shapes and forms, from modules that fit a hand-held organizer to cameras that look like a traditional film compact camera with autofocus and viewfinder. Realistically, their potential for close-up and macro work is limited.

TWO-MEGAPIXEL CAMERAS

Cameras in this class can generate ink-jet prints up to 25 x 20cm (10 x 8 in.) of sufficient quality to use in brochures or postcards. The more sophisticated models look like SLRs and come with a fixed zoom lens that will almost certainly have a 'macro' facility. Some have the full range of functions that you would expect from film cameras – autofocus, built-in flash and autoexposure plus a range of other functions permitting video clips, sound recording and so on.

THREE-MEGAPIXEL CAMERAS

Cameras in this range can produce files that will output to high-quality ink-jet prints of 28 x 22cm (11 x 8 1/2 in.). Cameras from major manufacturers such as Nikon and Olympus have won over a large audience through their excellent optical quality and ability in the close-up range. Although they have fixed lenses, they can be used with an additional relay lens as a serious tool for imaging through telescopes and microscopes.

THE DIGITAL SLR: FIVE MEGAPIXELS AND ABOVE

If you are serious about close-up and macro work and are not willing to accept a lower quality than you would achieve with film, you need a digital SLR.

Some manufacturers such as Olympus and Minolta have produced cameras that look like SLRs – the 'digicam' – but these are often grainy and hard to focus. They also have a monitor on the camera rear that shows the electronic picture. Some cameras have

a fully electronic viewing system, where you look at an LCD screen. These cameras have fixed lenses, but accept accessory lenses screwed into the front of the integral zoom lens. Other cameras are SLR bodies that can be fully integrated into an existing film-based SLR system. They allow you to focus through the lens, observing the image on a ground-glass screen rather than on a monitor in the viewfinder.

SLRs with sensor arrays of 6 megapixels are a serious rival to film-based cameras, especially when it comes to using digital files. Scanners can generate 'noise' – extraneous random pixels – while they are creating an image. Files originated in a digital camera often look far better than scanned files since they do not have this noise to the same extent.

MEDIUM-FORMAT AND LARGE-FORMAT DIGITAL CAMERAS

Medium-format cameras produced by Bronica, Hasselblad and Mamiya can be converted to digital using special camera backs. These work in the same way as flatbed scanners (see page 148), with a row of light-sensitive receptor cells (called Charged Coupled Devices or CCDs – see page 84) moving along the film length. They have to be used directly with a computer but can generate huge files up to 244 megabytes (MB), capturing astonishing details with a dynamic range that exceeds that of film. However, their price puts them out of the reach of most photographers.

**SWALLOWTAIL
WING PATTERN**
(Papilio demodocus)

The tiny scales on the wings are clearly revealed here, showing the exceptional level of detail that a 6.3-megapixel digital SLR can capture.
📷 *Nikon D100, Sigma 180mm f/3.5 apo macro with x2 converter, 1/15 sec. at f/8, ISO 200, twin tungsten lamps*

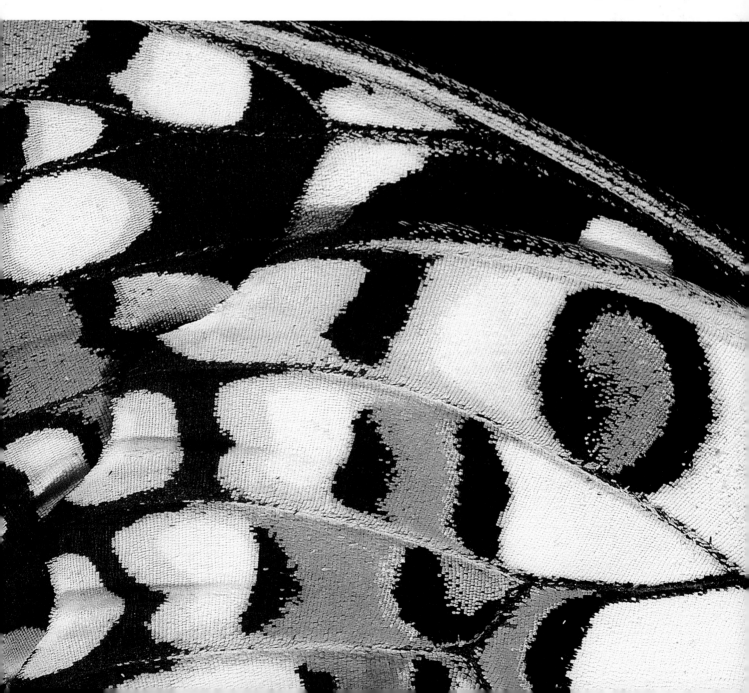

The technology

For a long time the debate raged over whether or not digital images could rival those from 35mm film. Now they can even surpass them.

SOME PROS AND CONS OF DIGITAL CAMERAS

The huge advantages of digital cameras are immediacy and the level of control that you have over the final result – both at the picture-taking and at the processing stages.

Cost is a distinct disadvantage. A good-quality digital camera is expensive enough, but you also have to buy ancillary equipment such as a laptop or portable hard drive in order to use it in the field. For assignments far from home, the complete dependence on electronics can be a worry. But the big question mark is over storage and accessibility. We all have computer disks just a decade old that are ancient technology. What will happen to the files we are accumulating now?

SENSOR ARRAYS IN DIGITAL CAMERAS

A detailed analysis of sensors for digital cameras is beyond the scope of this book, but it is helpful to know some basics in order to clarify what you can expect from your camera.

First, a sensor array is rigid and hence perfectly flat. This is not always the case with a film camera, where slight film curvature produces loss of definition.

The sensor array is a grid of individual cells – a matrix – each one of which acts like a tiny exposure meter. The more light each cell receives, the higher the signal it generates.

Data from these cells alone gives a greyscale image. To interpret colour, each cell is covered with a filter and responds to one of the primary colours of red, green and blue (these are the same colours used to build up pictures on a television screen). There are, in effect, two green filters, as the human eye is most sensitive to green, and one red and one blue, arranged in a Bayer pattern.

Colour and brightness data are processed via the camera's internal computer. Each pixel in the final image is created not just from one cell in the array but also from data produced by its immediate neighbours. For this reason, the number of pixels in the image and those on the sensor do not match exactly. In the more expensive models, the number of sensors and the final pixel count are very close.

Each pixel in the image is assigned a colour value electronically after the data has been processed by the camera's computer, so such things as colour, contrast and detail in the final image depend on the way the data from the pixels is handled by the camera.

Matrix sensors fall into distinct types – CCD, or Charge Coupled Device, in which data is passed from one cell to the next in a chain (there is a limit to speed of handling with this system), and CMOS (Complementary Metal Oxide Semiconductor) devices, in which each cell in the grid can be addressed

In a Bayer pattern, there are twice as many green-sensitive sites as either red or blue. The filter array is centred above the sensors.

Ideally filters should pass only their own colour, but a degree of mixing is allowed for in the camera software.

In the triple-well CCD, each sensor measures all three colours of light as they penetrate to different depths.

separately, allowing the same device to be used for autofocus and exposure metering.

The triple-well sensors manufactured by Foveo and used in Sigma cameras make use of the fact that silicon absorbs red, green and blue light differently according to the depth they penetrate the sensors. There is no need for filters: each sensor measures red, green and blue separately, and colour can be handled with much better fidelity and absence of colour fringing. Interpolation – the intelligent guesswork where the camera assesses data from the sensors – can sometimes result in inaccurate colour reproduction and also produce slight haloes around edges in the final image. (This halo effect is known as 'colour fringing'.)

VERSATILITY

Digital cameras offer an unprecedented level of control. A digital SLR can be used with existing camera systems and coupled to other devices such as telescopes, or a macroscope used to record the tiny foraminifera shell depicted here.

📷 *Nikon D100, Canon 20mm f/3.5 macro plus bellows, 1/4 sec. at f/5.6, twin-fibre optic lamps*

FILM AND DIGITAL COMPARED

PROPERTY	FILM	DIGITAL
Structure	A random pattern of dye clouds or grains of silver	Regular geometric array of identically sized sensors
Recording of colour	Layers sensitive to magenta, cyan and yellow separate the colours	Colours separated by filters (Bayer pattern) or depth of sensor (Foveon)
How colour is reproduced and amplified	Red, green and blue dye clouds subsequently developed by chemical means	Electronically constructed from data: signals from the array are processed by the camera
Quality and definition	Determined by the film speed (ISO rating), grain structure and film processing	Governed by the structure of the sensor (number of pixels in the sensor area), interpolation and compression employed
Image storage	Final image fixed after chemical removal of unexposed silver	Memory cards or hard disk for initial storage

Camera controls

Although most digital cameras give good pictures virtually out of the box, their sophisticated internal computers offer a bewildering range of adjustments and fine-tuning. Each camera is different, and you really must read the instruction manual to find out more about your own particular model. Only those adjustments that are of real significance to close-up and macro work are considered here.

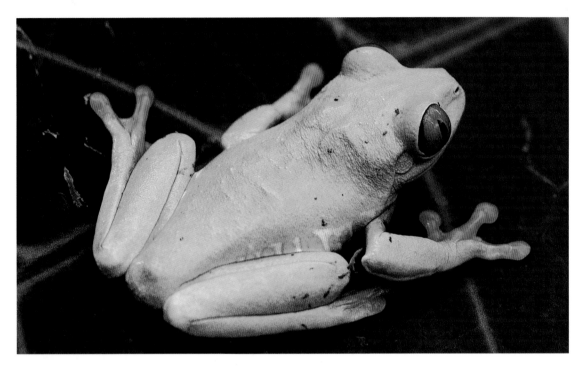

RED-EYED TREEFROG
(Agalychnis callidryas)

The beauty of digital photography is being able to see the result immediately. This red-eyed treefrog sat on a leaf in a hothouse. The use of 'cloudy' as the white balance setting provided a warmer feel to the picture while an ISO equivalent of 200 meant a shutter speed four times faster than I could have obtained with Velvia film stock.
◻ *Nikon D100, Sigma 180mm f/3.5 apo macro, 1/3 sec. at f/8, ISO 200*

COLOUR AND COLOUR SPACES

As software improves, the problems of balancing colour between camera or scanner, computer monitor display, and printer become fewer. Ideally, what you see in the camera viewfinder, on a computer monitor, and in a print should be identical. The better digital cameras permit you to set what is known as the 'colour space' (RGB, sRGB, CMYK) or colour gamut. This determines the range of reproducible colours: strong screen colours, for example, will always reproduce less vibrantly as a paper print because the monitor has a wider gamut than paper. The screen uses a grid of red, green, and blue phosphors to build up colours, whereas print uses four coloured inks – cyan, magenta, yellow and black (CMYK). There are some colours that you can display on a screen but not print and vice versa. A camera's colour controls allow you to remove colour casts, but in practice it is easier to deal with all corrections when files have been downloaded, and you're sitting at the computer.

FILE TYPES AND RESOLUTION

Digital SLRs offer a choice of capture modes for data. Raw mode captures the maximum amount of data without compression sharpening or other modification. TIFF files are not highly compressed and this format does not lose data when a file is repeatedly opened or closed, whereas others, such as JPEGs, do. However, a JPEG in fine mode from a digital SLR will come as a revelation to anyone who has avoided this format because of doubts about the quality. Only at pixel level on screen will you see differences between fine-mode JPEGs and the best-quality TIFFs: the bonus is that with fine-mode JPEGs you can capture six times as many pictures with a 6-megapixel SLR on a given flash card. What's more they write and download much faster. On the other hand, the larger the raw file a camera can produce, the more detail it can capture in a subject and so the resolution goes up.

BIRCH POLYPORE
(Piptoporus betulinus)

The pair of photographs (opposite) of a bracket fungus clearly show the difference that white-point settings can make. The left-hand picture (white point set to 'cloudy') looks warmer, since the camera electronically accentuates the proportion of red. The right-hand picture (set to 'direct sunlight') is bluer and cooler looking, since blue is emphasized.
◻ *Nikon D100, Sigma 180mm f/3.5 apo macro, 1/30 sec. at f/8, ISO 200*

SHARPENING

The sensor's regular grid pattern can interact with any other regular pattern in the subject you are trying to capture to create a Moiré pattern of bands of light and dark (like two pieces of overlapping silk). Most digital cameras deliberately blur the image electronically using an 'anti-aliasing' or 'low' pass filter to overcome this. This softens the image and so a sharpening mode has to be used to restore it – in the camera or later.

If you capture raw files and want the maximum 'pure' data to work on, then sharpening is usually turned off automatically. In other modes, I just leave it as 'normal' and it works; it does not knock out the efficacy of the Unsharp Mask (see page 146) later in the chain when you create files and prints.

The sharpening process seems to work much more effectively with a camera-generated file than with a scanner file – perhaps because of the 'noise' (see page 83) that a scanner generates in the form of random pixels. The proof of this pudding is in the eating: you can produce large exhibition prints that have biting sharpness at 200dpi (dots per inch – see page 84) from a digital SLR with a 6-megapixel array, even when pixels are added to increase the file size and create large prints.

WHITE POINT

The human eye has an amazing ability to see something as 'pure' white under a wide range of lighting conditions. With film, we deal with different light sources, either by using a film balanced for the light

FORAMINFERA

Unsharp Mask, used with the microscopic shell of a *Foraminfera* illustrated above, can to a certain extent offset the slight image degradation that occurs at high magnifications.

📷 *Nikon D100, Canon 20mm f/3.5 macro on bellows, 1/4 sec. at f/5.6, ISO 200, twin fibre-optic lamps used for dark field illumination*

source (daylight or tungsten) or by using suitable correction filters. With digital SLR cameras you can adjust the colour balance according to the colour temperature (see page 52) of the light source through the 'white point' control panel. What happens is that the digital camera takes the raw camera data and adjusts the ratio of red to blue determined by the white point setting. There are several fixed settings to suit various colour temperatures: auto (4200–8000K), incandescent (3000K), fluorescent (4200K), direct sunlight (5200K), flash (5400K), cloudy (6000K) and shade (8000K), each of which can be finely tuned, as auto white balance settings are often way off the mark. Alternatively, you can choose a white object, take a picture, and let the camera make adjustments from this. With close-up and macro subjects you can work with a range of light sources – daylight, flash or tungsten, for example – without having to wait to change film.

For absolute colour fidelity, you can work on the raw data with the manufacturer's own image-capture software or independent program.

If you have a personal preference for warm tones, the 'cloudy' setting will give what you want in daylight on all but the brightest of days – even in dull woodland conditions. The other settings that I use regularly are 'flash' and 'incandescent'. Digital cameras can even cope with such notoriously difficult lighting as fluorescent. It's a good idea to make test exposures and fine adjustments until it looks right.

File formats and sizes

Pixel counts, file sizes, print sizes: digital photography can be confusing for beginners and more experienced photographers alike. Everything depends on what you intend to use the pictures for.

BLACK KITE
(Milvus migrans)

The black kite was photographed at a hawking display. I needed to store a large number of pictures, so I set the file format to JPEG.
📷 *Nikon D100, Sigma 180mm f/3.5 apo macro with x2 converter, 1/250 sec. at f/8, ISO 200*

PHALAENOPSIS ORCHID
(Phalaenopsis sp.)

When I compared this digital photograph of a *Phalaenopsis* orchid with a print from 35mm film, the crisp detail of the digital file was obvious.
📷 *Nikon D100, 105mm f/2.8 macro, 1/15 sec. at f/16, ISO 200, twin tungsten lamps*

WHICH FILE FORMAT?

With a digital camera there are options for the way files are stored. A raw file captures the data processed by the camera without making any corrections such as sharpening or colour correction. TIFF and JPEG options both employ 'compression' algorithms, which condense the picture data into a smaller file.

JPEG is widely used for Web pictures and smaller files, because it lets you take and store many more pictures in a given space. But it comes with a 'health warning': every time you open a file, you lose data, unless you write it to a CD and use that file whenever you need it. My digital camera offers a choice of JPEG or TIFF. The former gives a 2.7MB file that opens to 17.4MB using the Adobe program Photoshop as it decompresses; the latter gives a 17.4MB file to begin with. The difference is that you can store over six times as many JPEGS on the same card.

PIXELS AND GRAINS

Pixels are the tiny, uniformly coloured squares that make up a digital picture. They are arranged in a regular array – unlike the grains in a film, which are randomly distributed.

INTERPOLATION: THE PIXEL GAME

When you are choosing a digital camera, you will notice that some seem to produce much larger files than others from the same-sized sensor. At first glance, this seems to imply that you are capturing more data in some way. What happens is that the data in the file can be processed in different ways, and in many cases this involves 'interpolation' – a method of adding pixels by electronic guesswork.

Although no camera can generate information that was not in the image at the time of taking, interpolation can work extremely well – you can almost double the file size with some cameras to produce stunning 60 x 50cm (24 x 20 in.) prints or do the same via the computer software you use. The ultimate test is the final appearance. Does the result look sharp? Are the colour and contrast what you expect?

HOUSEFLY'S WING
(Musca domestica)

This image of the fly's wing was intended to be used as a print: I decided to record it as a RAW file, preserving all the data captured by the camera. All my RAW files are stored and then cut to CD, giving them 'permanence' as far as I can assure it. It is too easy when manipulating files to make changes or lose pixels that cannot be recovered.
📷 *Nikon D100, Canon 20mm f/3.5 macro on bellows, 1/4 sec. at f/5.6, ISO 200, twin fibre-optic lamps used for dark-field illumination*

But surely there must be a vast difference in quality? Not a bit. The compression process used with these files is so sophisticated that there is no perceptible difference. If you examine individual pixels, you will see the pattern is not quite the same in any tiny area you take. But that is not how we view pictures: on a print they look identical and that is what matters.

IS DIGITAL AS GOOD AS FILM?

It is a fact that a 17MB TIFF file generated by a 6-megapixel digital SLR looks every bit as good as a high-resolution scan from a 35mm slide that produces a file size of 25–35MB. The first time you see this it is a shock: the results from a digital camera are so clean and sharp. Any scanner generates electronic noise that also manifests itself as random pixels thrown into the scan. Some writers suggest that this constitutes as much as 50 percent of the information from a dedicated slide scanner. Cameras with 12-megapixel arrays can capture as much data as the finest-grained transparency films (see page 36) and produce prints every bit as good as those taken on medium-format film. It is not a question of which is better, but of which tool suits the job you wish to do.

FILE SIZES

With any digital process there is the question of file size: what size file do you use for picture taking, what size do you need for a print and so on.

Remember, you can always cut a digital file – but trying to increase its size too far by adding pixels does not increase the detail. If you think you might need more detail, use the largest file size possible.

The table below gives you clear idea of what a given file will let you do.

DESTINATION	IMAGE SIZE		FILE SIZE	
Web Pages screen resolution 72dpi aspect ratio 3:2 (as for 35mm frame)	480 x 320 pixels		0.45MB	
	600 x 400 pixels		0.70MB	
	758 x 512 pixels		1.12MB	
	960 x 640 pixels		1.75MB	
Ink-jet Print **Magazine**			**200dpi**	**300dpi**
(200dpi) (300dpi)	7.5 x 12.5cm	(3 x 5 in.)	1.72MB	3.86MB
	10 x 15cm	(4 x 6 in.)	2.75MB	6.18MB
	20 x 25cm	(8 x 10 in.)	9.16MB	20.68MB
	15 x 21cm	(5.85 x 8.25 in.)	5.5MB	12.45MB
	21 x 30cm	(8.25 x 11.7 in.)	11MB	24.9MB
	30 x 42cm	(11.7 x 16.5 in.)	22.1MB	49.7MB

Digital close-up and macro

Much of what has been written earlier in this book is just as relevant to digital cameras as it is to film cameras. However, there are characteristics of digital cameras that make them ideal for close-up and macro work.

THE BODY MAGNIFICATION FACTOR

Writers in photographic magazines sometimes lament the fact that a digital sensor uses a smaller area than a 35mm film frame. They are clearly not wildlife photographers, because these cameras effectively produce a magnification boost that can be a great boon in two distinct areas. This is expressed as a body factor, usually 1.4–1.7 times, depending on the area of the sensor and how much it has to be scaled up to a 35mm frame.

The benefits come at opposite ends of the lens scale. When using telephotos for close-ups of birds or mammals, a 400mm lens fitted to your digital camera body with a x1.5 body factor produces the equivalent of a 600mm lens. With macro photography, where the 100mm macro lens you rely on gives you 1:1 magnification with film, it will now give x1.5 with the same digital body.

Digital sensor size

A DISADVANTAGE

With wide-angle lenses, the body factor is a nuisance when it turns a 24mm lens into a 36mm and ruins the impact of a close-up subject set in the foreground of a landscape (see page 114). In the past, lens designers have battled to make lenses perform right to the edge of the film. When they have to cope with the smaller area of a digital sensor, they consider light rays nearer the centre of the lens. It is easier to correct for these and all sorts of wonderful lens designs can be produced, such as a 12–24mm zoom that produces angles of view equivalent to an 18–36mm zoom on a traditional 35mm film camera.

MORPHO BUTTERFLY SCALES
(Morpho peleides)

The body magnification factor allowed me to photograph the wing of this morpho butterfly at x1.5 life-size (below left), using a portrait macro lens designed to give life-size magnification on 35mm film. The maximum magnification of x22.5 is sufficient to enlarge the scales more than 150 times on a 25 x 20cm (10 x 8 in.) print (below right). *Below left: Nikon D100, Sigma 180mm f/3.5 apo macro, 1/15 sec. at f/8, ISO 200, twin tungsten lamps. Below right: Nikon D100, Canon 20mm f/3.5 macro on bellows, 1/4 sec. at f/5. 6, ISO 200, twin fibre-optic lamps*

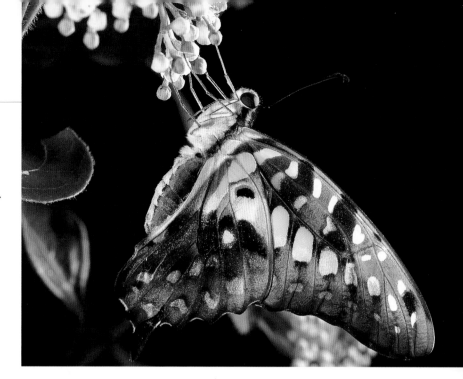

DEPTH OF FIELD

Few people seem to appreciate the distinct benefit of digital cameras in close-up and macro work. They give you greater depth of field for a given final magnification. This is a pretty bare statement that needs some explanation. Suppose you take a picture with a 1:1 macro lens, fully extended. A body factor of 1.5 means your final result would have a x1.5 magnification, but the depth of field associated with 1:1. Similarly, to get 1:1 on film, you now need a lens magnification of only two-thirds, and the depth of field is greater – the depth that you would associate with 2:3 magnification, not with 1:1. To understand this, think about the sensor. This is a two-dimensional array that captures everything associated with the image. The depth of field is fixed where the optical image is captured; whatever happens when this is magnified electronically, it does not change. The same thing happens with traditional enlargement: true, a picture might become more grainy and the detail might break up, but the depth of field remains the same.

FILM SPEED EQUIVALENT

Many digital SLRs have an equivalent speed of ISO 200 as their lowest rating. This gives you two stops more light than an ISO 50 film, which is what many wildlife photographers use. You will find yourself attempting close-ups using lower levels of natural light where you might well have used flash previously. There is much less risk of camera shake since you can use four times the shutter speed – or use twice the shutter speed and close down one stop for more depth.

LIGHTING AND EXPOSURE

Tungsten lamps are ideal for working in the home studio with a digital camera because they are small, inexpensive and have a high light output. In fact, many of the pictures illustrating the digital section of this book were taken in the depths of winter, using one to three small halogen desk lights from a hardware store. If you have a variety of lenses and use bellows or extension tubes, then a simple stopped-down metering mode on the camera is extremely useful. However, one apparent drawback is that the internal exposure meter of some digital cameras switches off unless you are using lenses that allow electronic coupling of functions. In practice it does not matter, for after a few trial exposures with lamps or with cameras and flash set to manual mode, you get excellent results.

GREEN TRIANGLE BUTTERFLY
(Graphium agamemnon)

With a digital camera, you can immediately see the effect of changing lighting. Here backlighting accentuated the transparent green patches and delineating hairs on the butterfly body, separating it from the background.
📷 *Nikon D100, Sigma 180mm f/3.5 apo macro, 1/30 sec. at f/8, ISO 200, twin tungsten lamps*

GREEN TRIANGLE BUTTERFLY
(Graphium agamemnon)

Digital photography has revolutionized the way I work. As the butterfly hung drying its wings, I was able to experiment with different lenses, adjust the position of the lights and see the image without having to wait for film to be processed.
📷 *Nikon D100, Sigma 180mm f/3.5 apo macro with x2 converter, 1/15 sec. at f/8, ISO 200, twin tungsten lamps*

**GREEN TRIANGLE
BUTTERFLY**
(Graphium agamemnon)

For this shot I used a digital
camera body, equipped with
a 180mm tele-macro lens
and a x2 converter. This gives
a maximum magnification of
x3 life-size at just 21.5cm
from the lens front.
📷 Nikon D100, Sigma 180mm
f/3.5 apo macro with x2 converter,
1/15 sec. at f/8, ISO 200, twin
tungsten lamps

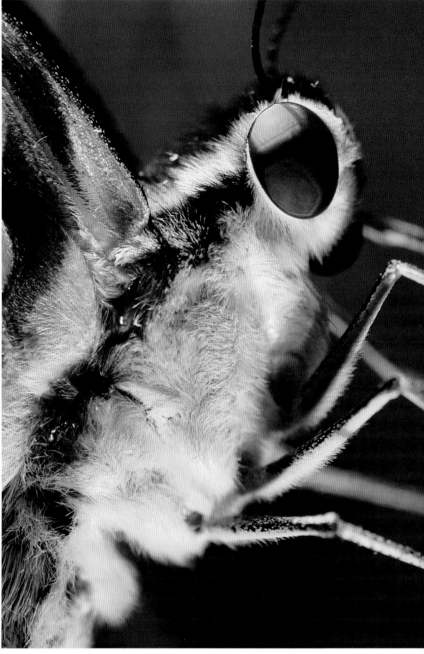

**PERSIAN
LEOPARD CUB**
(Panthera pardus)

Fine JPEG mode produced a
file with enough detail for a
large exhibition print. I also
used Unsharp Mask (see
page 146), which works
well on animal stripes,
whiskers and bird feathers.
📷 Nikon D100, Sigma 300mm
f/4 apo macro, 1/125 sec.
at f/5.6, ISO 200

EXPOSURE LATITUDE

Digital cameras have good tolerance to underexposure.
Even when results appear dark on screen – or more
underexposed than would be acceptable with film –
they can be lightened on screen to excellent effect.
In theory, if your camera's exposure meter allows a
stopped-down reading you should get the correct
exposure. Unfortunately, bellows extensions and low
light conditions can mean exposure is not always spot-
on with film, and results are under-exposed. With a
digital file, you can lighten the image on screen and all
the detail is still there: with digital, overexposure loses
detail more readily, just as it does with film. When

making exposures, you quickly get to know what to use
as a starting point for manual work with whatever lighting
set-up you are using. For close-up I use the power control
on the flash and set the output to 1/8 or 1/32. The flash is
held close to the subject, with its diffuser in place to
produce a broad light source (see page 42).

RELAY LENSES

Many people have found that fixed-focus cameras
such as Nikon's Coolpix make versatile cameras for
recording images through the microscope. They cannot
do this directly; instead, they have to be used with a
'relay' lens that diverges light rays and is fitted a couple

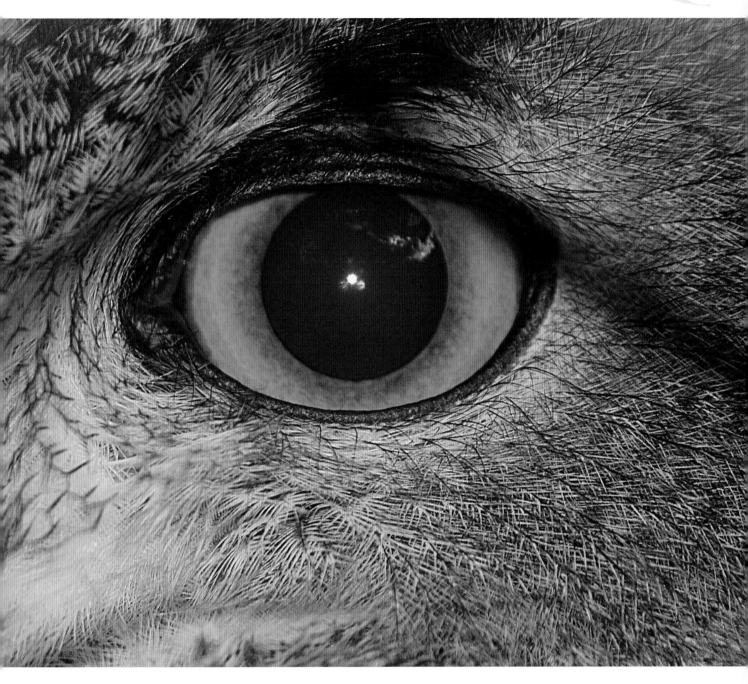

of millimetres from the lens front. This setup can either be used directly with a macro lens or microscope lens or be placed over the eyepiece of a microscope to produce higher magnifications.

FLASH SYSTEMS

If you have become used to relying on a TTL flash system, you may be disappointed to find your new digital SLR will work only with one or two dedicated D-TTL guns, depending on the camera make – very annoying if you already own an expensive macroflash unit. The TTL system of film cameras relies on measuring light reflected from the film, meaning that

only specially designed guns will function with it. Digital technology has taken a backward step and often uses a 'simulated' flash exposure that can go badly awry. If you do not have a D-TTL flashgun, the answer is to work with the guns set to manual and make trial exposures. With elusive subjects such as butterflies you have to make trials beforehand or make adjustments to the camera setting so that all you do is 'point and shoot'.

EYE OF AN EAGLE OWL
(Bubo bubo)

For this shot, adding a converter to a macro lens gave a small angle of view to enable photography through wire mesh; a D-TTL flashgun provided overall illumination and a catch-light in the pupil.
📷 *Nikon D100, Sigma 180mm f/3.5 apo macro, 1/125 sec. at f/16, ISO 200, SB-80 DX speedlight*

Field Work

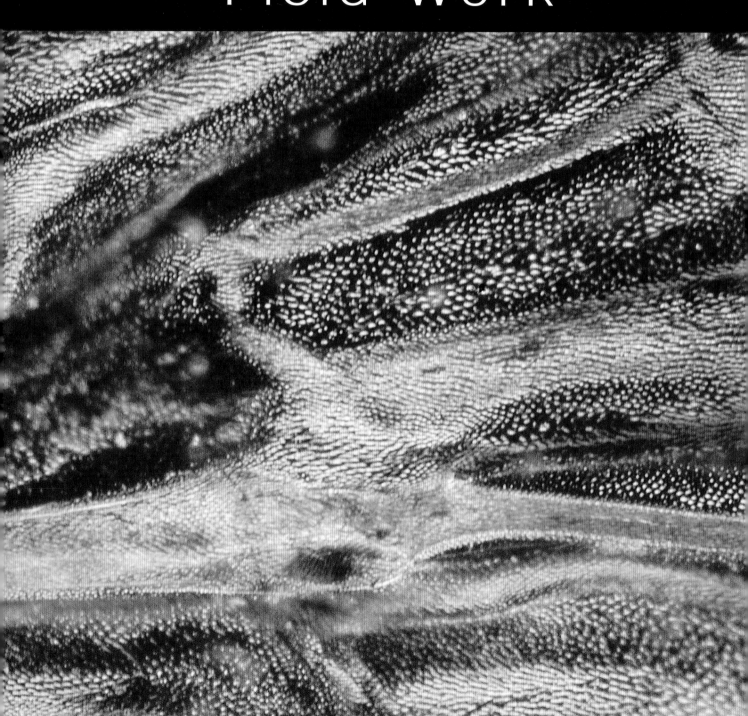

Once you have begun to photograph the natural world close up, you will never run out of subjects. You will probably start with one area and find that it leads you in other directions. My own interest in photography stemmed from my childhood fascination with wildlife. From there I went on to develop a passion for orchids and the challenges of photographing them, which in turn sparked an interest in the insects that pollinate them, the landscapes in which they grow and the other plants that grow around them.

You will never stop learning, whether it's through your own observations, through reading magazines and books or by coming into contact with other enthusiasts. Although you can appreciate the beauty of the natural world for its own sake, this kind of specialist knowledge about behaviour, habitat, form and function will always bring something extra to your pictures.

In this section there are lots of hints and tips relating to both photography and field-craft that I have picked up over the years, which I hope you will be able to build on through your own experiences.

Butterflies

Few people can remain unmoved by the sight of an exquisitely coloured butterfly flitting from flower to flower in search of nectar. The ancient Greeks called them *psyche*, the word they also used for soul, since they saw a parallel between human life and death, with the freeing of the soul, and the metamorphosis of a butterfly from egg through larva to pupa and then final flight.

Butterflies exist in an extraordinary variety, many with iridescent scales, vivid colours and remarkable eyespots. Whether we photograph butterflies in their entirety as adult insects or concentrate on the tiny scales that form their wing patterns, they are close-up subjects *par excellence*.

WHEN AND WHERE TO PHOTOGRAPH BUTTERFLIES

The obvious time to try to photograph butterflies is when they are relatively inactive and will settle. Early morning, before the air warms up, and towards the end of the day as they soak up the last of the sun's rays are good times – and you can be almost sure of getting your shot just after they emerge from the chrysalis, as

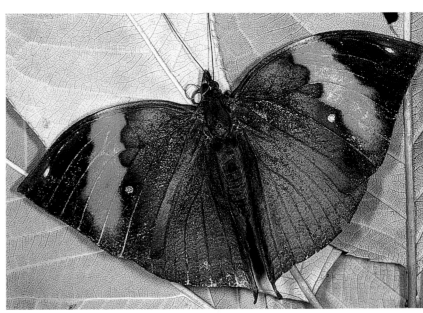

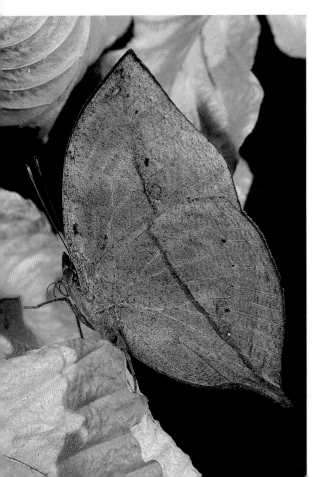

MALAYSIAN LEAF BUTTERFLY UNDERWING
(Kallima paralekta)

The difference between upper wing surface and underside is significant for the leaf butterfly. This is useful because many butterflies have similar upper wing surfaces and are impossible to identify if you cannot see the underside.
📷 *Nikon D100, Sigma 180mm f/3.5 apo macro, 1/125 sec. at f/8, ISO 200, SB-80 DX speedlight*

LEAF BUTTERFLY
(Kallima paralekta)

When the leaf butterfly closes its wings among dead and dried leaves it virtually disappears.
📷 *Nikon D100, Sigma 180mm f/3.5 apo macro, 1/15 sec. at f/16, ISO 200, twin tungsten lamps*

they will hang to dry their wings. Butterflies are less likely to fly away when they are feeding, and so learning about the feeding habits of particular species is a good way of enhancing your chances of success.

NECTAR-RICH PLANTS

Some plants rich in nectar attract a wide range of butterflies and other insects. If you are careful, you can set up your camera on a tripod and simply wait as the parade of species goes by, oblivious to your presence. In the wild, umbellifers, those flowers with great flat heads such as wild carrots and hemlocks, attract a host of nectar-feeding butterflies and other photogenic insects, such as iridescent beetles and hoverflies.

Fields of alfalfa in flower will attract butterflies in clouds, and *buddleia,* once a Himalayan plant but now a common species on waste ground in many countries, is also a butterfly magnet. In late summer and fall, sedums and various daisies attract the later butterflies. No matter how small your garden is, you can attract butterflies by planting these species.

WET PUDDLES

In tropical regions butterflies will gather at any muddy puddle in an open glade. They will also settle at wet mineral deposits. When camping, I have watched as butterflies settle on the ash left after a fire, probing it diligently with their probosces.

BAITING

If the above ideas fail, then you can always try to entice butterflies toward your lens by setting out food for them. Butterfly hunters past and present have long realized that a butterfly's tastes and ours are not necessarily the same. For example, some of the largest and most attractive species will come down from the trees to probe the juices of carrion or rotting fruit. In fact, when trying to bait large *Charaxes* butterflies with rotting figs, we found they preferred the feces of the wild boar that took them. Entomologists will admit to returning to places they have urinated at earlier to find the butterflies that gather there. It is a question of how badly you want that picture...

BUTTERFLY HOUSES

Whatever your opinion of the ethics, butterfly houses enable people to see displays they might not normally witness and the best ones educate the public about species that are at risk and have conservation programs. Many butterfly houses are sympathetic to photographers and, out of season on days free of school visits, you can photograph in a relaxed manner. If you want to use a tripod, however, always telephone beforehand to see if it's allowed.

Even on dull days, large colourful species will sit still for ages, their wings spread, allowing you to take photographs in natural light. The wings of dead butterflies with their patterns made from tiny scales make fascinating close-up subjects. Asking for dead insects at a butterfly house might seem like a strange request – but try it.

THE TECHNICALITIES

Large butterflies (and also dragonflies) have a definite zone of fear: come within 1 metre of them and they are gone. One answer is to use a long-range macro lens – something like a 180mm or 200mm – that provides a 'safe' distance between you and the subject. A zoom or telephoto with an extension tube will also do the job. Lens designs with internal focusing are easiest to use: the lens length does not change, forcing you to shift position slightly as you focus. If you are using natural light you will need some sort of support – a monopod, at the least – or be prepared to sacrifice depth of field and use higher shutter speeds to cut any possibility of camera shake.

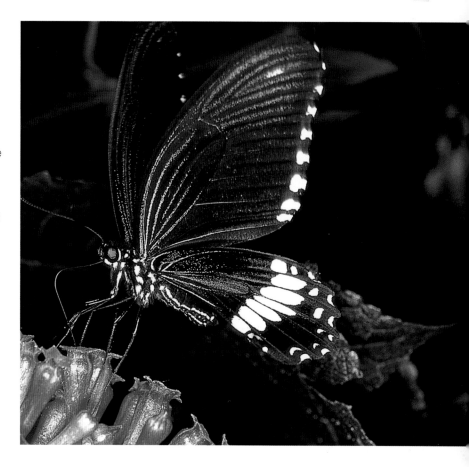

FLASH

Flash is an answer to many of the difficulties associated with photographing active insects, and a commercial or home-built macroflash unit might suit your purposes. The extra ISO equivalent of a digital SLR also allows you those few precious extra stops.

BACKLIGHTING

When photographing butterflies in the studio or conservatory after they emerge, I often backlight them by placing a lamp or flash behind the subject but out of view or placing the insects in front of a window. The backlighting emphasizes all the hairs along the body and wing edges, particularly if you are using black backgrounds (see page 40).

FILM CHOICE

I use ISO 100 film stock for most of my insect shots with flash. Employing a shutter speed of about 1/60 –1/125 second (or even longer in dull conditions) means that there is some natural light in the background, too, and this flash and daylight mix produces a natural-looking result that has slightly more 'punch' to the colours.

THE BUTTERFLY HOUSE

The tropical swallowtail shown here *(Papilio polytes)* is one that many people would not get to see if it was not for butterfly houses. They also provide excellent opportunities for photography.
📷 *Nikon D100, Sigma 180mm f/3.5 apo macro, 1/125 sec. at f/8, ISO 200, SB-80 DX speedlight*

Moths, mantids and spiders

Butterflies might be the most instantly appealing of insects and related 'crawlies', but there are numerous other insect species that provide a wealth of opportunities for close-up photography. As well as the insects themselves, there are constantly occurring themes within the insect world, such as camouflage, warning colours and stances, and parasitism. It is important to capture the subject – perhaps against its background, displaying, or with a host – in the right way to tell the full story.

MOTHS

The larger moths are every bit as attractive as butterflies, and although many species (but not all) fly at night, they can be found at rest in daytime if you look carefully. Some of the most striking moths are the sphinx moths (hawk moths): the adults are superb flying machines, often with dull, powerful forewings and brightly coloured hindwings. You can get them to display these by stroking the thorax with a soft watercolour brush. The larger silkmoths are also exceptionally attractive moths, with broad wings beautifully marked and shaded with prominent warning eyespots.

Both the sphinx moths and the silkmoths have larvae that are every bit as colourful as the adults. Many smaller moths are often drab, although their larvae are brightly coloured, almost by way of compensation. Caterpillars make excellent and obliging close-up subjects. When they are on a suitable food plant, they just sit, feed and defecate, giving you time to relax, experiment, and hone your close-up techniques.

It is the strange warning posture that sphinx moth larvae adopt when disturbed that suggested the common name of 'sphinx' moths. Many of them have a smooth appearance with bright stripes and spots and a 'horn' at the tail. In contrast, many silkmoths have

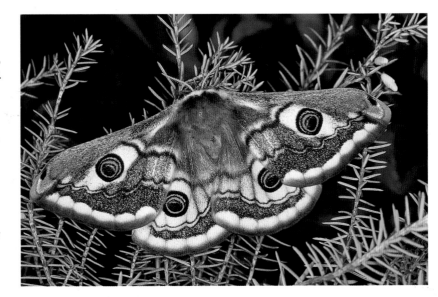

bizarrely coloured and spined larvae – some even have a sting like a nettle. In fact, any hairy larvae need careful handling since they can produce a skin irritation. As well as shots of the whole animal, the hairs and tubercules – those stout protuberances on silkmoth larvae – make intriguing close-up subjects.

MANTIDS AND OTHER INSECTS

Mantids are masters of camouflage, sitting unnoticed until prey passes when they react with lightning speed. My particular favourite is the pink orchid mantis, *Hymenopus coronatus* – a marvel of evolution and natural selection, with appendages that make it look like the *Phalaeonopsis* orchids in which it hides. Mantids are difficult to see, which is how they delude their prey; with the larger species, you can sometimes stare into a bush and see nothing – and then if you move your head sideways, the insect responds, suddenly alerts and you see it. I always try to approach along the line of sight,

EMPEROR MOTH
(Saturnia pavonia)

The emperor moth is one of a large genus of silkmoths (saturnids) that exhibit colours and markings as bright as any butterfly; many of them have eyespots that act as a warning.
📷 *Nikon F4, 105mm f/2.8 macro, 1/60 sec. at f/11, Fujichrome Velvia, SB20s macroflash*

DEATH'S HEAD HAWK MOTH LARVA
(Acherontia atropos)

Sphinx moth larvae can grow to 15cm and be thicker than a man's thumb. The head position when alerted gives the name 'sphinx' moth.
📷 *Nikon F4, 105mm f/2.8 macro, 1/60 sec. at f/11, Fujichrome Velvia, SB29s macroflash*

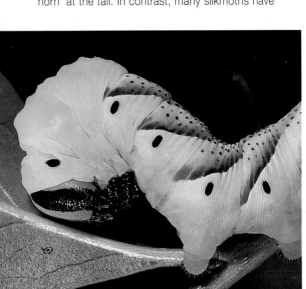

looking through the camera lens, refocusing as I move in, photographing the whole animal and then the head and the spiked legs that hold the prey. If you don't want to wait, you can feed a mantis with prey – small crickets, for example: they will strike as the insect is moved across their vision. Be warned, however: in close-up, the spectacle of a mantis making short work of an insect is not for the squeamish.

DRAGONFLIES

To photograph adult dragonflies in free flight is extremely difficult, but if you can identify a regular perch you can wait as they make forays for food, catching them just before they land, after take-off or while they hover. Dragonflies seem constantly alert and have superb peripheral vision so you have to stay outside this circle of awareness by using a telephoto lens with good close focus (see page 66). If possible, when using flash select a shutter speed that allows some natural light exposure, too (see page 97): the body will be captured sharply but the wings will be nicely blurred, suggesting rapid movement.

SPIDERS

Many otherwise fearless people have a degree of arachnophobia, but using a long-focus macro lens or zoom puts spiders outside your 'circle of fear'. They make fascinating subjects, from the patterns on their bodies to their minute ocelli, or eyes. It is often easier

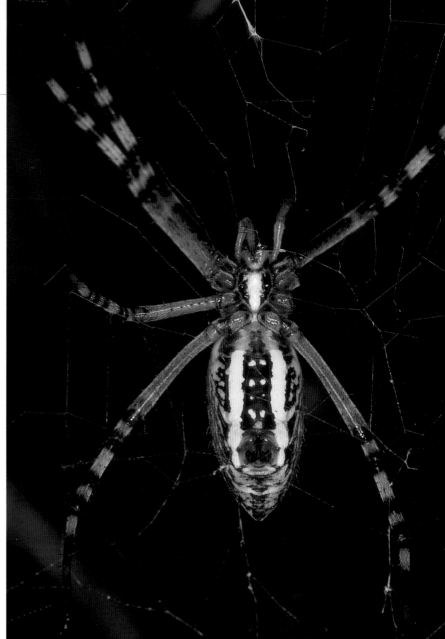

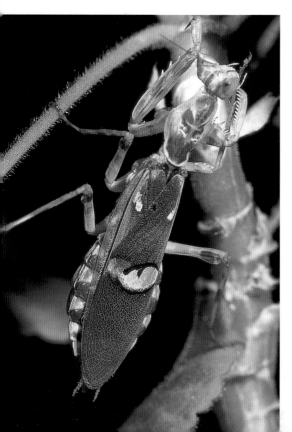

ORB WEB SPIDER
(Argiope bruennichii)

In late summer and autumn, the orb web spider spins large webs across pathways in scrub; the female, large and obviously coloured, sits at the centre.

 Nikon F4, 105mm f/2.8 macro, 1/60 sec. at f/16, Fujichrome Velvia, SB21B macroflash

AFRICAN FLOWER MANTIS
(Creobroter pictipennis)

The African flower mantis shown here is easily missed on vegetation because of its camouflage.

Nikon F4, Sigma 180mm f/3.5 apo macro, 1/60 sec. at f/11, Fujichrome Velvia, SB29s macroflash

to photograph those species of spider that build webs, for a freely strung web allows you to photograph the spider or the underparts with biting mouthparts and even the spinarets that produce the silk for the web. Other spiders – wolf spiders, crab spiders and jumping spiders – often remain hidden on plants: with care you can gently remove leaves between you and the subject. An old entomologist I know used to attract adults hidden in funnel webs using a tuning fork near the web centre to imitate the sound of distressed flies.

In Europe and North America there are relatively few venomous spiders, whereas in Australasia everything seems venomous. If in doubt, err on the side of caution. If something is brightly coloured, heed the warning: there will be time later to discover whether or not it is a mimic.

Life cycles

By photographing all the stages in an insect's life history, you tell a story on film – a truly satisfactory experience for you and for anyone who sees your pictures. The first time you photograph the emergence of a butterfly from its chrysalis or the splitting of a nymphal skin to release a dragonfly, the process is so fascinating it is hard to remember to press the shutter.

Insects such as butterflies and moths have several distinct stages: egg or ovum, larva or caterpillar, pupa (chrysalis with butterflies), and adult (imago). Each stage demands different photographic techniques. Eggs are tiny (1mm or less), with delicately sculpted surfaces, and lie in the realm of true macro photography. They are best photographed on the living food plant; if you remove pieces with eggs, the leaf will wilt and the larvae will die after hatching. Larvae can be camouflaged but are oblivious to your presence and you can take your time to make a composition. Pupae are stationary. Butterfly pupae often have shiny gold metallic spots or patches, so I tend to photograph them using natural light or tungsten lamps so that lighting direction can be changed to emphasize the metallic appearance. Adult butterflies can be photographed at rest by careful stalking or, with great difficulty, in flight.

Beetles, bugs and true flies also have these four stages, while grasshoppers, crickets and mantids produce nymphs that look much like the parents and go through several skin changes as they grow to maturity. The dragonfly has a voracious larva that lives in water and goes through several skin changes – the last one, after it climbs a plant stem, seeing the emergence of the winged adult. Tiny wriggling mosquito larva in water can be transferred to a 'micro-aquarium' (see page 112), where their feathery gills and the emergence of the adult can make superb photographs.

REARING INSECTS FROM EGGS

The best way to photograph a life cycle is by rearing insects from eggs. Butterfly and moth larvae need the correct food plant, though in captivity they will eat other plants as long as the eggs hatch on them. Once established, larvae do not like change and will often get dietary problems and die if the food plant is changed. Several firms will supply stock (as eggs, larvae or pupae) and give advice, too. In the process of changing from egg to larva, many insects increase in size by a factor of hundreds of times – all in a matter of a few weeks. The moth larva will ultimately pupate; you

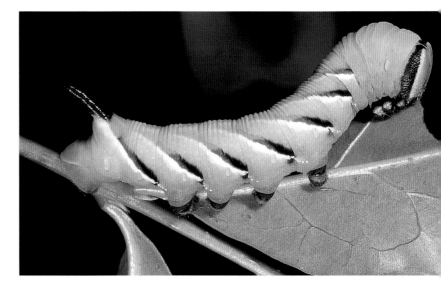

PRIVET HAWK MOTH LARVA
(Sphinx ligustris)

Many of the sphinx moths, such as the privet hawk are easy to keep from the egg stage, giving you the opportunity to photograph them at all stages of their development.

📷 *Nikon F4, 105mm f/2.8 macro, 1/60 sec. at f/16, Fujichrome Velvia, SB21B macroflash*

need to provide soft peat for them to burrow into. Some people rear larvae on growing food plants; I favour fresh-cut food plant, changed daily, in a margarine tub with tissue paper in the bottom and a lid. Larvae are pretty stupid: they will stay on stale vegetation when there is fresh foliage nearby and go into starvation mode, pupating early with disastrous results. When crowded, they become cannibals.

Moth pupae can be removed from the peat after a few days – but take care never to squeeze their sides since the adults will emerge crippled. Butterfly pupae are naturally fixed to their food plant; the caterpillar does not burrow, but weaves a pad of gossamer and splits its skin for the final time to reveal a chrysalis fixed to a plant stem by a thread of gossamer and a natural glue. You can remove the chrysalis plus its pad by means of fine-pointed scissors and attach it to a dowel rod in the emerging cage. Take a toothpick with a tiny amount of contact glue and touch it to the dowel rod and the end of the pupae (don't get any on the pupa sides, just the hard end point). After 5–10 minutes, carefully bring the pupa and dowel together to create a bond that allows the chrysalis to hang.

Dragonflies can also be raised by keeping their nymphs in an aquarium (some take two years from egg to maturity). Alternatively, a garden pond carefully observed in early summer will reveal dragonfly and damselfly nymphs climbing marginal plant stems, ready for the emergence of the adult.

PREDICTING EMERGENCE

There are obvious signs that a butterfly is about to emerge from its chrysalis when you begin to see the coloured embryonic wings showing distinctly through the skin casing a day or so beforehand. Only by regular checking, with your camera set up at the ready, will you catch the sequence; Murphy's Law dictates it will happen when you get up to make a cup of coffee. Moth pupae emergence is slightly harder to predict; there is some darkening of the skin, but with silkmoths in a cocoon this is impossible to see.

THE PERFECT INSECT

After emergence, butterflies hang upside down and the wings expand slowly, as gentle rhythmic body movements help pump the wing veins full of fluid. Adults will hang for several hours in perfect condition drying their wings – an ideal time to photograph them – but you must take care not to disturb them.

Sphinx moths and other moth species hatch on the ground and must not be hung up. After emergence they will climb, so you should provide twigs – or, better still, corrugated cardboard – in the aquarium tank or wherever they emerge.

TWO-TAILED PASHA
(Charaxes jasius)

The emergence of any butterfly will keep you spell-bound, but when the creature is as striking as the two-tailed pasha it can be hard to remember to press the shutter release. The pupa (far left, below) darkens just before emergence, clearly showing wing patterns. The wings expand slowly over a period of an hour or so when you must be very careful not to disturb the insect.
📷 *Nikon F4, 105mm f/2.8 macro, 1/60 sec. at f/16, Fujichrome Velvia, SB21B macroflash*

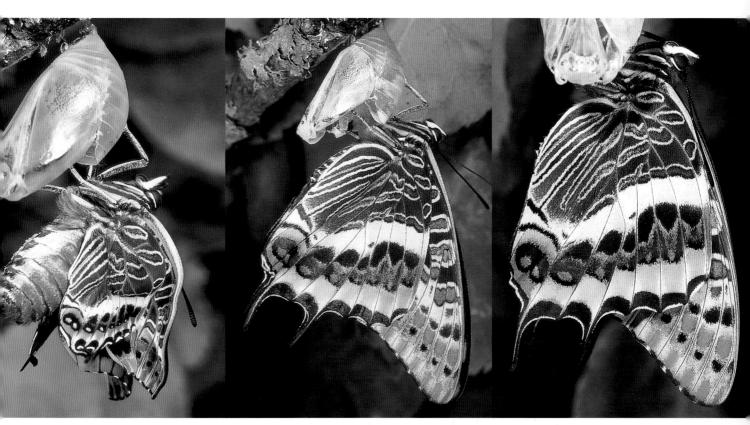

Insect details

At magnifications greater than life-size, you begin to enter the world of the insect itself. Larger insects are not difficult to photograph, provided you do it at times when the subjects are indolent, which means choosing times towards the beginning and end of the day, when insects are resting or feeding.

Often, having managed to get a photograph of an entire insect feeding, I move progressively closer, trying my luck. It is during such close-ups that patterns move from the recognizable to the abstract.

I find it easier to get close-ups in the wild of dragonflies, butterflies, wasps and hornets, for example, late in the season when lower temperatures (usually at the end of a sunny day) ensure they are far less active.

In the studio, insects warm up and become more active all too rapidly: they need to be on a twig in a jar or held by a small 'helping hands' stand (see page 107), because it is easier to focus this by moving or rotating to get the view you want.

INSECT EYES

The compound eyes of insects are incredibly diverse. Many of them are made up of a tessellating pattern of equal-sized hexagonal facets, and getting these pin-sharp is a test for any macro photographer and his or her lens. The camera must be rigidly secured using a stand or tripod and focused using a rack and pinion on a bellows or focusing slide (or move the subject in the

HORNET
(Vespa crabro)

A macroflash with twin tubes provided beautifully balanced light. I had no idea in advance whether the flash tubes would be visible in the eyes. Eventually I changed the lighting ratio, using a built-in diffuser to get a ratio of 1:4.
📷 *Nikon F4, Olympus 80mm f/4 macro on bellows, 1/60 sec. at f/16, Fujichrome Velvia, SB21B macroflash*

DRAGONFLY EYES
(Aeshna cyanea)

The eyes of the southern hawker dragonfly reveal changing blue reflections when lit from the right angle.
📷 *Nikon F4, 105mm f/2.8 macro, 1/60 sec. at f/16, Fujichrome Velvia, SB21B macroflash*

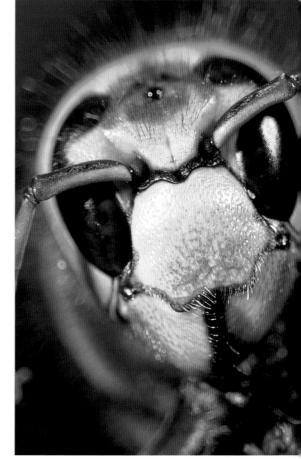

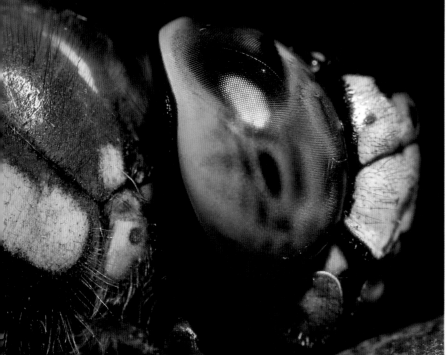

same way). The eye surface will be curved and the edges out of focus when the centre is sharp, even at small apertures; all you can do is change focus slightly and repeatedly until you make the best of the picture.

If you use twin flash units, then it is very easy to overlook the fact that you will produce unnatural-looking twin reflections. Diffuse the light with tissue paper or use a single flash to prevent this from happening (see page 43).

Some insects have highly reflective eyes in which you see coloured reflections as you change your angle of view. Some large hawker dragonflies, for example, show a range of blues whereas several genera of horseflies reveal bright rainbow reflections.

DAMSELFLY WINGS
(Agrion splendens)

I liked the shapes made by the thorax and wings of this banded agrion damselfly.

📷 *Nikon F100, Olympus 80mm f/4 macro on bellows, 1/60 sec. at f/16, Fujichrome Velvia, SB21B macroflash*

ROBIN MOTH BODY
(Hyalophora cecropia)

Many large moths have hairy bodies – the robin moth looks like a chequered carpet when the abdomen is isolated in close-up.

📷 *Nikon F4, 105mm f/2.8 macro plus x1.4 converter, 1/60 sec. at f/16, Fujichrome Velvia, SB29s macroflash*

WING STRUCTURES

Insect wings are extraordinarily beautiful. True flies and dragonflies have veined wings, and close-up photography can bring out the geometry of main and subsidiary veins. The surfaces are often reflective, and careful sidelighting can emphasize this. Dark field illumination (see page 78) can reveal vein and surface detail in a dramatic way.

Butterfly wings have fascinated me since childhood when the Christmas gift of a microscope and the discovery of an ancient case of tropical butterflies, ravaged by museum beetles, provided some wings for study. The wing patterns are made from innumerable tiny fan-shaped scales, and macro photography can reveal how eyespots are made or how the brilliant blue sheen of morpho butterflies is created as lighting angle changes. In Victorian times, when every middle-class home had its brass microscope, microscopists (a curiously obsessive bunch) arranged these scales individually using a very fine squirrel-hair brush to create nursery rhyme scenes or flower pictures.

Groups of scales can easily be discerned at life-size magnification. To pick out scale shapes and reveal the structure of eyespots on wings, magnification needs to be increased to 2 to 3 times life-size: I have achieved this with a butterfly wing on a flatbed scanner

(see page 148). At higher magnifications – x10 and beyond – the individual scales and their intricate fan shapes are easily visible.

ANTENNAE, WINGS AND WING CASES

Other parts of the insect anatomy provide macro subjects – antennae, for example. The large male silk-moths have feathery antennae, marvels of chemical detection capable of picking up single molecules of the female sex hormones (pheromones). Beetle wing cases (elytera), especially those showing iridescence, and insect legs all make intriguing shots. Just take time to search them out: a trip around the garden will reveal not only live insect subjects in any spider web in a quiet corner but also wings and the hard parts that the spider cannot eat but which you, the photographer, can turn into something intriguing.

JUNGLE NYMPH BODY
(Heteropteryx dilata)

The close-up lens reveals sharp spines all over the body of the jungle nymph.

📷 *Nikon F4, 105mm f/2.8 macro, 1/60 sec. at f/16, Fujichrome Velvia, SB21B macroflash*

Reptiles and amphibians

Many shots of reptiles and amphibians have to be planned knowing exactly where the creatures live and when they come out. A great many still pictures and most filming takes place after the animals have been moved to a vivarium built for these purposes.

VIVARIA

Shy creatures can be temporarily housed in a vivarium. This can be an aquarium tank or a commercial vivarium enclosure – but it is easy to build your own. Essentially, a vivarium is a box made from plywood that has been well sealed with varnish to make it damp-proof, since you may want to place peat, rocks and damp wood inside to produce a backdrop that is as close to nature as possible. One long side is made from glass that fits in slots and can be carefully raised both to avoid reflections and to give access to the inside. A lid, with a lamp to act as heater, completes it.

If you have no home or studio facilities to photograph reptiles, then zoos and aquaria open to the public often have days reserved for photographers. There you get a better chance to photograph species that you might not see without the co-operation of their handlers.

REPTILES

Snakes more than any other creature, except perhaps spiders, arouse deep-seated loathing in human beings. In close-up, however, their bright-eyed faces, forked tongues and skin patterns reveal considerable beauty.

CHINESE WATER DRAGON
(Physignathus cocincinus)

To capture detail, I often use a medium telephoto zoom lens, first to capture the whole creature and then to isolate the head region.
📷 *Nikon F4, 80–210mm f/2.8 zoom, 1/60 sec. at f/16, Fujichrome Velvia, SB25 speedlight*

GABON VIPER WITH PREY
(Bitis gabonicus)

Venomous creatures need skilled handling. The Gabon viper appeared to be unconscious until a dead rat was held above its cage, when it struck with lightning speed.
📷 *Nikon F4, 105mm f/2.8 macro, 1/60 sec. at f/16, Fujichrome Velvia, SB29s macroflash*

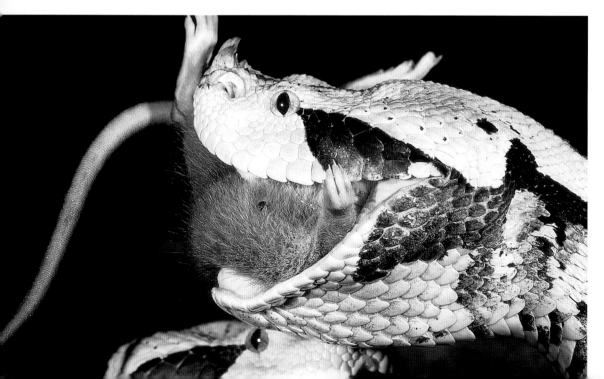

It might sound like a truism to say that care is needed when dealing with any venomous subject, but it is easy to get preoccupied with what you see in the viewfinder and to forget how close it is to you. Even with the relative security of long-focus lenses, your hands are within easy striking distance of a large snake as you manipulate the camera controls. This is one time when you really need to work with an assistant – preferably someone with expert knowledge of handling reptiles.

Like most wild creatures, snakes are far more wary of you than you are of them – but once you enter that circle of fear, intentionally or in error, they will act defensively. Stay outside and you can photograph calmly.

Those dramatic photographs of striking rattlesnakes or spitting cobras are usually obtained with a sheet of glass separating the subject from the camera. If the subject is indoors in a vivarium, then you can use the same lighting and reflection control as with an aquarium (see page 112). Outdoors you can use a black cloth or piece of velvet to cover the camera and the rear surface of the glass to prevent reflections, like an old-fashioned plate camera.

In the wild, many lizards bask at the end of the day, catching the last rays of the sun before nightfall. They are often territorial and this is a good time to visit rocks, sandy areas or tree trunks where you may have spotted them earlier in the day before they scuttle into some hole or other refuge. I often use a telephoto with close focus to enable me to approach lizards and get portrait shots; the heads and scales revealed can take you back millions of years to times when reptiles ruled the planet.

AMPHIBIANS

Amphibians, such as frogs, toads, newts and salamanders are easiest to find in the breeding and egg-laying season when they return to water. This is the best time, for example, to locate treefrogs that are vocal but extremely well-camouflaged and out of reach. The eggs and the tadpole stage need to be photographed in an aquarium.

Treefrogs are, to my mind, some of the most photogenic of subjects and can often be found on vegetation near water at breeding time. In tropical forests there are numerous vividly coloured species of frogs, some of which live and breed in bromeliad plants. The so-called 'poison arrow' frogs are the best known examples, but in the wild they metabolize neurotoxins in their food and can secrete these through the skin. They might be photogenic but they need expert handling with rubber gloves.

Many reptiles and amphibians are nocturnally active: with frogs, for example, it pays to follow the

calls and go out looking at night. An assistant can hold a flashlight to enable you to focus while you take the picture using a TTL flash. A diffuser over the flash head is essential, since many frogs have damp skin and hot-spot reflections may appear.

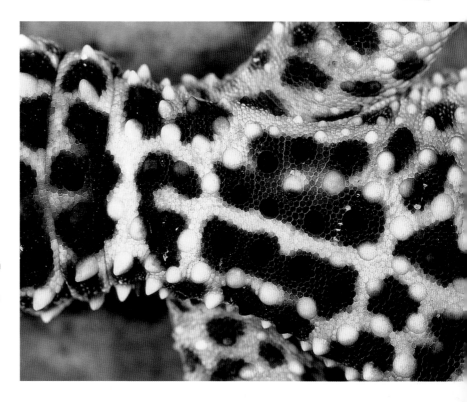

LEOPARD GECKO
(Eublepharius macularius)

The close-up lens reveals the texture of the gecko's skin.
📷 *Nikon F4, 105mm f/2.8 macro, 1/60 sec. at f/16, Fujichrome Velvia, SB21B macroflash*

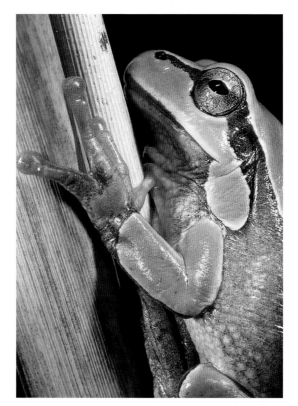

TREEFROG *(Hyla arborea)*

Treefrogs make an inordinate amount of noise given their small size (about 25mm). At night, enlist the help of an assistant to hold a flashlight so that you can see to focus.
📷 *Nikon F4, 105mm f/2.8 macro, 1/60 sec. at f/16, Fujichrome Velvia, SB21B macroflash*

Water droplets

Rivers, streams, lakes and waves provide a source of pictures for the landscape photographer, but water photographed on a small scale provides some equally intriguing possibilities.

DEW AND RAINDROPS

Morning dew delineating a spider web provides one of those classic nature subjects that we all try to photograph at some time or other. The secret is often to use a narrow depth of field (a wide aperture), so that the background is completely out of focus and does not distract from the delicacy of the web structure. Backlighting from the low-angled morning sun makes the droplets sparkle like jewels.

The eighteenth-century French painter, Pierre Joseph Redouté, made raindrops on rose petals a trademark in his detailed studies of roses. A mist of droplets can impart a definite freshness to subjects, but it is easy to overdo the effect. Before you try your hand with an atomizing spray, look carefully at how nature does the job with early-morning dew or raindrops.

WATER DROPLETS AS LENSES

If you look very closely at raindrops, you may see tiny images of flowers or leaves behind them. The droplet acts as a lens with a very short focus and produces an inverted image: it is almost like a fisheye lens and all sorts of extraneous detail can appear at the edges. Moving the subject behind the drop changes the size of the inverted image while several drops close together will produce a series of images.

However, when you get up close, the image in the drop and the grass blade or flower that it is on are not quite in the same place: it is important to have the image in the drop sharp and you have to experiment with the stop-down lever to make the best use of the available depth of field.

A line of raindrops can be photographed in a single shot using a macro lens that will give you 1:1 reproduction. For shots where one droplet dominates, you have to enter the macro realm with images of x3 magnification and more.

FORMING DROPS

You can go out on a rainy day looking for droplets that have collected on twigs or at leaf tips, but they will seldom be in the right place and the slightest disturbance will dislodge them. It is easier to construct your own imaging system by placing a twig just a few centimetres or so in front of your subject. In theory, if you spray or wet the twig, then droplets will form. It is easier to use a dropper and gently squeeze: control is difficult and persistence is essential.

In film making, plants are often sprayed with a mixture of one part by volume of glycerine to one part water. This is also a useful mix for creating your own 'raindrops', since the higher viscosity and different surface tension compared with pure water create larger, more stable droplets.

GERBERA FLOWER IN RAINDROP

When water droplets are used as lenses, the droplet and the image are close but not coincident – so you have to experiment, changing focus slightly and checking the depth of field to make sure that both lie within the realm of sharp focus.

 Nikon D100, Olympus 80mm f/4 macro on bellows, 1/250 sec. at f/16, ISO 200

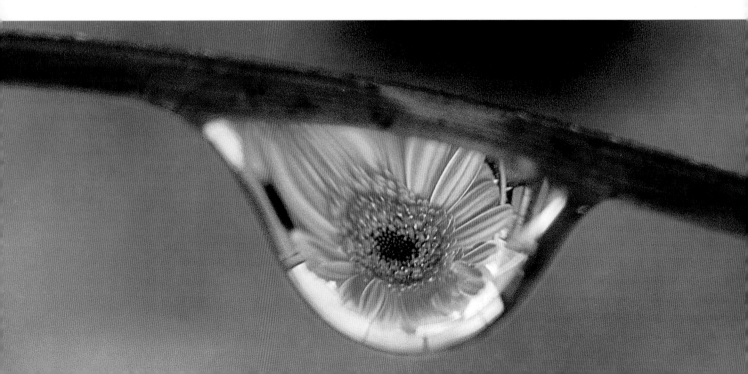

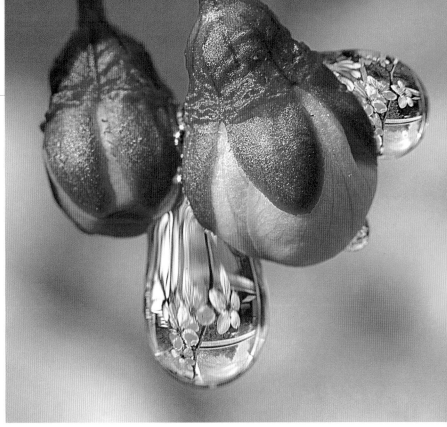

CHERRY BLOSSOM
(Prunus species)

Although the cherry blossom dominates the image (above), the water droplet lens has such a wide field of view that it has included the spars of the glass house. As droplets are sensitive to the slightest vibration, you may want to use a small stand to hold a twig with a water droplet in front of the flower to be imaged (left).

📷 *Nikon D100, Olympus 80mm f/4 macro on bellows, 1/250 sec. at f/16, ISO 200*

LIGHTING

Any form of artificial lighting is tricky at first, because you have to light the background and then avoid creating distracting reflections on the drop surface. If you are using tungsten lamps or sunlight where you can see what is happening, then you can fit a polarising filter to the lens front and eliminate the reflections. When you photograph a water droplet using a flash, it can create tiny but perfect images of the flash tube that you do not see until the slide is projected. These might be tolerable, but the twin bars of a macro flash appear unnatural. One solution is to use one tube, preferably diffused, or to experiment with a polarising filter.

Daylight, either in the field or with a camera set-up in a conservatory, provides far better lighting quality but the drops act as 'vibration detectors', quivering with the slightest breeze or movement.

LIGHTING SUGGESTIONS

The diagram shows suggested starting points for lighting. The acute lighting of the drop itself makes it less likely that rays will be reflected from the surface into the lens. Arrows marked 'A' show the light directed at the star drop; arrows marked 'B' show the lighting of the background on which the star drop image will fall.

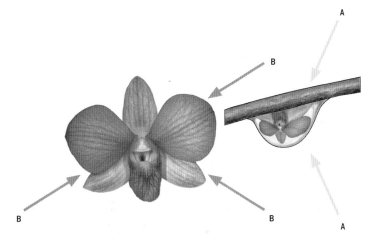

Life in pools

Ponds, streams and rock pools provide an endless source of fascination for the child within us all. Many larger aquatic creatures, both marine and freshwater, can be photographed without expensive underwater housings and scuba gear. The smaller creatures are best dealt with in a 'micro-aquarium' (see page 112).

PHOTOGRAPHING INTO WATER

As a prerequisite, you need still water surfaces and clear water. The problems centre on light reflections from the surface and how to get rid of them.

The simplest way to start is to set the camera on its tripod looking vertically down into the water. The camera back needs to be parallel to the water surface. Holding a black cloth or umbrella above the camera, or even shading the surface with dark clothes as you lean over the camera, can cut virtually all upward reflection from the water surface. Remember to keep checking the corners of the viewfinder for reflections that appear as you move. This approach works well on cloudy days, too, when there is no strong direction of the light and surface reflection becomes potentially more awkward to control.

USING FLASH

When light levels are low, a flash gun can provide excellent illumination from above the surface in shallow water such as in rock pools. As with daylight, a flash

HERMIT CRAB
(Eupagurus berhardus)

This picture was taken in a rock pool, using a viewing tube with a glass end.
📷 *Nikon F4, 105mm f/2.8 macro, 1/60 sec. at f/11, Fujichrome Velvia, SB24 speedlight*

gun can create reflections from the surface but these are easy to miss until the film is processed and the tell-tale hot spots are all too visible.

You can avoid reflections if you use a flash gun (with a diffuser to spread its light) held away from the camera at at least 45° to the water surface, so that none of its light is reflected into the lens. In practice, with a TTL flash system you might that find you need to increase exposure by about 2/3 of a stop to compensate for light absorption.

THE BREWSTER ANGLE

A camera can be used from the side with a polarising filter to make surface reflections disappear. The effect is most pronounced when the camera is held at 53° (the Brewster angle) to the vertical position, since the degree of polarisation is greatest and most reflected light can then be cut (see page 155).

VIEWING TUBES

Sometimes the water is not as clear as you would like, as organic and inorganic materials can come between your and your subject. For example, you can easily disturb bottom material in a rock pool or pond if you are standing in the water, or the water might be full of tiny planktonic forms, darting about like tiny motes in a sunbeam. In these situations, you can reduce the

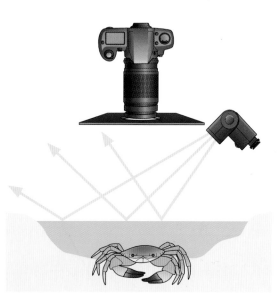

ANGLE OF FLASH

You can avoid reflections if you use a flash gun with a diffuser held away from the camera at at least 45° to the water surface so that none of its light is reflected into the camera lens.

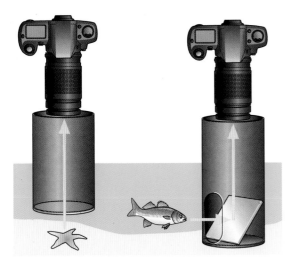

VIEWING TUBE AND PERISCOPE

If the water is full of tiny life-forms, use a viewing tube with a glass window at the bottom end to reduce the depth between you and your subject (left). A periscope (right) is a viewing tube with a mirror set at 45° at the lower end and a clear 'window' in the tube.

depth of water between you and the subject by using a viewing tube. This is easy to make from a length of plastic drain piping painted matt black inside (or, better still, lined with flock paper) and with a glass window cemented and sealed with silicone aquarium cement at the bottom end: the camera is held at the top. Ordinary picture glass will do and can be cut to fit by a local supplier.

BELOW THE SURFACE

Hermit crabs, shrimps and sea anemones make intriguing rock-pool subjects, but the view from above can be restrictive. In shallow water, it is still possible to take pictures underwater without a camera housing.

PERISCOPES

For the gadgeteer, one answer is to use a periscope – a variation on the viewing tube described above. The end that goes in the water is sealed and you need a single flat mirror – it must be front-silvered, and of good optical quality. These can be obtained from suppliers ` or from ex-army equipment dealers.

UNDERWATER HOUSINGS

If you are going to do a lot of beach work, it might be worth purchasing an acrylic housing for your camera or even a waterproof cape to protect it from the corrosive effects of both salt water and of salt- and sand-laden wind (see page 111).

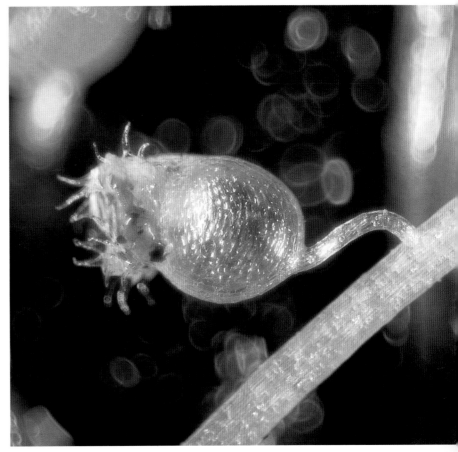

BLADDERWORT
(Utricularia sandersonii)

The tiny bladders of *Utricularia* (bladderwort) are sophisticated traps with a hair trigger and hydraulic system acting in less than 1/500 second.

📷 *Nikon D100, Canon 20mm f/3.5 macro on bellows, 1/4 sec. at f/8, ISO 200, twin tungsten lamps*

USING A GLASS TANK

An excellent method for medium-format cameras with a waist-level viewfinder, or for cine and video cameras, is to place the camera in a small fish tank with its lens front up against the glass wall to avoid reflections of the camera. The maximum depth is limited by the depth of the tank, but it works well in shallow streams. It goes without saying that great care is needed to make sure no water rises up over the sides.

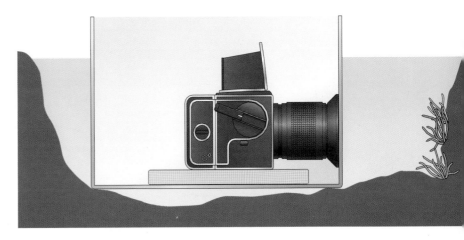

Underwater

Many highly photogenic marine subjects live on and around rocks close to shore or on coral reefs. Although we are used to seeing images of larger fish and other marine creatures, many of the smaller inhabitants, from fish to live corals, anemones and multi-coloured sea slugs are equally fascinating and make stunning close-up subjects. Fish become inquisitive to the point of being tame and marine subjects are not as easily scared as terrestrial animals when you are in their submarine world.

STAR SEA SQUIRT
(Botryllus schlosseri)

Adults of this species of sea squirt live encrusted on rocks, where they form colonies. The larval stage is free swimming.
📷 *Nikon 801 (in Subal housing), 60 mm f/2.8 AF macro, 1/125 sec. at f/16, Fujichrome Velvia, two Sea & Sea YS50 flashguns*

Besides a camera and housing, all you need in shallow water is the basic equipment for snorkelling – a good mask, snorkel, fins, a weight belt to achieve neutral buoyancy and a wet suit if you intend to spend any length of time in cold water.

Work that involves diving to significant depths demands a significant investment in both equipment and training before you can practise it safely.

EQUIPMENT

There are many simple 'disposable' cameras that can be used to experiment underwater. They are of limited use for close-up work, but many people are bitten with a bug for underwater photography after taking pictures with them.

Cameras such as the Nikonos, and models from Sea & Sea, are designed to be used underwater without a special housing. They offer a full range of lenses and flash guns and connections are sealed with O-rings to ensure they are fully waterproof.

UNDERWATER HOUSINGS

The most sophisticated underwater housings are specially engineered for particular makes and models of camera. But in depths to around 10 metres, flexible housings such as those made by Ewa-marine are ideal for close-up work.

Many divers have discovered the benefits of digital photography. Not only are the pictures bright and punchy, but you can take many more shots without returning to the surface to change film. 35mm film is limited to 36 exposures: with a 512MB memory card, on the other hand, you can capture more than 140 high-resolution JPEG files.

For focusing with close-ups, it is useful to have cameras with a 'high point' viewfinder – that is, one where you see the full image with the eye a short

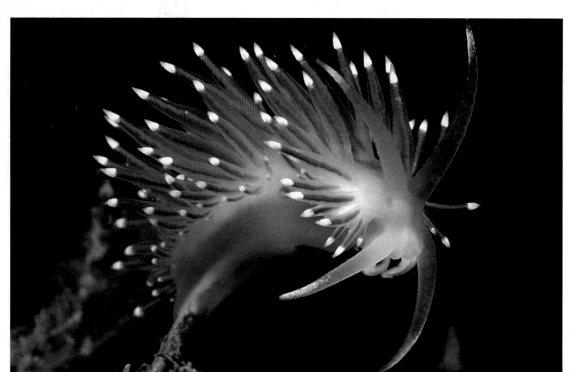

NUDIBRANCH SEA SLUG
(Coryphella browni)

Sea slugs are among the most colourful of invertebrate creatures. Many of them are less than 25mm long, some much smaller. They are carnivorous, with their tastes often confined to a particular hydroid – if that is located then a search might reveal the nudibranch.
📷 *Nikon 801 (in Subal housing), 60 mm f/2.8 AF macro, 1/125 sec. at f/16, Fujichrome Velvia, two Sea & Sea YS50 flashguns*

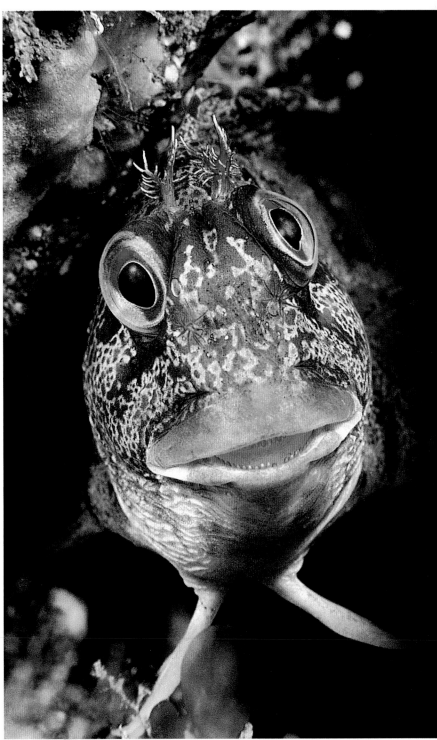

distance from the viewfinder. A 24mm or wider-angle lens can allow you to take underwater landscapes with great depth of field. Up to about 4 metres below the surface in clear water, there is enough natural light to retain foreground colour. If you plan to go deeper than this, you will need to use a flash with sufficient coverage.

It is very tempting to brace yourself against something when using a macro lens, but this must be avoided at all costs: coral breaks so easily and damage is easily done.

FLASH SYSTEMS

A TTL flash system is a godsend underwater, where there is often little light. A housing that takes a 35mm camera with 50–60mm AF macro and a flash is a versatile piece of equipment for close-up work: if it has small waterproof flash guns attached, it is even better. The flash brings out strong colours that you did not appreciate underwater. You can use the system exactly as you would a terrestrial macro system.

SALT-WATER CAMERA DAMAGE

Care has to become second nature when you take photographs underwater, as salt water and electronics do not mix: faulty O-rings beneath the surface spell disaster, as does accidentally dropping equipment into salt water. The usual advice is to immerse the equipment in a bucket of fresh water as soon as possible to wash off the salt and then take it for repair. But the bills could prove to be astronomical and electronic equipment might still be a write-off, so it pays to be fully insured.

TOMPOT BLENNY
(Parablennius gattorugine)

Fish are generally inquisitive when you are in their environment. For lighting, arrange flash guns to point just beyond the subject as you see it in the viewfinder – that is where the subject really is: you see its apparent position because of refraction of light by the water/glass/air surfaces in your mask and camera.

📷 *Nikon 801 (in Subal housing), 60mm f/2.8 AF macro, 1/125 sec. at f/16, Fujichrome Velvia, two Sea & Sea YS50 flashguns*

Aquaria

In all aquarium photography, the first objective must be to eliminate the disconcerting reflection of your camera and lens in the glass front of the tank.

The diagrams here show how this can be done, using either a large lens hood or a black velvet drape with a hole in it through which the lens protrudes. My lens hood is made from the rain collector from the top of a drainpipe sprayed matt black. This is pressed against the aquarium glass; there are no reflections from either the lens or the guns. Paired flash guns are used to the sides of the hood.

A glass tank can be successfully lit from above or through the sides, depending on the effect you want to create; you have only to visit the best commercial aquaria or displays in stores for the aquarist to see how effective this can be.

FRAMING THE FISH

When you set up your camera in front of a tank, fish can swim in and out of focus and rapidly disappear altogether from the frame. I like to use a zoom lens so that in a large aquarium there is some chance of being able to frame the subject and follow it. At home, you can carefully restrict the movement of fish, large and small, by placing sheets of glass in the aquarium without causing them undue distress.

PHOTOGRAPHING IN A TANK

The large drain-pipe hood is pressed against the tank glass, eliminating surface reflections – a black velvet drape with a hole cut for the lens would do the same. Twin flashguns provide a good light source, although tungsten lamps are useful for focusing, and you need not switch them off – the flashes are much more powerful and override them at the point when the picture is taken.

THE MICRO-AQUARIUM

With small aquatic life-forms or animals that live on fronds of weed, it is better to use a small aquarium built for the purpose – a 'micro-aquarium'. When there is too great a depth of water between camera lens and subject, it is almost impossible to find what you are searching for.

I have several micro-aquaria of different sizes, the smallest being made from pairs of microscope slides. Standard microscope slides are 7.5 x 2.5cm and are made from a higher-quality glass than picture glass, which has a distinct green colour when you look at a cut edge. They can be used in pairs, separated by a piece of Plexiglas (acrylic) material cut as shown in the diagram.

Your local DIY store can cut glass for you, but it is useful to have one of the faces made from special optical glass (the windows available from optics firms such as Edmund Scientific). Sides can be made from polycarbonate or acrylic sheet. Stores catering for the hobby aquarist sell silicone cements for bonding the sides. Sides are best assembled in pairs using a tri-square or set-square to join them at right angles.

PHOTOGRAPHY WITH A MICRO AQUARIUM

A micro-aquarium can be made with two glass sides separated by Plexiglas (acrylic) or a bent U-shaped rubber tube: the glass faces are secured with rubber bands to form a water-tight seal. In the above diagram, the tank is lit from above, eliminating flash reflections from the glass, and a dark background is placed behind. Lighting from behind can create a form of dark field illumination (see page 78).

SUBJECT WELFARE

All aquatic plants and animals need care when removed from their natural habitat, even if it is for only a short time. Water quickly becomes warm and de-oxygenated and you should return the inhabitants of your aquarium to their habitat as soon as possible.

AT THE LIMITS

A tank that you treat as an indoor pond allowing algae to grow and small organisms to proliferate might be anathema to the aquarist, but it provides an endless source of material for the true macro realm. In fact, small photogenic organisms in the realm between macro and the true microscopic are everywhere: if you take a handful of dry hay and soak it in fresh water, tiny creatures appear as if by magic. Early biologists called these 'infusoria' and thought they were created spontaneously. In fact, they hatch from a cyst stage adapted to survive winter or dry periods. Even a small amount of semi–decayed leaf matter from a damp roof gutter can yield some subjects such as tiny blood worms and semi-transparent creatures called rotifers or 'wheel animals', all of which are seen at their best with dark field illumination (see page 78).

WATER FLEA
(Cyclops sp.)

To photograph these tiny little organisms you need a macroscope or low-powered microscope: they never seem to stay still and it is easiest to use flash and to release the shutter when one comes into view.

📷 *Nikon D100, 20mm f/3.5 Canon macro. 1/125 sec. at f/5.6, SB23 flash used manually after test exposures*

Plants in the landscape

The techniques of landscape and close-up photography meet when, for example, you use groups of flowers or rocks in the foreground to add interest and act as a device for leading the eye into the frame. Setting a plant in the context of the surrounding landscape captures information about the habitat as well as about the shape and growth characteristics of the subject.

The close-focusing abilities of a wide-angle lens (see page 58) make it ideal for this kind of work. A low viewpoint can often give a picture greater impact. This involves lying on the ground and using a low tripod or camera bag as a support. Alternatively, you can look from above the camera using a right-angled viewfinder with a 35mm camera or the standard waist-level viewfinder with a medium-format camera.

HYPERFOCAL DISTANCE

These photos show the depth-of-field and aperture scales on a wide-angle lens. The left-hand picture shows the infinity mark opposite the point of sharpest focus. On the right, the focus ring has been moved until the infinity mark is opposite f/16; sharpest focus is at about 1.8m, but the other limit of the scale is at 1.0m. At this setting, the lens can capture everything from about 1.0m to infinity sharply.

TREE SHAPES

While whole trees are arguably not close-up subjects, leaves, branches, flowers and fruits can all be used to create foreground interest or to act as 'frames' in a composition (see page 124). In winter, the skeletal nature of bare deciduous trees makes arrangements of branches and twigs more obvious: simply by moving the camera position and zooming in or out, you can isolate elements and emphasize geometrical patterns.

PERSPECTIVE DISTORTION

A wide-angle lens used at close quarters distorts perspective. Parts closest to the lens are exaggerated: the more extreme the wide angle, the more pronounced the effect. With flowers, this distortion gives impact – perhaps because flowers have evolved as 'beacons' for pollinators and we also happen to notice them first. With animals, the effect has to be used cautiously, but it can create startling results.

ALPINE FLOWERS

Vivid colour displays are often made by alpine flowers. Exaggerating the perspective slightly with a wide-angle lens gives the picture a lot more impact.
📷 *Nikon F4, 24mm f/2.8 wide angle with circular polarising filter, 1/60 sec. at f/11, Fujichrome Velvia*

DEPTH OF FIELD AND HYPERFOCAL DISTANCE

To set a flowering plant or tree in the landscape, it helps to understand depth of field – how to make the best use of it and its limitations.

A depth-of-view preview button (see page 15) is useful when judging the extent of the depth of field, as the lens is stopped down to its taking aperture. The field of view gets decidedly darker, but you will see more appear in focus behind and in front of the subject as your eye gets used to the low light intensity.

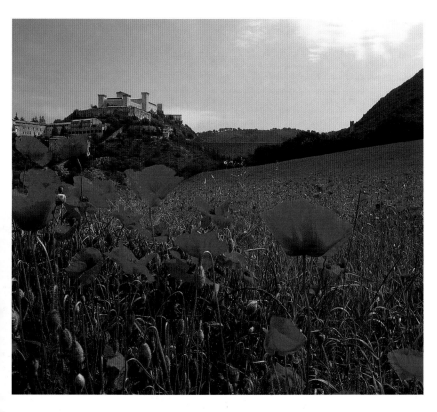

Modern agricultural methods mean weed-free crops, but displays can still be found at field edges. A low viewpoint and wide-angle lens imply that flowers fill the landscape.

📷 *Mamiya 645 Pro TL, 45mm f/2.8 with linear polarising filter, 1/30 sec. at f/16, Fujichrome Velvia*

There is a more technical way of maximizing depth of field. The lenses for manual focus 35mm SLRs and rangefinder cameras, as well as medium-format and all larger format lenses, have a depth-of-field scale engraved on the lens barrel. The limits of the depth of field at different apertures can be read either side of the sharp focus mark and help determine what is called the hyperfocal distance.

FINDING THE HYPERFOCAL DISTANCE

The depth-of-field scale extends either side of the focus mark and is engraved with a set of aperture numbers. One end marks the far limit of sharp focus and the other the closest for a given aperture. If you want your subject and background in focus all the way to infinity, first move the infinity mark until it is opposite the far limit. The other end of the scale now marks the closest limit. The point at which the lens is now focused when you look through it is the hyperfocal distance. Everything from halfway between you and this point and infinity is in focus.

In practice, you should adjust your position and carefully choose the aperture that places your subject at the nearest point of sharp focus. In reality, with practice you focus just beyond the subject and check that the subject is sharp by using the stop-down preview. Sharp focus may not extend to infinity; in fact, with mountains this slight blur accentuates the foreground and the background is still recognizable.

POPPIES
(Papaver rhoeas)

Flowers can be used to set the scene in landscape or travel shot – and none more so than scarlet poppies. Always shoot whenever you see a scene like this – hay can be cut in a matter of days and the next year the display may not be the same.

📷 *Mamiya 645 Pro TL, 45mm f/2.8 with linear polarising filter, 1/60 sec. at f/11, Fujichrome Velvia*

CORN MARIGOLDS
(Chrysanthemum segetum)

Whenever I am faced with blue skies and contrasting colours such as the yellow of corn marigolds, I use a polarising filter. It deepens the blue of the sky and eliminates surface reflections from the flowers, making the yellow appear deeper and clearer.

📷 *Nikon F4, 28mm f/2.8 with circular polarising filter, 1/60 sec. at f/11, Fujichrome Velvia*

Flowers and fruits

Good flower portraits can be taken with any lens that has the close-focus capability to produce the size of image you want. For smaller flowers you will need a macro lens; but for larger, single flowers, such as roses or gladioli, or for groups of flowers, then a mid-range zoom will do the job just as well.

IRIS FLOWER
(Iris pseudopumila)

A portrait of a single flower, or perhaps just two flowers, concentrates the eye on the design of a bloom. To my mind, irises are some of the loveliest of all flowers – the dwarf wild irises winning top prize. This photograph was one of a series taken on a hillside in Gargano, southern Italy, where blooms grew in white, cream, yellow, blue and even brown.
📷 *Nikon F4, 60mm f/2.8 macro, 1/60 sec. at f/16, Fujichrome Velvia, SB29s macroflash*

Your lens choice might depend on how you want the background to appear. Telephotos can isolate a flower from the background to give a portrait set against a soft blur: wide-angle lenses can be used to set a flower in the context of its habitat (see page 114).

If you are going to use your work in slide shows or show it to publishers, it is important to vary the way you take flower portraits; otherwise your shots begin to show a characteristic sameness. It is good to have a personal style, but too much spells boredom.

FRAMING

Single-flower pictures can look very dramatic. It is worth adjusting your viewpoint to fit the field of view and then moving closer so that the frame is over-filled – perhaps placing the flower centre according to the rule of thirds (see page 124).

PATTERNS

By framing a subject to include two or more flowers, you can both create a more interesting portrait and convey more information, especially if one flower is viewed face on and the other offers a side or partial side view.

However, you will create greater visual impact if you select a flower group that makes a shape – a circle, ellipse or triangle, for example – or where flowers are arranged along a diagonal or a curve that flows through the picture (see page 126).

MONKEY ORCHIDS
(Orchis simia)

Moving in close often reveals bizarre forms. One of my favourite flowers is the monkey orchid: the third petal or 'lip' is divided to give arms, legs and a tail.
📷 *Nikon F4, 105mm f/2.8 macro, 1/60 sec. at f/16, Fujichrome Velvia, SB29s macroflash*

VIEWPOINTS

Daisies and other radially symmetrical flowers are often photographed so that they appear flat, and you have to decide where to put them in the frame. Many flowers – and orchids are some of the biggest offenders in this respect – have a three-dimensionality that makes it hard to decide how best to photograph them. Having photographed literally thousands of orchid species, I now seldom take a full-frontal portrait. With small orchids you have limited depth of field, since you are using magnifications around life-size.

DIAGNOSTIC FEATURES

If you intend your pictures to be used to identify plants, you must include other parts of a plant, such as the leaves or tendrils, as diagnostic features.

WATER LILY
(Nymphaea 'Blue Beauty')

Detailed close-ups of water lilies are often possible only with a telephoto lens that has an integral close-focus or can be used with an extension tube.
📷 *Nikon F4, Sigma 300mm f/4 apo macro, 1/125 sec. at f/11, Fujichrome Provia*

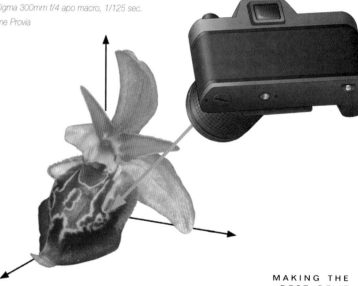

PHALAENOPSIS

Every orchid possesses a third petal or 'lip': the sheer variety of shape and form is astonishing and contributes to the appeal of orchids. The *Phalaenopsis* lip is a complicated structure that has evolved to assist in the pollination process.
📷 *Nikon F4, Sigma 180mm f/3.5 apo macro, 1/60 sec. at f/16, Fujichrome Velvia, SB29s macroflash*

FRUITS

Fruits such as berries can be as brightly coloured as any flower and are a source of stunning pictures: reds and other dark shades are often contrasted with green foliage to make the berries visible to the birds that eat the fruit and pass on the seeds through their feces.

Berries also have highly reflective surfaces. If you shoot them with flash, diffuse the light or risk ending up with unsightly 'hot spots'.

Many common flowers also have attractive fruit heads. Dandelions with their 'parachutes' and clematis with their feathery fruits work particularly well with backlighting to accentuate the structure and reveal tiny hairs on the edges of stems.

MAKING THE
BEST OF IT

To make the best use of the available depth of field, you need to imagine a plane that will contain most of what you want. A good start is to approach the flower from a plane at 30–45° to one side and then from above by the same angle.

Flower details and small plants

Close-up and macro photography are ideal for revealing plant and flower details such as stamens, parts of petals, seeds, hairs on stems and even the small creatures that live on and in flowers. Often, when you close in on familiar flowers, an isolated detail becomes a design in which shape, pattern, colours and textures are more important than the actual subject. The small, and often insignificant plants such as lichens, mosses and liverworts are easy to overlook – but as soon as you start to photograph plants at life- size and larger, all that changes and you will start to perceive opportunities for pictures everywhere.

POKEWEED FLOWERS
(Phytolacca pruinosa)

The fruit heads of pokeweed, with their almost black berries, are very distinctive. The flowers are a uniform red; I photographed them simply because they made a pleasing group.
📷 *Nikon F4, 60mm f/2.8 macro, 1/60 sec. at f/16, Fujichrome Velvia, SB29s macroflash*

LIGHTING FOR FLOWER DETAILS

When you intend to use a shallow depth of field that allows shutter speeds fast enough to avoid camera and subject shake (over 1/125 second), daylight is ideal. To give the picture the greatest impact, you then need to select the range of sharp focus (see page 153). For maximum depth of field, you will generally find that a flash setup (either macro flash or a single diffused gun) works best.

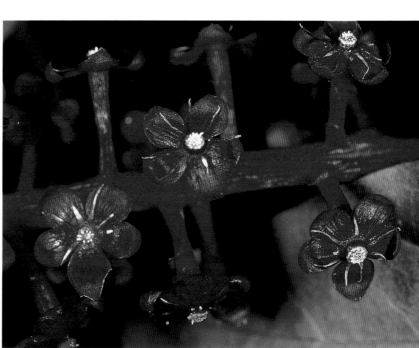

GLORIOSA LILY STAMENS
(Gloriosa speciosa)

The gloriosa lily has a pistil that bends sharply at right angles in a rather extravagantly coloured flower. The first stage is to isolate a flower; you then begin to see other possibilities in terms of shape and design.
📷 *Nikon F4, 60mm f/2.8 macro, 1/60 sec. at f/16, Fujichrome Velvia, SB29s macroflash*

HIBISCUS – PISTIL AND STAMENS
(Hibiscus rosa-sinensis)

Eliminating all but one of the petals of the hibiscus emphasizes the design of the stamens and pistils.
📷 *Nikon F4, 60mm f/2.8 macro, 160 sec. at f/16, Fujichrome Velvia, SB21B macroflash*

Flowers often benefit from some backlighting, which can emphasize the translucency of petals and accentuate edge details such as hairs. This can be achieved using a second small flash gun linked to the first by a TTL cord or simply triggered by the first flash.

GRASSES

Grass stems and seedheads are especially beautiful with a degree of backlighting from a low sun to emphasize the delicate hairs. Grass flowers are often overlooked, though noticeable by legions of hayfever sufferers. Through a magnifying glass, grass flowers show themselves to be very delicately structured. To photograph them, you need a magnification of around four times life-size and more. Indoor photography is the easiest course, since grass stamens are delicately attached and the slightest breeze moves them.

LICHENS AND MOSSES

Lichens and mosses are tiny, slow-growing plants that often create patterns as they spread; such patterns are large enough to be captured by any camera with a close-focus facility.

Mosses and lichens do not produce flowers, yet they have a delicate beauty close up, particularly when

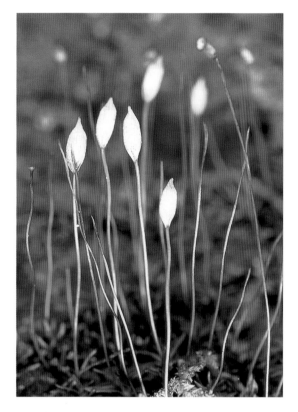

MOSS CAPSULES
(Ceratodon purpureus)

Fruiting bodies appear on many mosses in winter. Close examination reveals their delicate beauty.

📷 *Nikon F100, Sigma 180mm f/3.5 apo macro with x2 converter, Fujichrome Velvia, SB29s macroflash*

GRASS FLOWERS

As a hayfever sufferer with an allergy to grass pollens, it took a long time for me to be able to look at grass flowers with anything other than venom. As the photograph shows, they are delicate structures with yellow stamens finely suspended so that pollen can be scattered on the wind.

📷 *Nikon F801, Olympus 80mm f/4 macro on bellows, 1/60 sec. at f/16, Fujichrome Velvia, SB29s macroflash*

NETTLE HAIRS
(Urtica dioica)

When magnified, the hairs of a stinging nettle reveal a structure like a hypodermic needle, ready to penetrate the skin and exude the acidic cocktail that stings.

📷 *Nikon F801, Olympus 80mm f/4 macro on bellows, 1/60 sec. at f/16, Fujichrome Velvia, SB29s macroflash*

fruiting. This takes place in winter, when there are fewer subjects around to photograph.

Low afternoon sunlight with long shadows delineates the surface detail – especially in the crustose lichens on rocks and gravestones. Lichens make excellent natural-light close-up subjects: they are flat and firmly attached to rocks, and thus wind is never a problem.

Some lichen species have attractive scarlet cups as part of their fruiting bodies, while mosses have delicate capsules with textured surfaces. What you see at a cursory glance is just a forest of tiny, orange-brown stems. Mosses can form into attractive fern-like patterns as they grow or form tiny tight green cushions on rock surfaces. Some, such as the sphagnum mosses, can form thick dense mats of vegetation in which many other plants grow.

In the field, the best way to capture this level of detail is by using one lens reversed on to the front of another as a high-quality supplementary lens (see page 70). You can photograph the small subjects *in situ* by getting down to their level and resting the lens barrel on a bean bag. Focus by moving the whole camera unit carefully, in tiny stages.

If the moss or lichen is on a twig or stone, it is easier to set your camera firmly on a tripod and gently move the subject while looking through the viewfinder. I fix such subjects to a small gadget that has a heavy base and an arm on which two crocodile clips sit capable of holding a twig. This is the simplest possible 'optical bench', but it works.

Ferns and fungi

Although flowers might be the most obviously attractive items in the plant world, there are vast numbers of plants that do not produce flowers, such as ferns and fungi, and mosses and lichens (see page 119). Many of them have a secret beauty that is best revealed by moving in close with a camera.

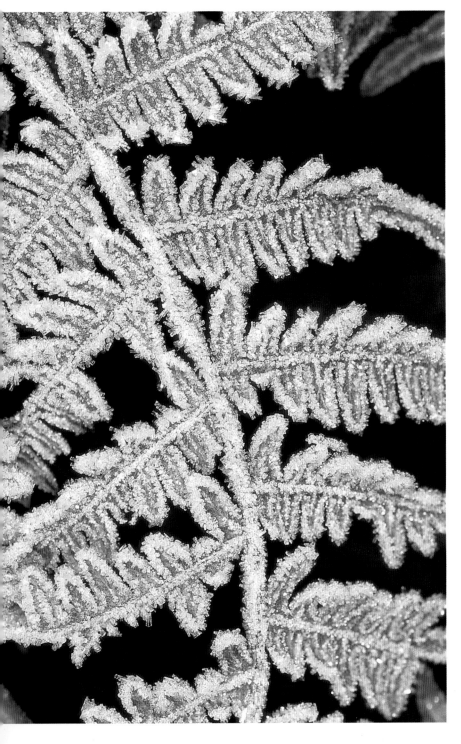

FERNS

Ferns are everywhere in moist woodlands. When the new growth first emerges, the unfurling fronds make an almost classic tight spiral design that is highly photogenic. Fern leaves are often divided and subdivided in a complex fashion, offering the possibilities of exploring patterns with a camera, while beneath the leaves the fruiting bodies produce spores that are true macro subjects.

FUNGI

Fungi show an astonishing diversity of size, form and colour, from large bracket fungi at one extreme to microscopic slime moulds at the other. Fungi are non-flowering plants and contain no chlorophyll: the parts we see above ground are just the fruiting bodies, while below ground are mycelia – the thread-like fungal growths that spread through the soil.

Many fungi grow in woodlands where light levels are low and exposures have to be long. However, most have strong stalks and sheltered habitats, so subject shake is almost eliminated. Fungal colours and tints are subtle, and best captured using natural light with a fill-in flash when the light is too low.

Highly reflective fungal surfaces create tell-tale 'hot spots' and any flash light needs to be heavily diffused to avoid this. Fungi look particularly impressive when viewed from below with a wide-angle lens, so you need a tripod capable of reaching low positions (see page 28). With pale-coloured fungi, backlighting can emphasize the gills beneath the cap, since the cap is translucent.

BRACKEN WITH FROST

Frost crystals form at edges of stems and leaves and they can delineate leaf structures effectively. Here they have formed on dry leaves of bracken.
📷 *Nikon F4, 60mm f/2.8 macro, 1/60 sec. at f/16, Fujichrome Velvia, SB21B macroflash*

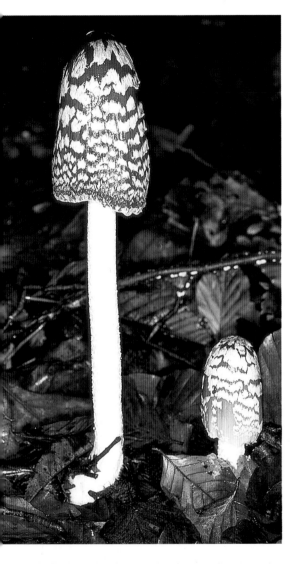

MAGPIE INKCAP
(Coprinus picaceus)

The magpie inkcap (left) grows in beech woods and I included several leaves in the picture to reveal the habitat.
📷 *Nikon F4, 50mm f/2.8 macro, 1/60 sec. at f/11, Fujichrome Velvia, SB29s macroflash*

TOADSTOOL COLONY
(Mycena inclinata)

In autumn, a mature log pile can suddenly start sprouting fungi as spores germinate in rotting logs (right).
📷 *Nikon F4, Sigma 180mm f/3.5 apo macro, 1/60 sec. at f/11, Fujichrome Velvia, SB23 twin flash with diffusers*

JEW'S EAR
(Auricularia auricula-judae)

The soft almost fleshy texture of the Jew's ear fungus makes it easily recognizable. Like many fungi, however, it has a reflective surface; when flash is used it is almost impossible to eliminate hot spots completely.
📷 *Nikon F4, 60mm f/2.8 macro, 1/60 sec. at f/16, Fujichrome Velvia, SB29s macroflash*

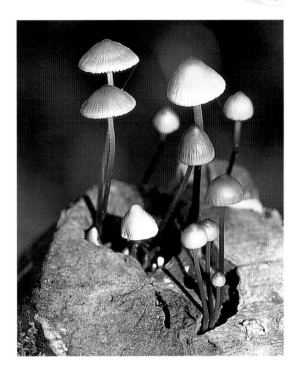

FINDING FUNGI

Woodlands in autumn are the best places to find fungi in temperate countries, and each woodland 'type' such as birch, beech, oak or pine woodland, has its own characteristic fungi. In tropical forests fungi are everywhere, an essential component of the complex ecosystem, quickly digesting all dead organic material. Many species also grow out in the open on dune lands and in meadows – anywhere where there is short, well-grazed turf.

Old trees are often hosts for large bracket fungi well out of easy reach and these can only be photographed with a telephoto lens. Fallen trees are easier to get at. In winter, when the leaves have disappeared from the trees, you will inevitably include the sky when photographing fungi from below. You will need some form of fill-in flash (see page 42) to balance the exposure of sun and background. In a tropical forest diffused flash may be the only practical light to use, since little light penetrates to the forest floor.

MOULDS

Many small fungi and tiny slime moulds are easily overlooked yet they make attractive subjects for the macro lens. They can be found in cracks in rotten wood, on rotting fruit and on dead animals. Foodstuffs such as cooked rice and yoghurt offer a culture medium for moulds – usually by accident when you overlook them at the back of the fridge. If you can overcome the urge to throw them away, the abstract patterns make interesting photographs.

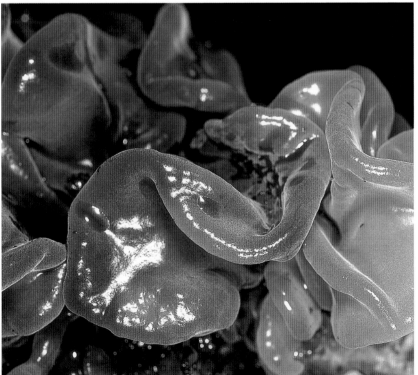

Designing the Picture

In any branch of photography you take great strides forward when you start to think about composition – the way you assemble the various elements of your images. But although the intention of natural history photography is often simply to record your subject accurately, there is no reason why your close-up and macro shots should not be every bit as compelling as the great landscape photographs of Ansel Adams, or the stunning studio work of Edward Weston.

As this chapter demonstrates, thinking about shapes, colours, patterns, textures, the way you position your subject within the frame and even technicalities such as the point of focus will lift your close-up and macro photographs above the mundane 'record' shot and into the realm of creative artistry. You will learn how to take real control over your images, consciously planning and designing them in the same way that an artist plans and executes a painting in oils or any other medium.

Using the frame

Regardless of the format you are using, there are certain key decisions that you need to make before you press the shutter. Your choices will have a fundamental impact on the final image.

CHOOSING YOUR FORMAT

The first decision you need to make (unless you are using a square format) is the orientation of the camera. With 35mm and other rectangular formats, you can turn the camera body to produce either a horizontal (landscape) or a vertical (portrait) image. Traditionally, if a subject is broader than it is long, we use landscape; if it is long and narrow, we go for the portrait format.

Photographers often underestimate the potential of portrait-format shots. Often, the most dramatic compositions use the frame in an unexpected way. Although we tend to think of landscapes as being horizontal in format, a vertical shot of a tall subject such as a lone tree taken on a 6 x 17cm camera can create a very dramatic image. When you're in doubt about which format works best, take both portrait and landscape versions of a picture.

If you feel a picture would make a good magazine cover, take it not only in portrait format, but also leave an area of empty space within the frame so that the title of the magazine can be printed over the image.

THE RULE OF THIRDS: POSITIONING THE SUBJECT

Most pictures, even regular patterns, tend to have a main point of interest – a focal point. Placing an object in the very centre of a frame – the bull's-eye position – can make a shot look static.

USING THIRDS

I framed the red-eyed treefrog (below left) to make a composition that I liked, given the shape made by the animal. The superimposed grid shows how the head and rear lie approximately at the intersection of the thirds. Flower centres often give the most effective result when they are placed at the lower left intersection of the thirds grid (below right); we start our gaze from bottom left and this leads the eye into the frame. Rules are not to be followed consciously however – do what looks right.
Nikon F4, Sigma 180mm f/3.5 AF macro, 1/60 sec. (at f/16 for frog and f/11 for flower), Fujichrome Velvia, SB29s macroflash

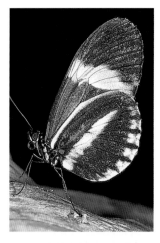

PORTRAIT OR LANDSCAPE FORMAT?

Whenever the question is hard to answer, then shoot both. Neither is better, but they will suit different layouts or sequences as this *Heliconid* butterfly shows.
Nikon F4, Sigma 180mm f/3.5 AF macro, 1/60 sec. at f/16, Fujichrome Velvia, SB29s macroflash

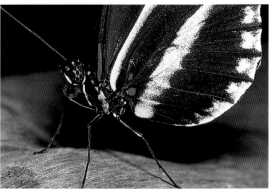

There is a compositional guide known as the rule of thirds, which is related to the idea of the Golden Mean used by the architects of Classical Greece, who were well aware of pleasing proportions. The Golden Mean is a way of dividing a line into two parts, so that the ratio of the smaller to the larger is the same as that of the larger to the whole length: this turns out to be approximately thirds.

When you divide a rectangular frame into thirds by means of straight lines, both vertically and horizontally, you create four points where the lines meet. Placing the point of interest on or near any of these points gives a picture immediate impact.

FILLING AND OVERFILLING A FRAME

When you move in close, your subject first fills the frame and then overfills it. Suppose you photograph a caterpillar, for example: you might take one shot in which it fills the frame and then reverse a lens onto a zoom lens or short telephoto and perhaps photograph just part of the body. In this way, natural objects can begin to take on an abstract appearance.

Overfilling the frame, so that only part of your subject is visible, is an important compositional tool in macro photography. You can zoom or use a bellows to adjust the scale and produce an image that looks right to you.

FRAMES WITHIN FRAMES

The landscape photographer's stand-by of framing scenes with branches or rocks can be translated to the domain of the close-up by using twigs, petals or flower stamens to frame your subject.

POSITIVE AND NEGATIVE SPACE

You will often come across the terms 'positive' and 'negative' space in books about art and composition. Putting it simplistically, positive space is essentially your subject, while negative space is the empty space around it. Imagine drawing an outline of your subject in order to define it: the area inside the line represents a solid, physical object, while the area outside it is nothing but thin air.

These positive and negative spaces need to balance each other in order for a photograph to be successful. It is difficult to give guidelines about the relative proportions of each, as everything depends on the mood and feeling that you want to evoke. In a landscape, for example, you might choose to show a lone plant in the foreground to emphasize the extent and nature of the surrounding countryside or you might come in close, with a single flower filling three-quarters or more of the frame, in order to concentrate on the colour and texture of the petals.

PUSSYCAT, PUSSYCAT

Several feral kittens were living in an old handcart in a square in Bevagna, Italy. The spokes of the wheel framed a portrait that cried out (literally) to be taken.

📷 *Nikon F100, 28–80mm f/2.8 AF zoom, 1/60 sec. at f/11, Fujichrome Velvia*

Lines and shapes

If you feel drawn to a picture, be it a painting or a photograph, it is often because shapes, lines and curves within it appeal to your senses, albeit on a subconscious level. These lines and shapes also help to guide your eye around the picture to the main focus of interest: sometimes you have to stand back from a picture to see where these are and how they work, but once you are aware of them and their power, you can deliberately incorporate such elements into your own compositions.

COXCOMB PLANT
(Celosia cristata)

The convoluted flowers of this strange plant look like a coxcomb or coral. By over-filling the frame, the curves dominate: orientate the camera to select the groups you prefer in the viewfinder.
Nikon F100, 60mm f/2.8 AF macro, 1/60 sec. at f/16, Fujichrome Velvia, SB29s macroflash

SHAPES

Familiar geometric shapes are pleasing to the eye. Although they can be obvious in the outline shape of a flower or animal, for example, it is the 'hidden' shapes that help to raise a composition above the ordinary.

For example, with moderate close-ups, groups of flowers, insects or fish can form a simple closed shape such as a circle, ellipse or triangle. If you emphasize this shape, you can create a picture that has more impact than a close-up of one element. Another advantage is that this can allow you to show the subject from several viewpoints (front, side and overhead, for example) within the same shot.

LINES

Lines, implied or real, are a way of leading the eye into the picture towards the main focus of interest. In landscape shots horizons, hedges, hills, beaches, streams and rivers, trees and even long shadows are all examples of such lines.

Similar elements exist in close-up or macro photography, but you are usually freed from things that have to be horizontal (the horizon in a seascape) or vertical (a tall cypress tree). You can rotate the camera body and see how lines look relative to the picture frame: the direction of any line, straight or curved, is important in the final result.

SALSIFY
(Tragopogon porrifolius)

By isolating the few 'parachute' seeds left on a salsify seedhead, the composition makes use of the curves in the subject without it becoming cluttered.
📷 *Nikon F4, 105mm f/2.8 AF macro, 1/125 sec. at f/16, Fujichrome Velvia, SB29s macroflash*

BUTTERFLY EGG – ORANGE TIP
(Anthocaris cardamines)

Butterfly eggs are strictly subjects for the macro realm and their surfaces are often beautifully sculpted. The curved stem of the food plant (and a hint of flower beyond) meant the egg was not lost in the frame.
📷 *Nikon F4, Olympus 38mm f/3.5 macro plus bellows, 1/60 sec. at f/16, Fujichrome Velvia, SB23 flash*

HORIZONTAL LINES

Lines on the horizontal create or echo horizons. We have a tendency to begin at the bottom of a picture and work upwards, so horizontal lines divide an image into sections. Here, the rule of thirds (see page 124) often creates a better composition: a horizon or line through the centre, creating two halves, might be effective only when one is a reflection of the other in water, for example. By setting the horizon a third of the way up the picture, when photographing rocks, plants or animals in the context of their surroundings, we can emphasize the subjects against the sky. Conversely, placing it one third of the way down accentuates the land. Both ways produce a far better composition.

VERTICAL LINES

Any vertical line, such as trees, stripes and leaf veins, adds movement to a composition, because it has a pronounced sense of direction. You can accentuate the dynamic effect of such lines in the frame by using a 35mm frame in vertical format.

DIAGONAL LINES

Diagonal lines are extremely effective in close-up and macro shots as a way of creating a sense of movement in subjects that are essentially static, such as plant stems. Often, all you need to do is rotate your camera until your subject seems to lie along the diagonal – and the shot can be used in either a vertical or horizontal format. Our gaze tends to drift from bottom left to top right in a picture and so a diagonal line that runs in that direction has the most powerful effect.

CONVERGING LINES

Converging lines can give a great sense of depth to a picture, even when working with shallow depth of field. The effect is exaggerated by using a close-focus wide-angle lens such as a 24mm or 28mm (see page 58).

AGAVE LEAVES

Succulents often have leaves with curves and spines. Close in on portions of the plant to create patterns from the interplay of lines and shapes.
📷 *Nikon F60, 28–80mm f/3.5 AF zoom, 1/60 sec. at f/8, Fujichrome Velvia*

CURVES

Curves of all sorts, whether simple arcs or compound curves like an 'S' shape, can weave their way through a frame and create a sense of flow from one part of the image to another. For example, by moving in close on the tendrils of climbing plants, you can emphasize whole spirals or select parts of them winding through the frame. Snakes and centipedes are also natural candidates for curvaceous compositions.

Colour and perspective

Although the frame of a picture and the shapes within it are important, other factors, such as colour and perspective, also strongly influence the final result. They are often the starting point for a composition – perhaps a colour catches your eye or a commonplace object is seen from an unusual viewpoint, giving a perspective with impact. Your creative task is to place the elements in your viewfinder at whatever scale looks right to you, from a viewpoint that accentuates the subject.

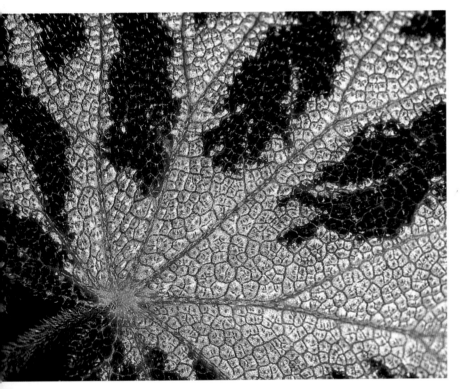

BEGONIA LEAF VEINS

Begonias are often grown more for their patterned leaves than for their flowers. The most obvious part of this composition is the simple contrast between dark green and grey green, but the texture of the surface is important, too.
📷 *Nikon F4, 60mm f/2.8 AF macro, 1/60 sec. at f/16, Fujichrome Velvia, SB29s macroflash*

COLOUR

Most photographers use colour film or create digital images in colour, making colour an extremely important tool in many compositions, whether in the subject or in the background. Colour can do a great deal to influence not only the way in which we perceive subjects but also how we feel about them.

ORDER

Strong, simple colours in both background and foreground can bring order to a complex composition. When a subject is a riot of colour, the simpler the composition the better. It is more effective to try to select a few well-balanced elements in the viewfinder and isolate them either by zooming in or by moving closer.

MOOD

Colour can affect the mood we perceive in a picture. Earth tones such as ochres, browns and greys can make a room feel relaxing and they have exactly the same effect in pictures. Strong bright colours, on the other hand, give a lively feel. Colours towards the red end of the spectrum such as red, orange, and to a lesser extent yellow, create a warm feel, while shades of blue or anything with a blue tinge can feel cool. Mixes of blue and red, such as purples, feel warm or cool depending on whether red or blue dominates.

DEPTH

Colour can impart a feeling of depth in a picture: have you noticed how colours create successive planes in a landscape that contains distant mountains? The mountains that are furthest away are in shades of pale, purplish grey, while those in the foreground are darker in tone. This is important when we take close-ups of plants in a landscape; in the macro realm, depth of field is so small that this distance effect does not come into play.

BACKGROUND COLOURS

Brightly coloured and complicated subjects need natural backgrounds of a simple, single colour; garishly coloured backgrounds will confuse a composition. Brightly coloured subjects tend to look dramatic against backgrounds that are either darker or of a complementary colour. In nature a blur of green vegetation, rocks or sand will provide this.

In close-up photography, reducing these backgrounds to a soft blur happens naturally and is an important creative tool.

Black is the ultimate dark background: there is nothing to distract and foreground colour is accentuated, as colours seem to take on an added vibrancy (see page 40). Pure white backgrounds can also be extremely effective when used in a studio with single flowers or when you create selections digitally and place them against white (see page 142).

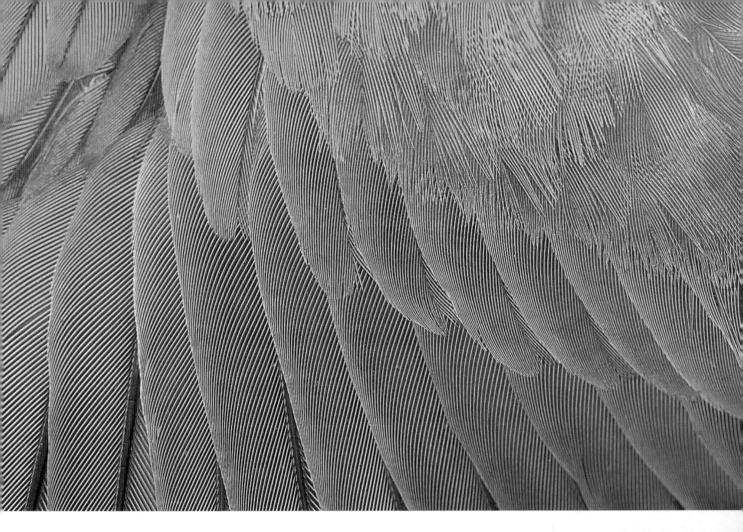

CAMOUFLAGE

When you set out to show camouflage, the last thing you want is to contrast subject and background – although in nature you do find rather unintelligent yellow crab spiders trying to hide in purple flowers.

PERSPECTIVE AND VIEWPOINT

A lot of what we learn in landscape photography can be put to very good use on the smaller scales of close-up and macro work.

Perspective is about the way objects relate to one another in a scene. If you zoom in on a subject without changing your position, you change depth of field as the magnification changes. The perspective, however, remains the same. But if you photograph the same subject with a range of lenses or at different zoom settings and then move to make the subject the same size in the frame (a good exercise with trees or rocks in a landscape), other elements change position relative to the subject as you alter yours: thus the perspective changes.

The extreme positions are worm's-eye – where you are on the ground looking up – and bird's-eye – looking down on your subject from above.

In close-up and macro work, you often need to adjust the camera position to get as much in focus as possible and to find a plane that enables you to do this (see page 117). This will often determine the viewpoint you need to select.

BEE EATER WING
(Merops apiaster)

On discovering a bee eater that had been senselessly shot, I photographed the bird's outspread wing. Even in death it had great beauty, the intricate texture and soft greens and browns of its feathers in staggering evidence here.

📷 *Nikon F100, Sigma 180mm f/3.5 macro, 1/60 sec. at f/8, Fujichrome Velvia*

PASSIFLORA TENDRIL
(Passiflora sp.)

Some shapes reveal their full extent from a single position. A spiral tendril from a passiflora can be photographed from one end to create an 'artistic' shot, but only from the side does the perspective allow it to be seen as a tendril.

📷 *Nikon F100, Sigma 180mm f/3.5 macro, 1/250 sec. at f/16, Fujichrome Velvia, SB29s macroflash*

Pattern and symmetry

Pattern is all around us, from patterns within numbers and man-made objects to patterns in the natural world, such as scales on skin, and stripes on leaves. Some patterns are highly regular while others, such as lichens on rocks, are completely abstract.

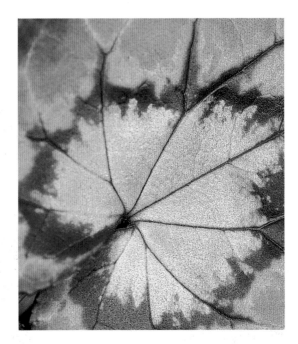

By recognizing a pattern and then setting out to emphasize it, we can create a picture with a 'wow' factor – one that conveys a message about the intrinsic beauty of such things. This is the approach I use unashamedly when beating the drum about conservation: things of beauty are in themselves worthy causes for help and protection.

Patterns of all sorts please the human mind; they are intrinsic to the way we are built and the way we think, and we seem to be comforted by order. At close-up and macro levels, patterns are one of the strongest compositional tools at our disposal. High magnification often reveals surprising and exquisite patterns that we could not see with the naked eye.

LOOKING FOR PATTERN

As soon as you become aware of patterns, you begin to see them everywhere in nature – particularly at the macro level. Patterns are obvious in the geometry of

MOTHER-IN-LAW'S SEAT
(Echinocatus gruisonii)

This unkindly named cactus is a great favourite with photographers. In close-up, the spined ridges form photogenic patterns. In this shot, the side growths were deliberately positioned in the frame to break the regularity of the pattern.
📷 *Nikon F4, 60mm f/2.8 AF macro, 1/60 sec. at f/16, Fujichrome Velvia, SB29s macroflash*

CYCLAMEN LEAF

When we ask ourselves why we like a subject, 'patterns' are often involved. Here a leaf vein creates a diagonal and the pattern is mirrored on either side of it. The branching veins suggest order and the colours create contrasts that emphasize the pattern.
📷 *Nikon F4, 60mm f/2.8 AF macro, 1/60 sec. at f/11, Fujichrome Velvia, SB29s macroflash*

GERBERA

Any number of lines (equal to half the number of petals, in fact) can be drawn to cut this flower in two – an example of radial symmetry.

SYMMETRY

In many natural objects we can recognize one of two types of symmetry: radial and bilateral.

RADIAL SYMMETRY

Things that are radially symmetrical can be cut into two equal parts in many ways along a radius or diameter. Many primitive creatures that are sedentary, such as sea anemones and sea urchins, have this symmetry, as do the segments of an orange or a daisy flower. Often, subjects with radial symmetry benefit from being positioned off-centre in the frame: the rule of thirds (see page 124) provides a useful starting point.

nature: a great example is the spider's web, particularly in autumn when it is delineated by frost or dew drops. Inanimate natural objects too, such as crystals from minerals or snowflakes, have complex symmetries that arise from the structured way those atoms and molecules have become ordered as the crystal grows.

If we can take a metaphorical backward step and detach ourselves from the immediate and obvious, then we can view any subject – be it a leaf, a tree or a zebra – as an arrangement of shapes, lines and colours. By looking at portions of a subject in this way, you open up a vast store of material for your compositions, especially those with an abstract feel.

HEARTSEASE FRUIT
(Viola tricolour)

There is a simple three-fold symmetry in this fruithead. Subject orientation is often important in a photograph: here one of the bracts lies in the bottom left-hand corner and the rest are laid roughly along diagonals, giving a flow to the composition.
 Nikon F4, Sigma 180mm f/3.5 AF macro, 1/60 sec. at f/16, Fujichrome Velvia, SB29s macroflash

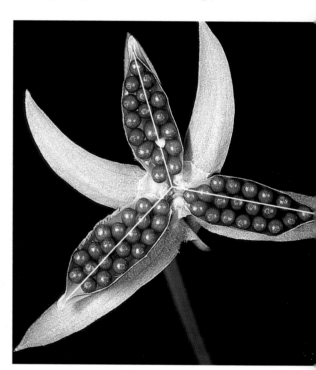

RED ADMIRAL
(Dendrobium biggibum)

The butterfly can clearly be 'cut' into two equal halves just by drawing a line from top to bottom – bilateral symmetry.

TEXTURE AND PATTERN

Emphasizing the texture of an object can reveal and enhance patterns. By using light obliquely to create relief, we can accentuate the texture of a surface such as the surface of a seed, grains of sand, the hairs on a leaf or the skin of a lizard. Patterns that might have escaped unnoticed then become more obvious. You know you have really succeeded when someone says your picture makes them want to touch it.

BILATERAL SYMMETRY

Bilateral symmetry is something possessed by all creatures that have an identifiable head: they can be cut into two 'halves' in only one way.

Humans have bilateral symmetry, although we are so well-attuned to appearance that we notice irregularities. Suppose you take a full-face portrait and print it first the right way round and then back to front, from a reversed negative. Now cut each print in half and reassemble them, using two left sides in one photo and two right sides in the other. You will get a shock: one picture will look lean, while the other will appear bloated in a disturbing way. Although I have never tried this with any other animal, large or small, it would make an interesting close-up exercise – particularly with those animals nearest to humans in evolutionary terms, such as other primates.

Creative use of depth of field

We usually think of depth of field under the list of 'problems' when it comes to close-up photography, because we seem to use a great deal of time and energy dealing with its limitations. If we accept the restrictions, then we can see the control of depth of field as a useful creative tool in our compositions.

MAXIMIZING DEPTH OF FIELD

In close-up and macro photography you become used to using small apertures to maximize depth of field. There is a delicate balance between creating depth of field and avoiding image degradation due to diffraction (see page 153) that happens with shooting through small apertures. To optimize depth of field with a subject that is not flat, it is best to arrange the camera parallel to an imaginary plane in which as much of the subject as possible appears to be in focus (see page 117). You may not be able to keep the whole subject in sharp focus, and so you need to make a conscious decision about which parts of the image you can accept as being soft. The sharp parts automatically become the centre of interest. With many subjects, it does not matter too much what is in focus and what is not. However, it is essential that anything that looks like an eye, whether it is the genuine thing or an eye-spot,

DEPTH OF FIELD AND MAGNIFICATION

The higher the magnification, the shallower the depth of field. With these lily stamens the depth was only a fraction of a millimetre even at f/22.

📷 *Nikon F100, Sigma 180mm f/3.5 AF macro plus x2 converter, 1/60 sec. at f/5.6, Fujichrome Velvia, SB29s macroflash*

CONTROLLING DEPTH OF FIELD

An aperture of f/5.6 or larger allows a narrow zone of focus, as with these lily stamens. Experiment to see how the zone of sharp focus changes.

📷 *Nikon F100, Sigma 180mm f/3.5 AF macro plus x2 converter, 1/60 sec. at f/5.6, Fujichrome Velvia, SB29s macroflash*

is in sharp focus. Eyes are always a point of contact: our gaze is automatically drawn to them and, while we can forgive other elements that are out of focus, if the eyes are soft the picture will look wrong.

BLURRING THE BACKGROUND

In landscape photography, one way in which a sense of depth is created is through colour: foreground objects are darker in tone than those that are further away. This tonal changing establishes successive planes, so that a scene appears to have depth.

In the macro realm, the depth of field is too small to use this device successfully, but in close-up work at around one-tenth to one-third life-size scale of reproduction, you can set plants or other objects against a background, using wide-angle lenses (see page 114). The foreground objects will be sharp, with the background in soft focus – although its form and colour will still be visible.

DEPTH OF FIELD AND FOCAL LENGTH

At closer ranges, the focal length of a lens makes a difference to the way the background is treated. There is an appreciable difference, for example, between a macro subject taken with a 50mm macro and a 200mm macro at the same magnification. The longer lens always tends to produce a condensed perspective, giving the subject a 'flatter' feel; it also produces a background as a soft blur. With the shorter lens, some elements close to the subject may still be distinguishable and rather distracting.

SHALLOW DEPTH OF FIELD

There are always fashions in illustrative photography. Currently, and for some years now, there has been a tendency to use shallow depth of field as a creative device. In fact, a lot of photographs in cookbooks and, to a lesser extent, books about flowers, use images that have only the tiniest portion in focus or are blurred altogether.

But before you rush to rescue those out-of-focus poppy shots that you threw away, there is a world of difference between accidental blur and deliberate control of depth of field. By deliberately controlling the depth of field, you decide the most important part of the image and the one you want to accentuate.

Using an aperture of f/5.6 (any wider and there is the risk of too little being in focus), experiment by photographing flowers in a vase or jar, focusing perhaps on the stamens or a droplet of dew on a leaf. You will see how your composition changes as you

shift focus slightly and different parts of the image become more important.

In natural history photography, particularly for identification, it is important to be able to see what the subject is and the accepted approach has been to maximize the depth of field. Used with care, however, a shallow depth of field can add mood to a shot – particularly when shooting flowers and plants. If you wish to sell your pictures, it is worth photographing floral subjects with shallow and maximum depth of field, since they can be used for different projects or even different markets.

PASSION FLOWER STAMENS

The problem with a flower as complex as a passion flower is not how to achieve shallow focus, but how to avoid it. I always feel such subjects deserve the sharpest focus you can give to reveal the marvel of the structure.

📷 *Nikon F4, Sigma 180mm f/3.5 AF macro plus x2 converter, 1/60 sec. at f/16, Fujichrome Velvia, SB29s macroflash*

Adapting Imagery

Many photographers first realized the power of digital manipulation with the arrival of digital film scanners and ink jet printers, which allowed them to produce work at home that outshone the commercial printing available from photo labs. The 'digital darkroom' opens up endless possibilities for producing prints and correcting photographs and transparencies, and myriad photographic effects from mimicking traditional effects, such as sepia toning, to solarization and Sabatier.

The purpose of this section is to demonstrate a range of techniques and procedures that can improve the quality of your output. Although the procedures and screen shots show Adobe® Photoshop®, the accepted industry standard, the same principles apply to other photo-manipulation programs.

All the material was handled on a Macintosh G4 computer. Although this is not the place to enter the PC / Mac debate, having used the Mac system for over a decade I would not, and could not bear to, use anything else. Many photographers, editors and design professionals feel the same.

Manipulation

As soon as a digital file is loaded into a computer, the image can be changed in all sorts of ways. The most basic changes involve those to the size of the picture and the parts you want to keep – analogous to the size of enlargement and cropping in the traditional darkroom. And this is only the beginning of processes that are as exciting as taking the picture in the first place.

OPENING IMAGES

The first step in any photo manipulation is to open an image on the computer desktop. If you work with any photo-manipulation program and the file does not open automatically, a dialogue box will appear saying that the program that created the image cannot be found and offering you a choice. Many people working on files open Photoshop first and then File > Open on individual files.

THE FILE BROWSER

Looking for folders and files and then opening them can become tedious. Photoshop's File Browser lets you look at what folders you have; those with images can be opened at a click and a large thumbnail displayed – seen here on the right-hand side of the screen. You click on a file to open it in Photoshop.

BROWSING

When Photoshop is open, the File Browser tab appears in the top right-hand corner of the screen. Clicking on this brings up thumbnails of whatever files you might want to work with. Even better, you can then rename files and rank them in any way you choose.

CROPPING

Files can be cropped to any square or rectangular shape you want or, using Marquee tools, to elliptical and circular formats. In Photoshop you can set a colour for the cropped area to show exactly what you are doing.

RESIZING

Pictures can be resized (Image > Image Size) and you can work in centimetres or inches (for prints) or pixels (the most convenient for Web pictures).

As you change picture size, the resolution changes as well; the computer does the arithmetic, keeping input file and output file the same size. If you are making big enlargements but trying to keep to 200dpi print resolution, then the computer increases the file size by interpolation – adding pixels. Up to 50 percent increase, you will see virtually no change.

Even with exhibition prints, at normal viewing distances you will see no discernible difference between prints produced at 200dpi and those at 300dpi. The file size is much smaller with the 200dpi, as the dialogue box shows.

If the file size drops before you hit the OK button, think about whether you need the data in the original file and use Save As for the new size. Cutting file size means cutting pixels and losing data.

The Crop tool can be dragged to any size by means of its 'handles' and repositioned on screen where you make a fixed-size cropping rectangle. The area to be cropped can be set to a darker tone; this makes it easier to decide the best way to crop an image.

FIXED-SIZE CROP

Suppose you want to scan to crop to a fixed size for use on a website – say 600 x 400 pixels at 72dpi. In Photoshop 7 and in earlier versions, you can set these dimensions on the toolbar.

ROTATION

Pictures can be rotated 90° clockwise or anti-clockwise (Image > Rotate) to change them from a horizontal to a vertical format and vice versa or 180° to turn them upside down. By flipping an image horizontally, you can create a mirror image, while flipping it vertically turns it top to bottom.

In fact, a picture can be rotated to any extent you like (Image > Rotate > Arbitrary) – a useful feature when horizons are not straight. The result can then be cropped to produce a rectangular frame.

HISTORY

Early versions of Photoshop made one almost paranoid about losing results after a series of steps. The History palette records the steps that you make in any manipulation and allows you to go back to any point in the process and modify it. You begin again from that point, which is better than going back to step one. Unfortunately the history – the way you have created a file – is lost when you close it. You cannot open a file again and go back to some point in the creation process. However, if you have worked in layers for each step (see page 144), then each layer can be preserved and changes made without starting again.

When you enlarge an image to look at detail, forget about using the window handles to move the image up or down, left or right. It is much easier to use the navigator; by clicking and dragging, you can move the whole picture. The screen area is shown on the navigator.

Contrast and colour

Contrast and colour in a picture can be controlled to an almost magical degree in a digital file, and the possibility for experimentation is vast. It is easy to get carried away, so always work on a copy of your original.

ROUGH ADJUSTMENTS

For many purposes all you need is a basic adjustment of tone and of colours and this can be done via the Image > Adjustments menu.

BRIGHTNESS AND CONTRAST SLIDERS

The simplest adjustment can be made via Image > Adjustments > Brightness/Contrast: simply move the sliders until you get the result you want. Often just reducing brightness and increasing contrast by a scale reading of 10 gives a lift to the picture.

HUE AND SATURATION

Adjustments to colour can also be made from Image > Adjustments > Hue/Saturation, although in practice this

is better for toning (see page 141). Image > Adjustments > Variations produces a collection of images showing the effects of brightness and colour changes.

FINER CONTROL

A much better degree of control is possible through two options – Levels and Curves. These are used by people who work routinely with Photoshop, and can be used either to change the appearance of a whole picture or, better still, a part of it. After selecting a part of your image, click the Create New Adjustment layer button in the Layers palette (see page 144) and then choose Layers or Curves from the drop-down menu. In this way, using layers, you can adjust the selection and leave your original pixels unchanged.

LEVELS

Levels controls the tonal range of images. The distribution of tones in a picture appears as a histogram – a statistical map showing their relative proportions. Moving the end pointers (left and right) closer together increases the contrast. Moving the

BRIGHTNESS AND CONTRAST

A small increase in contrast and a tiny decrease in brightness can do wonders for an image and might sometimes be all that is needed. However, when you need to deal carefully with shadow and highlight areas, Levels or Curves offer a better alternative.

LEVELS HISTOGRAMS

The Levels histograms offer a quick visual display of the state of a scan by displaying tonal values. The RGB channel gives an overall view, while the red, green, and blue channels deal with single colours. They are not difficult to read, but most people just move the sliders until things look right.

HUE/SATURATION

Quick and dramatic colour changes can be effected by moving the Hue slider over its colour range and then adjusting Saturation and Lightness: the changes are not subtle, but that is not always what one wants.

VARIATION

When it is hard to visualize the effect of small changes in colour, the Variations option (Image > Adjustments > Variations) produces a series of pictures showing tone changes, allowing you to increase or decrease an option and then select what you want.

TECHNICAL NOTE

Curves lets you quickly correct brightness and tonal balance together when tweaking a batch of scanned slides shot on your standard film stock. With the RGB curve, the central point is moved up (to brighten the image overall) or lowered (to darken it).

centre slider changes the overall density. The Auto button makes the brightest pixel white and the darkest black, and evenly spreads values between. It is useful only to give yourself a rough idea of the tones.

WHAT THE HISTOGRAM MEANS

A good scan or properly exposed image shows most values filled (no gaps), with gentle peaks.

A dark scan or image has most values condensed to the left; a light scan has them to the right. Gross under- or overexposure appears as a sharp peak to the left or right respectively. If lots of values are missing – and the histogram looks like the teeth of a comb – changes of tone or colour are sudden, like a posterized image.

COLOUR ADJUSTMENTS

Examining the red, green and blue channels separately offers a way of controlling colour casts. You can use the Auto button to correct and provide a better balance of pixels, leaving the other channels unaffected.

CURVES

Essentially, you can use the Curves tool to control contrasts between tones in a given tonal range.

TECHNICAL NOTE

The output level slider in the Levels dialogue box sets the black (left) and white (right) points as they will be interpreted by your printer. Moving each about five points towards one another condenses the tonal range: you see no loss of density, but you get a better print.

COLOUR CASTS

Colour casts can be corrected by examining the red, green and blue channels separately. Take the red channel: moving the point upwards creates a red cast, while moving it down gives a complementary cast (cyan). Similarly, with the green channel you can correct magenta and with the blue channel you also control yellow.

CHANGING SHAPE

Flattening the curve in the shadow areas (shown in the dialogue box) reduces contrast in shadows: steepening the curve in the mid-tone region boosts those areas. Radical movement of the curves produces results that are occasionally bizarre. In advanced work, sampling the corresponding part of the curve produces very subtle changes.

ADJUSTING CURVES

Dramatic changes can be made by clicking on the curve and dragging: the picture shows the routine adjustment that I make after scanning – a slight movement of the centre. When there are shadows or highlights to adjust, move the lower or upper end of the curve respectively and watch the screen.

Creating monochromes and other prints

By creating a digital file, you can operate on individual pixels and groups of pixels through a vast range of processes and filters within Photoshop and other programs.

It is great fun to learn through play, but far too many of these processes will make your picture end up looking like an album cover from the Psychedelic Sixties. I have included only those processes that have proved useful to me on a number of occasions.

MONOCHROME FROM COLOUR

Within Photoshop there always seem to be several distinct 'recipes' for achieving any result and the creation of monochrome pictures from colour files is no exception.

DESATURATE

For a straightforward monochrome image from a colour file, Image > Adjustments > Desaturate is the first step: you can then adjust the Contrast and Brightness controls (Image > Adjustments > Brightness/Contrast) to suit – just like changing the grades on black-and-white paper.

DESATURATE

A simple and effective way of creating a monochrome result is through the Desaturation command (Image > Adjustments > Desaturate), which simply leaches colour out of the original.

CHANNELS

Each channel can contain quite different monochrome information from the others. In black-and-white photography, tonal depth is intensified by using a filter of a complementary colour to the subject – green for a magenta flower, for example. Suppose that the magenta channel viewed on screen gives the monochrome effect that you are looking for. In Photoshop, by using File > Save As, you can create a monochrome file for that channel under a new name, then print from this new file in the same way as you would from any other.

COLOUR RANGE

Colour Range offers an alternative way of creating a greyscale image (Select > Colour Range), with startling results.

CHANNELS

Most of the colour information for the magenta flower is carried in the green channel (green is the complementary colour of magenta). Similarly, the red channel carries red and cyan information, while the blue channel is selected for yellow and blue.

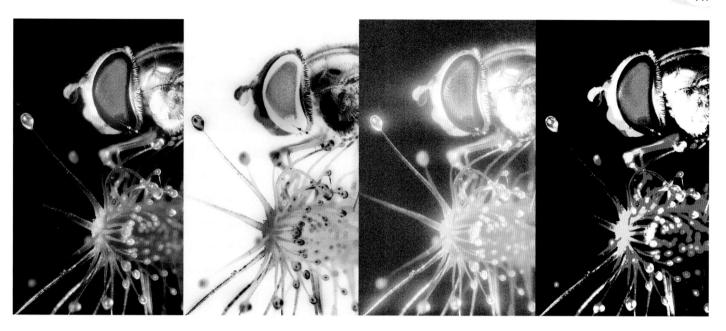

GREY TONES

Creating a greyscale image offers possibilities for toning. First, use Image > Mode > Greyscale to remove colour, followed by Image > Mode > RGB. This allows you to add colour via Hue/Saturation (Image > Adjustments > Hue/Saturation). Check the Colorize box and vary the slider positions to set the tone, the extent to which the greys are tinted and the lightness or darkness of the final image. You can create all degrees of toning like this.

DUOTONES (AND TRITONES)

Image > Mode > Duotone allows one or two inks (specified as Pantone colours) to be mixed with the greyscale images. There are presets that generate sepia, platinum and other colours.

PROCESSES

Images can be radically changed by the digital duplication of some techniques familiar from 'wet' chemistry. These techniques are found under Image > Adjustments. They are Invert, Equalize and Posterize.

Many more things can be done by spending some time and working through the 'creative filters' found under the Filter banner heading. They are fun to look at, but not as much use as Sharpen (see page 146), Extract (see page 143) and Other (see page147), which are also accessible from the Filter menu.

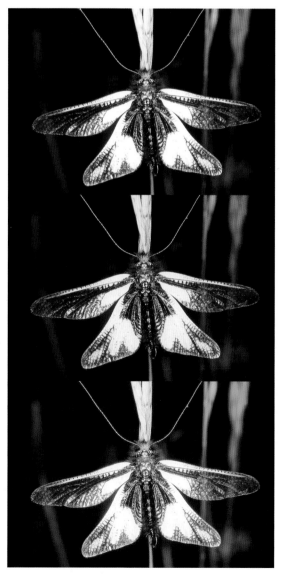

DESATURATION

Wet chemistry allows you to create dramatic effects, which you can mirror digitally either by using items in the Filter menu or by experimenting with Image > Adjustments. From far left, above (following the normal image), Invert, Equalize and Posterize are used in turn.

GREY TONES

By using a greyscale image and converting it back to RGB, you have an easy way of creating sepia or any other toned result. Use Image > Adjustments > Hue/Saturation, check the Colorize box, and move the sliders to control hue and saturation. Images left show (from top to bottom), greyscale, sepia and blue tone.

Selection

The key to a great deal of work in photo manipulation is being able to accurately select parts of an image or of a whole subject with all its fine edge details intact. By mastering selection you can replace the background, change the background colour, or even blur it. You can correct the brightness of individual parts of an image – the electronic version of 'burning in' – or correct or change tones.

TECHNICAL NOTE

For any selection tool (except the Hand tool), holding down the space bar turns the tool into the Hand tool and lets you move the image to continue the selection.

Always work with an enlarged image and work slowly and methodically. At first you will make a lot of uncontrolled movements and have to start again. Several tools allow you to make selections.

THE PEN TOOL

The Pen tool can create accurate selections as anchor points are set along a path. You can easily modify the selection to improve it when you zoom in on the image, adding or removing points from the Pen menu (click on the icons).

THE LASSO

The Lasso tool creates a selection as you click and drag around the edges of an object. The magnetic lasso searches for edges of contrast and the polygonal lasso builds a selection from straight edges.

Using the Lasso tool is infuriating at first: if you lift a finger from the mouse button, it assumes you have finished and closes the selection with a straight line back to the start. Always hold down the Option key with your other hand; this allows you to lift your finger from the mouse or reposition it. You can also change between various Lasso tools using the Option key. When a selection is complete, you can add bits to it by holding down the Shift key and dragging the Lasso or Marquee tools inside or outside an area; to remove part of a selection, hold down Option and drag the same tools.

LASSO AND SELECTION

The Lasso tools produce the famous 'marching ants'. Pressing Cut removes the area enclosed by the Lasso, leaving a blank; you can then paste the area removed into another file or return via the History palette to the selected image then use Select > Inverse, followed by Edit > Cut to remove the background and leave the selection.

MAGIC WAND

Increasing the tolerance expands the range of tones the Magic Wand will capture. Pressing Shift and clicking on other areas adds them to the selection. The Magic Wand is useful with areas of dark shadow: click to select, then lighten using Curves.

THE MAGIC WAND

Where a subject is against a largely plain background – the black generated in so many macro shots, for example – the Magic Wand works well. Through the tolerance setting you can adjust the variation in tone accepted in a selection. Holding down Shift allows you to add areas to the selection with a single click of the mouse: you can remove them by holding down Option and clicking. Magic Wand allows you to remove large areas and then tidy up edges with the Eraser tool.

SELECTION AIDS

Whatever method of selection, you choose the result can be improved by using a couple of additional processes.

FEATHERING

Feathering softens the edges of any selection over a width governed by choosing the number of pixels in a dialogue box. It smooths out tiny errors and makes most selections – particularly those destined to stand against a plain background – look far less stark.

EXTRACTION

With practice, the Extract command becomes the quickest to use for precise selections. After using the Felt Tip to make a first selection, you can then work on the detail, rubbing out and touching up by using the tools in the extraction palette.

QUICK MASK

Any selection appears with a boundary traditionally called 'marching ants' because of its screen appearance. Using the Quick Mask tool fills the area within the selection with a coloured but transparent mask. This not only makes it easier to see what you have selected but also enables you to check the effect of feathering, which is not apparent with the marching ants border.

EXTRACT

Versions of Photoshop from 5.5 onwards have a remarkable tool hidden in the Filter menu – Extract. Once you have used it, you will be unlikely to use any other means of selection.

Via Filter > Extract, you are presented with a separate screen and, in principle, all you do is draw an outline around what you want using a marker pen. You can stop anywhere, rub out errors or change the width of the pen. By keeping an even overlap between subject and background, the Extract function can better determine what pixels to keep or discard.

The selected area is then filled to show up the parts that remain intact and a preview lets you see the result and any bits to correct. Where there are hard edges, checking the Smart Highlighting option in the Extract dialogue box makes the brush follow the edge automatically.

If you make mistakes with the highlighter, use Option+Z (Mac) or Ctrl-Z (PC) to undo the last action. Alternatively, select the Eraser tool from the Extract icons and remove the green.

FINE CORRECTION

After extraction, zoom in on the selection. You can then work around the edges, rubbing out anything unwanted or using the History Brush tool to restore detail that you have inadvertently removed, changing the tool size accordingly.

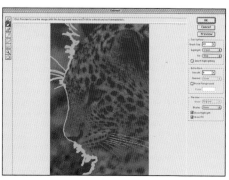

Backgrounds and layers

You often need to make a selection of a subject in order to work on the background – to blur it, change its colour or even introduce another scene. This is often done in a series of steps using 'layers', which act like acetate sheets but can be mixed, blended and moved relative to one another as you choose.

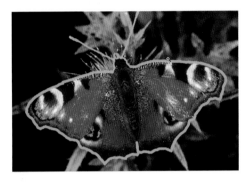

EXTRACTION AND FILLING

To create a 'fill', first select the main subject – in this case, a peacock butterfly. The extraction filter (Filter > Extract) allows you to control the detail. The extracted image can be pasted into another file or onto any background. For example, you can create a new canvas, fill it with the background you like, create a new layer and paste the butterfly into this so that you can move it anywhere you wish. Here a colour fill has been used, and the butterfly pasted into a layer above it.

FILLS

Many publishers use cut-out images in books. You can achieve this with a carefully selected, cut, and feathered image. First use Select > Inverse to select the background. Cut it and then use a pure white fill. You can either pick what you think is white from a colour display or set the following numerical values in the dialogue boxes – Red 255, Green 255, Blue 255.

From the colour circles you can select any fill you want to suit the use you have in mind. Black is particularly useful when you have images taken with true macro lenses using dark-ground illumination. If your subject is living in water, there are numerous smaller creatures, barely visible that only show as disconcerting points of light. If you find these obtrusive, then select the subject by your preferred method, feather the edge of the selection slightly and then use a fill of pure black in the background.

LAYERS

Using layers is similar to using acetate overlays. You can create duplicate layers to leave an original untouched. Adjustment layers permit you to vary tones and contrasts, and make corrections and text layers. All of these can be blended to any extent you choose, because you can adjust their opacity.

The final image should be flattened to save file space, since working in layers increases the size of files dramatically. The first you know, if you have not fitted sufficient RAM, is that the application locks out. Layers remain adjustable until the flattening process.

BLURS

One useful process using selection is to create a layer in which you work on the background independently of the main subject. The example shows how a background can be blurred – a similar effect to

GAUSSIAN BLUR

A background can be controlled to look as if the depth of field has been changed. First, create an adjustment layer. Select the image, then invert it to select the background. Now, use Filter > Blur > Gaussian Blur and experiment with the settings; two degrees of blur are shown here. The final result is obtained by flattening the layers (Layer > Flatten Image).

changing depth of field by changing lens aperture. The blur is created by a filter (Filter > Blur > Gaussian Blur). It is easier to work by creating a layer into which the background is pasted.

ENHANCING DEPTH OF FIELD
With very small subjects, limited depth of field is an inevitability when working at high magnifications. It is possible to make a series of pictures, each one with slightly changed focus (easiest if you have a fine-focus mechanism such as those on a microscope). The images are stacked in layers and then blended. Register is critical, but the results can approach the startling depth you see with scanning electron micrographs.

SELECTIVE SHARPENING
When parts of an image need more sharpening than others, you can create a separate layer, select the required area is selected and then sharpen it: the layers are then blended.

CLEANING AND CORRECTING IMAGES

By creating a duplicate layer, rather than working on the original, you can remove dust spots and repair scratches using the Healing Brush tool (in the Tools palette) or the even more versatile Cloning tool.

CLONING TOOL
After selecting the Cloning tool, you define the pick-up point by holding down the Option key and clicking on the selected area. Then by releasing the Option key and moving the mouse on another part of the image, you can drop in the cloned pixels to repair scratches and other blemishes. The pick-up point can even be in another file and you can clone whole images from one picture to another.

Effective image repair takes a good eye and some care. Work on small areas. Use a brush with a fuzzy edge and change the sample point when working on a long scratch, for example, otherwise you will see the repair.

REMOVAL AND CORRECTION

When a picture is too cluttered, items can be removed by cloning. Essentially, anything that is not wanted is replaced by sampling pixels from the surroundings using the Cloning tool on the tools palette and depositing them. In the picture of an oleander hawk moth, this has been done to remove underexposed background elements. Photographs can be corrected in the same way. Spots are easy to remove by selecting the appropriate brush size for the Cloning tool (one with fuzzy edges shows less). Invisible mending of scratches is something that should not be rushed and careful sampling is required to fill the blemish.

Sharpness and blurs

No matter how sharp your original transparency is, the scanning process 'softens' the image slightly. The extent of the softening only becomes apparent when you see exactly the same shot originated directly by a digital SLR.

For the bulk of all the digital work we do, there is only one sharpening mode in general use – and that is Unsharp Mask (USM). This confusing name covers an effect that is almost magical when you see it happen on screen. It cannot increase information, but it puts to best use what is already there.

HOW UNSHARP MASK WORKS

Unsharp Mask, like other sharpening methods, is, in effect, a high-pass filter. It holds back low-frequency information and allows high-frequency information to pass. It operates on a grid of pixels defined by the values set and improves edge definition.

In Photoshop, Unsharp Mask is found under the Filter menu – Filter > Sharpen > Unsharp Mask.

UNSHARP MASK

Unsharp Mask works exceptionally well with hairs and feathers, since it accentuates the edges of such details. With fine detail I use amounts of 150–220% with large files (17–35MB); for small files for the Web (say 600 x 400 pixels), I use 50–80%. USM makes scratches and blemishes more obvious, so correct these before you apply it.

Two settings control the way the sharpening is applied. Threshold governs the number of pixels affected by the sharpening algorithm based on brightness differences: a low setting sharpens nearly all pixels, while at higher settings only neighbouring pixels that are very different in brightness are affected. Radius affects edges: the higher the settings, the more contrasty the edge differences. For large files I set the radius between 1.5 and 1.8 and the threshold at 1; for Web scans at 72dpi I set the radius between 1 and 1.5 and the threshold at about 8.

UNSHARP MASK AND MACRO PHOTOGRAPHY

With macro photography, images become softened by diffraction (see page 152). At x10 magnification, for example, you cannot stop down a 20mm macro lens beyond a f/5.6 marked aperture without seeing a noticeable deterioration in the viewfinder image.

Diffraction (an optical process) and Unsharp Mask have no physical connection, and yet they affect the same subjective sensation of sharpness.

To some extent, the use of Unsharp Mask can offset slight image deterioration due to diffraction and restore 'apparent' sharpness. This works particularly well with the clean images generated by a digital camera. When used in scans, Unsharp Mask can emphasize image artifacts – spots, scratches and blotches – by sharpening their edges. Unsharp Mask can effectively undo about a couple of stops worth of deterioration, affording a more generous depth of field since you can then use a smaller aperture.

UNSHARP MASK IN SCANNER OR CAMERA

Most scanners and cameras offer some sort of sharpening facility that uses an Unsharp Mask algorithm. If you want maximum control at any one stage, then use it only in Photoshop. In practice, you will find that using it in a scanner or camera to offset noise and the softening effect of the filters restores lost sharpness. You can make your final correction as usual after resizing.

If digital files are to be used for a number of purposes, consider storing them on CD without USM, even if they do not look so good on screen. You can then apply Unsharp Mask after opening and resizing.

ALTERNATIVES

There is a High Pass filter found under Filter > Other > High Pass. This can improve the appearance of images made with old microscope lenses and other optics by giving them a sharper edge.

First open the High Pass filter and duplicate the working layer (see page 142). Move the radius slider to the left until only the edges show in a monochrome image. Open the Layers palette and change the blending to overlay.

USM DIALOGUE BOX

The USM dialogue box allows three adjustments: Amount governs the strength of USM. Threshold controls the number of pixels affected by sharpening. It looks at the relative brightness of neighbouring pixels: if this is above the threshold, USM accentuates it. Increasing Radius makes edges more contrasty – a bit like changing the feathering of a selection threshold.

For digital prints from large files (25MB and above) typical settings might be:
Amount 160% (Scan)
200% (Digital camera)
Radius 1.2–2 pixels
Threshold 0

For 600 x 400 pixel images at 72dpi to be used on screen:
Amount 80–90%
Radius 1.5–3 pixels
Threshold 5–8

TECHNICAL NOTE

It is best to leave make USM to the last procedure in any chain after resizing, colour correction, and so on. It causes changes that can only be undone with great difficulty. Also, dust and scratches are exaggerated by USM and need to be removed first.

Flatbed scanners

Until relatively recently, many flatbed scanners for home use were little more than toys. Now, however, there are excellent scanners capable of dealing with film formats from 35mm to sheet film. Affordable models with superb definition scanning at a genuine 2400dpi and above are a real boon for the photographer working with several formats who needs large prints. They can also be used as imaging devices for 'camera-free' close-up photography. The scanning engine that moves beneath the glass plate of a flatbed scanner has a tiny lens of small aperture and relatively high depth of field.

DYNAMIC RANGE

The ability to handle a wide range of tones and contrasts, keeping detail in shadows and highlights alike, is known as the dynamic range. A colour transparency records detail over a six-stop range, black-and-white film has a nine-stop range and digital cameras cover around seven stops. A dedicated film scanner has a dynamic range of around 4.2 and many flatbeds are much less. To record as much of the original as possible, go for a scanner that has a dynamic range of 3.4 and above.

THE ARITHMETIC

With any scanner you have to keep an eye on the input and output file sizes. If the output size is larger than the input, the scanner creates data by interpolation (see page 88). This is not noticeable in the final print at

normal print viewing distances as long as the output size represents no more than about 40–50 percent increase in input file size. The illustration shows a TWAIN dialogue box where you can set the types of scan (including transparencies).

SCANNER BIT DEPTH

Bit depth refers to the capture colour palette. For example, 24-bit depth means a palette of 16 million colours, while 36- and 42-bit depths run into billions. Whether you will see any difference at all between 24 and 36 with your ink-jet printer is a moot point: 24 is certainly good enough for most purposes and you shouldn't be swayed by the advertising hype.

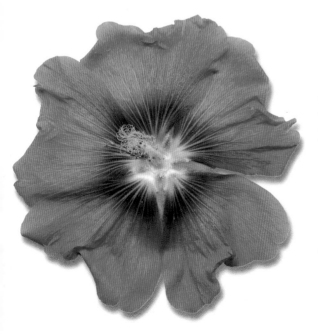

THE SCANNER AS A CAMERA

The amount of detail that a flatbed scanner can capture is quite astonishing and the depth of field much more than expected. Naturally, you have to select subjects carefully to avoid squashing them – but for flat leaves and flowers such as daisies, it works well.

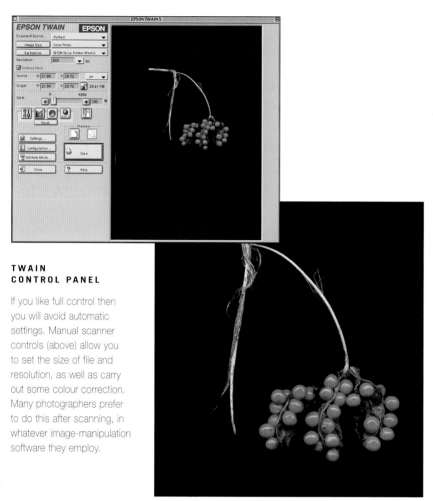

BERRIES

The berries were arranged on the flatbed and scanned. The black cloth proved spotty, so the background was selected, feathered and filled – first with black and then with blue. The small photo shows the detail that a flatbed scanner designed for transparencies (in this case, an Epson 2450 Photo) can capture.

TWAIN
CONTROL PANEL

If you like full control then you will avoid automatic settings. Manual scanner controls (above) allow you to set the size of file and resolution, as well as carry out some colour correction. Many photographers prefer to do this after scanning, in whatever image-manipulation software they employ.

EXPERIMENTING WITH A FLATBED SCANNER

Home tests with a 2400dpi true resolution scanner produced some surprising results. For example, a few cut flowers produced scans with a higher depth of field than was expected.

Some scanners have a hinge arrangement that allows books and other thick objects to be placed on the glass. You can support the lid with small wooden blocks or something similar to prevent squashing of a plant – it does nothing for the final image or the cleanliness of the glass plate. It is important to shield the scanner from extraneous light and covering with black felt or similar while scanning is a good idea. Be scrupulously clean: use soft optical cloths on the flatbed and a blower brush to remove dust and you will need to do less tidying up of the final image.

CLEANING UP SCANS

Some of the accompanying images were scanned with a white background, others with black. In either case you will almost certainly find you have to use one of the selection methods. The background is uniform enough for Magic Wand: use Select > Inverse to select the background – just cutting it fills it with the background colour, which you can set to any shade you wish including black and 'pure' white (see page 144). Using Select > Feather and choosing a range of even a few pixels (2–5) softens the edges and makes the scan less stark.

MAPLE LEAF

A flatbed scanner is ideal for producing the cut-out images that seem popular in books and articles. No camera is needed. Small bits of card can help support a lid and prevent crushing. You may need to cover the scanner with a black cloth and prevent light from outside reducing contrast.

The portable studio

Successful macro photography depends on controlling your subject and its environment to some extent, so that luck does not play such a great part. You can bring small subjects to a fixed camera set-up – your tabletop studio, or move that set-up within a garden or glasshouse. It saves time if you can keep the unit assembled and your lighting can be chosen to suit the occasion – daylight, flash or desk lamps.

YELLOW SKUNK CABBAGE
(Lysichiton americanus)

Many of your best pictures can be taken in your garden. Chances are you will know everything going on there and be quick to spot new opportunities as plants flower and insects emerge.
📷 *Nikon D100, Sigma 180mm f/3.5 apo macro, 1/250 sec. at f/8.*

SWALLOWTAIL
(Papilio machaon)

Adult butterflies are at their best just after emergence. As they fly around, the trials of their lives result in torn wings and rubbed scales. For perfect pictures, why not breed them? This allows photographs of eggs, larvae and, best of all, the emergence process.
📷 *Nikon D100, Sigma 180 mm f/3.5 apo macro, 1/250 sec. at f/11*

SETTING UP

In a greenhouse, on a day with light clouds, you have perfect lighting and no breeze, so even at greater than life-size magnification there is no need for flash unless your subject is agile. But with long exposures do everything you can to eliminate all other vibration sources, too. For example, take every care to clamp the camera carefully to a rigid table and use the mirror lock-up (or anti-shock mode) if your camera has it: employ a cable release so that you can stand well away from the camera and subject. This is particularly important with medium format, simply because of the size of the mirror and the energy that has to be absorbed in the damping.

SUPPORTS

A table-top studio is essentially portable and mine can be set up wherever I happen to be using a black bag of Climpex scaffolding (a series of black-anodized tubes, connectors, clamps and flexible arms that derives from laboratory scaffolding). With it, you can support just about anything around and on a table-top set. Alternatively, a scientific laboratory supplier can furnish you with retort stands, clamps and labjacks.

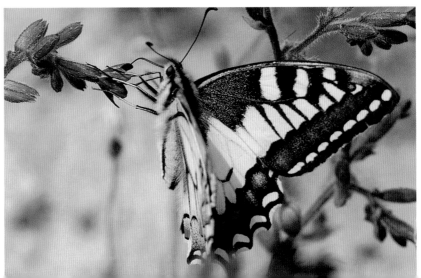

TOOLS

With a bit of effort and practice, most of us can muster the skills to build studio items from sturdy benches, to small aquaria, to optical benches.

The secret is patience: always measure out with squares and firmly secure work with clamps so that nothing moves or wobbles and then you can cut or drill accurately. Use an electric drill in a rigid stand or with any jig that ensures vertical drilling. Hobby stores have saws with guides for cutting miters that enable near-perfect right angles in wood and metal: a saw bench is even better. Your tool list will grow as you need things, but there is much you can do with the following basic equipment:

- Hacksaws, large and small
- Electric drill (with variable speed) and drill stand (or pillar drill)
- Miniature modeller's hobby drill for fine work
- Bench vice
- Drill vice
- Screwdrivers in varying sizes
- Hexagonal wrenches
- Set of taps and dies for thread-cutting
- Measuring implements (e.g. engineer's square, carpenter's tri-square, steel rules)
- Spirit level
- Wet and dry abrasive paper in grades from 200–1200 grit

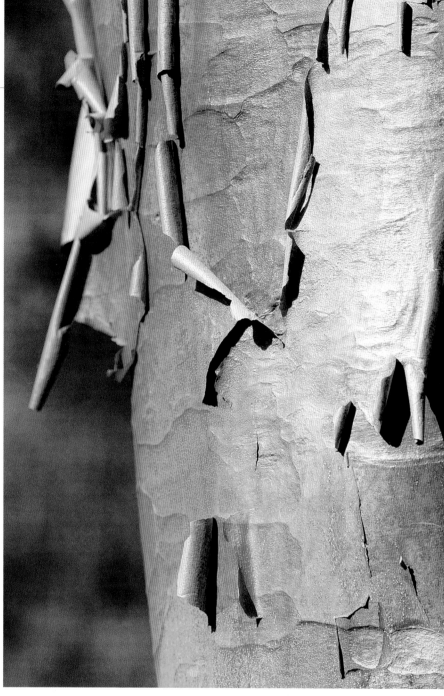

A SPACE OF ITS OWN

If you have space in which your studio can remain assembled it is easy to find objects when you are doing something else and to photograph them quickly – such as the slipper orchid flower growing in a pot, well out of view (left). Alternatively you can take your studio outside to take photographs (see tree bark above) An optical bench or macro-scope can sit rigidly on a carpenter's 'workmate'.

📷 *Nikon D100, Sigma 180mm f/3.5 apo macro, 1/250 sec. at f/8, ISO 200*

SOURCES OF HARDWARE

Many large camera stores and local camera repairers accumulate useful bits and might be worth approaching – especially if they can make items for you. Most DIY stores have limited ranges of hardware and often in packs in sizes you don't need. This is where your local telephone directory or the Internet comes in useful in locating materials. This is the only way to get aluminium alloy in sizes to assure rigidity – and many suppliers sell off-cuts.

Technical data

Having spent years reading mathematical texts, I acknowledge how quickly the sight of a formula can send many people to sleep. When you probe deeply into close-up and macro photography, however, you discover that there are things that are clarified through the shorthand of mathematics, or by using graphs and numerical tables. I have tried here to collect useful bits of information, to create a basis from which you can carry out your own investigations and gain a deeper insight into macro photography.

SHARPNESS AND RESOLUTION

CIRCLES OF CONFUSION

Whether we are examining transparencies or prints, sharpness is a subjective sensation that depends on a number of factors from the viewer's eyesight to the resolving power of the lens, lighting contrast and film structure.

An ideal lens takes a 'point' of light reflected from a subject and then reproduces it as a corresponding image point. These points can only be critically focused on a flat film to give a sharp image if the subject itself is a plane. Light reflected from parts of the subject lying either side of this imaginary plane of sharp focus gives rise to discs of varying sizes on a film called 'circles of confusion' or blur circles. Human vision will accept parts of an image as sharp as long as these discs are small enough to appear as points. The limits to acceptable sharpness in front of and behind the plane of sharpest focus dictate the depth of field at a given aperture.

The size of the disc that can still appear as a sharp point ultimately depends on the individual eyesight of a viewer, the size of the original image, the viewing distance and the degree of image enlargement. However, for convenience, it is assumed that, with the human eye, a disc of 1/30mm (0.03mm) in diameter or smaller, appears on the print as a sharp point at 'normal' viewing distances: this is the 'circle of least confusion', or blur circle, for 35mm film format. On film, the blur circle is much smaller than this since it is enlarged by a factor of eight times to produce the print itself.

The values given in the table opposite apply to 35mm film format. The larger the format, the bigger the least circle of confusion is taken to be, because the recorded image does not need to be enlarged as much to yield a print of a given size. In medium format it is accepted as 1/60mm (0.06mm), which makes a difference to the values quoted in depth-of-field and hyperfocal distance tables.

RESOLUTION

Resolution describes the ability of a lens, film or sensor to distinguish fine detail. Resolution is just one of the factors affecting sharpness and is traditionally measured by the ability of a lens to separate evenly spaced lines (or, more accurately, line pairs). The lens is used at a specified distance to photograph a target consisting of grids of alternate black and white lines where each grid has a greater density of lines than the last. A line pair comprises one black and one white line of equal thickness and a lens is said to resolve a particular grid as long as the black lines can be distinguished from the white. When the lines become more closely spaced, the lens cannot distinguish them tonally and they appear as an undifferentiated gray. The result is measured in line pairs per millimetre (lp/mm). The higher the number, the finer the subject detail that the lens can reproduce.

Ultimately, what we can distinguish depends on human vision. Two objects can appear very close together in our field of view, be they tiny insects right next to us or distant stars, light years away. When light

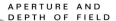

APERTURE AND DEPTH OF FIELD

The diagram shows light rays coming to a sharp focus on film – only rays from the plane of sharp focus do this. Rays from points either side of this plane are focused in front of or behind the film. They appear as small circles because of the way the light rays spread. Only if these circles are small enough will the eye accept them as points. Making the lens aperture smaller reduces the size of the circles, increasing depth of field – there is greater latitude either side of the plane of sharp focus.

Plane of sharp focus light Points become circles Light
rays converge to 'points' as rays spread rays

Reproduction ratio	Magnification (M)	Aperture					
		f/5.6	f/8	f/11	f/16	f/22	f/32
1:10	0.10	41	59	81	118	162	235
1:8	0.12	27	38	53	77	106	154
1:6	0.17	15.7	22	31	45	62	90
1:5	0.20	11.2	16	22	32	44	64
1:4	0.25	7.5	10.6	14.6	21	29	43
1:3	0.33	4.5	7.2	8.8	14.4	17.6	29
1:2.5	0.40	3.24	4.6	6.38	9.28	12.8	18.6
1:2	0.50	2.25	3.2	4.40	6.4	8.80	12.8
1:1.7	0.58	1.74	2.48	3.41	4.96	6.82	9.92
1:1.4	0.71	1.30	1.84	2.53	3.68	5.06	7.28
1:1	1.00	0.75	1.07	1.47	2.14	2.93	4.27
2:1	2.00	0.28	0.4	0.55	0.8	1.10	1.6
3:1	3.00	0.16	0.24	0.32	0.47	0.65	0.95
4:1	4.00	0.11	0.17	0.23	0.34	0.46	0.68
5:1	5.00	0.09	0.13	0.18	0.25	0.36	0.51

DEPTH OF FIELD FOR MAGNIFICATIONS FROM X0.1 TO X5 (IN MILLIMETRES)

In general photography it is usually necessary to know the focal length of the lens and the distance at which it is focused in order to calculate depth of field for a particular aperture. In close-up photography, it is enough to use the magnification (or reproduction ratio) to work out the depth of field for different apertures. In landscape photography about one third of the available depth of field lies in front of the point of focus and two thirds beyond, whereas in macro work it is more evenly distributed, allowing us to deal with a single front to back' distance for depth of field.

The accompanying table gives the total depth of field in millimetres (the distance between the near and far limits of sharp focus) for different magnifications and apertures. The values are based on a circle of least confusion of 1/30mm, are valid for the 35mm film format and give a good guide for medium format. Notice just how limited depth of field becomes, even at relatively low magnifications. At life-size magnification (1:1 reproduction) depth of field extends just over 1mm at f/8, and only just over 4mm at f/32. It is worth remembering that doubling the f-number increases depth of field by a factor of 2. Closing down one stop, meanwhile, changes depth of field by a factor of 1.4.

To work out values for other magnifications and formats, the formula for calculating depth of field (D) is: $D = 2cf(M+1)/M^2$ where c is the diameter of the circle of least confusion, f is the aperture and M is the magnification. For magnifications greater than x10 this can be simplified to $D = 2cf/M$.

rays form images of these points on the retina there is an angle between them. This is their 'angular separation' and someone with normal vision can 'resolve' objects separated by about one minute of arc (1/60 of a degree). To appreciate what this means in practice photographers traditionally refer to a 25 x 20cm (10 x 8 in.) print viewed at a normal viewing distance of 25cm. Detail at 8 lp/mm is just separated by the human eye.

RESOLUTION AND ENLARGEMENT

Suppose a lens resolves 100 lp/mm, then using the 8 lp/mm visual limit, an image recorded with this lens can be enlarged 12.5 times. Enlarging it any further reveals no more detail; in fact, it then begins to appear unsharp, as the image breaks up. For the 35mm format, this would represent maximum resolution being obtained in a print measuring 43 x 29cm (17 x 11 in.).

DIFFRACTION LIMIT OF LENSES

The resolving power of a lens is affected by the contrast between detail and background, so you will get lower resolution for a lower contrast subject. Lens resolution is also highly dependent on aperture. Most significantly, for macro photography, diffraction has to be taken into account (see page 21). Light waves interact with the hard edges of any aperture, giving rise to diffraction, a wave effect that softens the image and becomes increasingly apparent as a lens aperture gets smaller. Thus although depth of field is improved by stopping down, there has to be a careful balance between increased depth of field and diffraction softening to get the best resolution from a lens. Optical theory shows that at 50 percent contrast between detail and background, the 'diffraction limit' to the theoretical resolving power of the lens (in lp/mm) is approximately 1000/n – where n is the aperture. For example, an f/4 lens has a diffraction limit of 1000/4 = 250 lp/mm. At f/16 a macro lens might be able to resolve 1000/16 or 62 lp/mm – but at 1:1 magnification an aperture of f/16 becomes f/32 and the diffraction limit is reduced to 31 lp/mm.

To go back to our 25 x 20cm (10 x 8 in.) print viewed from a distance of 25cm and a resolution of 8 lp/mm, this would mean the transparency could be enlarged just four times to reach that limit. In practice much greater enlargement is tolerable since we view from considerably further away than this.

Few 35mm-format lenses have f-stops smaller than f/22, because of the limits imposed by diffraction at small apertures. Most give their best resolution at around f/8 to f/11 (at larger apertures resolution is usually reduced by other optical defects). The diffraction effect is less marked with larger film formats.

DIGITAL RESOLUTION

In digital photography, print resolution is calculated in terms of 'dots per inch' (dpi) or pixels. There is a link between the resolution needed for digital and traditional prints as both are dictated by the perceptual limits of human vision. The ideal print resolution has come to be regarded as 300dpi, although, in practice, there is no noticeable difference for 200dpi. Converting to mm for comparison: 200dpi = 200/25.4 = 7.9 dots per mm. What matters is separation of detail, whether in lines or dots, and so 200dpi (7.9 dots/mm) on a digital print and 8 line pairs/mm are very near equivalents.

PIXELS AND RESOLUTION

The amount of detail that you can resolve with a digital array depends on the number of pixels per millimetre. To define any pair of lines takes two pixels – one for the black line on the test grid, the other for the white space. Because the camera electronics interpolate detail from pixels and their near neighbours this is not exactly true, but it gives a good basis for an estimate.

A typical digital SLR has an array 23.7 x 15.6mm which gives a maximum resolution of 3008 x 2000 pixels (6.016 million pixels). For a ballpark calculation

there are 3008/23.7 = 128 pixels per mm. In effect, the array can resolve no more than the equivalent of 64 lp/mm. Quoted resolution values for several films are shown in the table below. These give maximum resolution figures for the emulsions using both high-contrast and low-contrast targets. The finest grain transparency film – Fujichrome Velvia is capable of resolving considerably more than the 6.1 megapixel digital camera.

CALCULATING MAGNIFICATION

There are several formulas that give the magnification (M) of a lens. When using these formulas, it is essential that each measurement must be in the same units; distances are conveniently measured in (or converted to) millimetres, so we are using the same units as used to measure the focal length of the lens.

FILM	ISO	RESOLVING POWER lp/mm (HIGH/LOW CONTRAST)
Fujicolor Superia CN	100	125/63
Fujichrome Velvia	50	160/80
Fujichrome Velvia 100F	100	160/80
Fujichrome Provia 100F	100	140/60
Kodachrome 64 Pro	64	100/63
Kodak Ektachrome 64 Pro	64	125/50

MAGNIFICATION USING A MILLIMETRE RULE

The direct method of viewing a millimetre scale works with any format of camera as long as you know the amount of image area the viewfinder covers; viewfinder coverage and film coverage differ slightly. If you photograph the scale, then magnification is width of frame in millimetres divided by the number of millimetre divisions visible in the shot. In the example illustrated, 20mm of the ruler fill the frame. Dividing 36mm (the width of the 35mm-format image area) by 20mm, we discover that the magnification for this particular setup is 1.8.

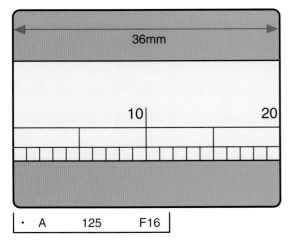

These are two of the most useful formulas: $M = V/U$, where V is the distance of the image from the lens and U the distance of the lens from the subject. Alternatively, when a lens is extended, the image on film is magnified according to this formula: $M = d/F$, where d = lens extension, and F = focal length.

MEASURING MAGNIFICATION

Calculating magnification using the above formulas is sometimes more trouble than it is worth. An easier way is to measure it directly by looking at the relationship between the image area and the subject area. Simply place a metal ruler where the subject is and count the number of millimetre divisions spanning the width of the viewfinder (see diagram). The viewfinder of a 35mm camera is nominally 36mm across. By dividing the number of millimetre divisions seen in the viewfinder by 36, therefore, we have the magnification.

EXPOSURE COMPENSATION

The exposure factor (E) is the number by which normal exposure time must be multiplied when working at high magnifications. Once the magnification (M) is known (see above), the exposure compensation can be worked out using the following formula: $(M + 1)^2$.

Reproduction ratio	Magnification (M)	Exposure factor $(M + 1)^2$	Exposure compensation (nearest equivalent in stops)
1:10	0.10	1.2	0
1:8	0.12	1.26	0
1:6	0.17	1.36	0
1:5	0.20	1.44	0.5
1:4	0.25	1.66	0.5
1:3	0.33	1.8	0.5
1:2.5	0.40	2.0	1
1:2	0.50	2.25	1
1.1.7	0.58	2.5	1
1.1.4	0.71	3	1.5
1:1	1.00	4	2
2:1	2.00	9	3
3:1	3.00	16	4
4:1	4.00	25	4.5
5:1	5.00	36	5
6:1	6.00	49	5.5
7:1	7.00	64	6
8:1	8.00	81	6.5
9:1	9.00	100	6.5
10:1	10.00	121	7
11:1	11.00	144	7
12:1	12.00	169	7.5
13:1	13.00	196	7.5
14:1	14.00	225	8
15:1	15.00	256	8

If you want to work out how many stops (n) this corresponds to you need to use the following formula: $2n = E$, and alternately, for those with scientific calculators: $n = logE/0.3$.

The exposure factors and the amounts of exposure compensation needed for a wide range of image magnifications is provided on the table above.

EXPOSURE COMPENSATION FOR DIFFERENT IMAGE MAGNIFICATIONS

This table gives the amount of exposure adjustment needed to correct for the drop in image brightness which is associated with increasing the distance between the lens and the film (or imaging chip) – see page 27. The 'exposure factor' gives the figure by which exposure time needs to be increased. The exposure compensation figure shows the number of stops that the aperture would need to be opened by. These adjustments are only necessary if the shutter speed and aperture are being set manually. If through-the-lens metering is available, then the drop in image brightness will be corrected for automatically.

Glossary

aberration The failure of a lens to produce a 'true' image. There are various forms of aberration: spherical aberration, curvature of field, astigmatism, coma, distortion, chromatic aberration. A lens designer can often correct some only by allowing others to remain.

acutance An objective measurement of the way edges are recorded on film.

Advanced Photo System (APS) A photographic system developed by Kodak and other companies that is based on a new film format, and innovative film, camera and photofinishing technologies.

ambient light The available natural light completely surrounding a subject – the light not provided by the photographer.

angle of view The widest angle of light rays reaching a lens that form a sharp image on film. The angle is widest when a lens is focused at infinity.

aperture The hole or opening formed by the metal leaf diaphragm inside the lens, or the opening in a camera lens through which light passes to expose the film.

aperture priority An exposure mode that allows a lens aperture to be set so that the camera determines the shutter speed for correct exposure.

apo (apochromatic) Having the ability to bring all colours of the visible spectrum to a common plane of focus, within close tolerances.

aspect ratio The ratio of width to height in photographic prints – 2:3 in 35mm pictures to produce photographs most commonly measuring 9 x 13cm (3.5 x 5 in.) or 10 x 15cm (4 x 6 in.); Advanced Photo System cameras deliver three aspect ratios as selected by the user.

aspherical lens A lens whose curved surface does not conform to the shape of a sphere.

autofocus (AF) An electronic system in which the camera plus the lens automatically focus the image of a selected part of the picture subject.

Automatic Exposure Lock (AE-L) A camera metering facility that fixes the exposure setting when used in the automatic mode.

backlighting Light coming from behind the subject, towards the camera lens, so that the subject stands out vividly against the background. Sometimes produces a silhouette effect.

balanced fill-flash operation A flash photography technique that balances flash illumination with the scene's ambient light.

bit The fundamental unit of all computer processing, based on a binary system with two values: 0 and 1 that can represent 'on and off' or 'up and down'.

bracketing Taking a series of photographs of the same subject at different exposures to ensure the 'correct' exposure; useful when shooting in situations where a normal metering reading is difficult to obtain.

byte A unit of digital information: 1 byte = 8 bits. *See also* megabyte (MB) and gigabyte (GB).

CCD (Charged Coupled Device) An electronic sensor used by all autofocus cameras, capable of detecting subject contrast; also an image-receiving device for video cameras.

CD-R and CD-RW (Compact Disk Recordable and Compact Disk Re-writable) Storage media for digital images each offering 640MB capacity.

closest focus Usually quoted by manufacturers as the distance from the subject to the film plane. A closest focus of 20cm can still mean a lens front is just 10cm or so from a subject.

CMYK Identifies the four colours used in traditional printing presses, and stands for, respectively, cyan, magenta, yellow and black. K is used for black to prevent confusion with blue.

colour temperature A measure of the quality of colour of a light source expressed on the Kelvin (K) temperature scale.

compact (point-and-shoot) camera An all-in-one camera designed for convenience and ease of use, usually with automatic exposure and autofocusing. It does not have a facility for changing lenses or reflex viewing.

compression The use of a mathematical algorithm on large digital files to reduce data size and squeeze more images onto storage media.

contrast The range of difference in the light to dark areas of a negative, print or slide (also called density). The brightness range of a subject or the scene lighting.

CPU (Central Processing Unit) or the 'chip' is that part of an electronic device that receives and evaluates instructions and issues instructions to other parts of the system.

dedicated flash A fully automatic flash that works only with specific cameras. Dedicated flash units automatically set the proper flash sync speed, lens aperture and electronic sensors within the camera.

depth of field The zone of acceptable sharpness in front of and behind the subject on which the lens is focused; approximately one-third of the distance lies in front of the subject in focus and two-thirds behind.

depth of focus The distance range over which the film can be moved at the film plane inside the camera and still have the subject appear in sharp focus (often confused with depth of field).

diaphragm An adjustable device inside the lens which is similar to the iris in the human eye; comprised of six or seven overlapping metal blades; continuously adjustable from 'wide open' to 'stopped down'; it controls the amount of light allowed to pass through the lens.

dpi (dots per inch) For a scanner this is a measure of the maximum resolution. For a printer it is the maximum number of separate ink droplets it can spray onto the paper. For an image, the pixels can be made larger or smaller by altering their spatial resolution – pixels per inch or ppi.

electromagnetic spectrum A map of all forms of electromagnetic radiation arranged according to wavelength or frequency. Visible light, infrared and ultraviolet are all forms of electromagnetic radiation as are radiowaves, X-rays and gamma rays.

element Single lens used in association with others to form a compound construction.

EV (exposure value) A number representing the available combinations of shutter speeds and apertures that give the same exposure effect under conditions of similar scene brightness and ISO. At ISO 100, the combination of a one-second shutter speed and an aperture of f/1.4 is defined as EV1.

file format The method or structure of computer data storage (e.g., JPEG, TIFF, PSD) for various uses (e-mail, print, or Web).

FireWire (also known as IEE 1394) A connector used to download digital data at extremely high speeds from a high-end digital camera to a computer.

flare Non-image-forming light rays caused by reflection and scattering that soften the image produced by a lens.

Flash memory card A type of electronic storage medium used by many digital cameras. It resembles film in conventional photography.

flash sync speed Shutter speed at which the entire film frame is exposed when the flash is fired. For many film plane shutters a 35mm camera's flash sync speed is 1/250 sec (slower with medium-format film). With 'between the lens' shutters, the sync speeds are the same as the shutter speeds.

f-number (or f-stop) The numbers on the lens aperture ring (and a digital camera's LCD) indicating the relative size of the lens aperture opening. The f-number series is a geometric progression based on changes in the size of the lens aperture as it is opened and closed. Each number is multiplied by a factor of 1.4 (in fact the square root of 2) as the scale rises. The standard numbers for lens calibration are 1.0, 1.4, 2, 2.8, 4, 5.6, 8, 11, 16, 22, 32, etc. Each change results in a doubling or halving of the amount of light transmitted by the lens.

focal length In a simple lens, the distance (typically in mm) between the lens and the position of the sharp image for a subject a great distance away. For 35mm-format cameras, lenses with a focal length of around 50mm are called normal or standard lenses. Those with a focal length less than 35mm are called wide-angle lenses; lenses with a focal length more than approximately 85mm are called telephoto lenses.

format The size of the photograph, either slide or negative, produced by a camera.

full aperture metering Where the TTL metering system in a camera simulates the effect of stopping down the lens as the aperture ring is turned. The diaphragm remains fully open to give maximum focusing screen brightness.

GIF (Graphics Interchange Format) A small low-resolution file format used for graphics.

gigabyte (GB) 1024 megabytes.

GN (guide number) Used to express the power output of the flash unit. It indicates the power of a flash in relation to ISO film speed. Guide numbers are quoted in either meters or feet.

grain The individual light-sensitive crystal on a film, usually a silver halide.

grey card (or 18% grey card) Tone recognized as the mid-tone of an average subject. The standard grey card reflects 18 percent of the light falling on it.

greyscale mode Used to capture black-and-white images with 256 steps from white to black.

hyperfocal distance The minimum distance at which a lens records a subject sharply when focused at infinity.

interpolation Insertion of pixels into a digital image based on existing data from adjacent pixels.

iris (iris diaphragm) Controls the size of the lens aperture and consists of thin overlapping metal leaves (six or more) to form a circular opening of variable size to control light transmission through a lens.

ISO (International Standards Organisation) The accepted protocol for measuring film speed – numerically equal to ASA. Doubling or halving the ISO rating is equivalent to a one-stop increase or decrease respectively in film speed/exposure needed.

JPEG (Joint Photographic Expert Group) A file format for graphics in which the compression effect for data reduces file size but loses data more noticeably in small files than in large files.

kelvin (K) The standard unit of thermodynamic temperature (add 273 to temperature in °C). Used in phototography to measure the colour temperature. 5000K refers to normal daylight.

LCD (Liquid Crystal Display) panel A device displaying electronically generated text, numerals, and symbols.

lens speed The largest lens opening (smallest f-number) at which a lens can be set. A fast lens transmits more light and has a larger opening than a slow lens.

long-focus lens A lens of relatively long focal length designed to provide a narrower angle of view than the normal or standard lens.

macro lens Commonly taken to include lenses with a close-focusing facility giving up to life-size (1:1) magnification. True macro lenses cover up to x16 magnification, and each optic is designed to give best results over a small magnification range.

macro photography Now broadly used to cover photography with macro lenses from around one-tenth life-size to x20.

macrophotography Originally a term used for large-scale photographs to cover walls but now completely confused with macro photography.

magnification ratio A ratio that expresses the greatest possible magnifying power of the lens on film. Used commonly on the macro setting of the zoom lenses, macro lens or with bellows.

manual flash mode Flash output is controlled manually in manual flash mode unlike in auto flash mode, where flash output power varies automatically according to the selected aperture.

matrix The two-dimensional array of CCD sensors.

matrix metering A form of TTL metering that evaluates exposure from different areas of the viewfinder and combines them to produce 'correct' exposure by comparison with stored values in the camera software.

megabyte (MB) A million bytes.

megapixel A million pixels; used to define the resolution of a digital camera.

Moiré An interference pattern producing bands or colours when two regular arrays, differing in orientation are superimposed (named after the silk in which the pattern is observed).

normal (or standard) lens A lens with a focal length equal to the diagonal of the film format.

optical axis Imaginary line passing though the centre of a lens system.

OTF (Off-the-Film) metering A metering mode that determines exposure by reading light reflected from the film during picture-taking.

parallax The apparent relative movement of two objects relative to one another when viewed from different positions. In a rangefinder camera, parallax is the difference between what the viewfinder sees and what the camera records (especially at close distances caused by the separation of the viewfinder and the camera lens).

perspective The rendition of apparent space in a flat photograph, i.e., how far the foreground and background appear to be separated from each other; determined by only one factor – the camera-to-subject distance; if objects appear in their normal size relations, the perspective is considered 'normal'; if the foreground objects are much larger than the ones in the background, the perspective is considered 'exaggerated'; when there is little difference in size between foreground and background, we say the perspective looks 'compressed'.

pin-cushion distortion A lens aberration sometimes seen in extreme wide-angle designs where the straight sides of a rectangle become concave.

pixel (from PICture ELement) Smallest unit of a digital image. Mainly square in shape, a pixel is one of a multitude of squares of coloured light that form a photographic image. Pixels are arranged in a mosaic-like grid called a bitmap. The more pixels used for an image, the higher its resolution.

polarised light Light waves with electric field vectors vibrating in one plane only as opposed to the multi-directional vibrations of normal rays; natural effect produced by some reflecting surfaces, such as glass, water and polished wood.

RAM (Random Access Memory) The internal component of a computer in which data is stored temporarily and accessed rapidly.

rangefinder An instrument for measuring distances from a given point, usually based on slightly separated views of the scene provided by mirrors or prisms; may be built into non-reflex cameras.

reproduction ratio Term used in macro photography to indicate the magnification of a subject; specifically the size of the image recorded on film divided by the actual size of the subject.

resolution The ability of a lens to discern small detail.

RGB (Red, Green, Blue) Refers to the so-called scientific hues – the additive primary colours red, green and blue – that, when mixed together in equal amounts, create white light. Most scanners capture their image in RGB values, necessitating the conversion of the image to CMYK values for printed reproduction.

saturation A property of perceived colour, or the percentage of hue in a colour. Saturated colours are called vivid, strong or deep. Desaturated colours are called dull, weak or washed out.

SCSI (Small Computers Systems Interface) A standard for connecting external devices such as hard disks and scanners to computers.

sharpness A term used to describe the ability of a lens to render fine detail clearly. Sharpness is dependent on both the contrast and resolution of a lens. In general, a lens is sharpest at the middle apertures and varies with the f-number.

shutter priority An exposure mode on an automatic or autofocus camera that lets you select the desired shutter speed; the camera sets the aperture for proper exposure.

SLR (single lens reflex) A type of camera that allows you to look in the camera's viewfinder and see through the camera lens that takes the picture, usually via a mirror and glass prism.

SmartMedia The thinner type of removal memory cards for digital cameras.

stop-down metering A form of TTL metering where the light is measured at the picture-taking aperture. The meter just measures the light passing through the lens with no need for any lens-camera interconnections.

supplementary lens Generally a simple positive (converging) lens used in front of the camera lens to enable it to focus at close range.

telephoto lens A lens that makes a subject appear larger on film than does a normal lens at the same camera-to-subject distance, and has a longer focal length and narrower field of view than a normal lens.

TIFF (Tag Image File Format) A widely used image file format that supports up to 24 bits of colour per pixel and can be compressed without data loss.

TTL (Through-the-Lens) Most SLR cameras have built-in meters that measure light after it has passed through the lens. This feature enables exposure readings to be made whatever the lens angle of view, regardless of whether a filter, bellow or extension tubes are used.

transparency Slide film – positive photographic image on film, viewed or projected by transmitted light (light shining through film).

tungsten light Light from regular room lamps and ceiling fixtures; not fluorescent.

TWAIN (Toolkit without an Interesting Name) Software that allows a range of different devices such as cameras and scanners to communicate with applications such as Adobe® Photoshop®.

ultra-wide-angle lens Usually those lenses with an angle of view greater than 90°. For 35mm cameras the description usually applies to lenses of shorter focal length than about 24mm.

Unsharp Mask (USM) An image-processing filter that enhances the apparent sharpness of an image.

vignetting Diminished illumination on the film from the centre to the corners, most often caused with wide-angle lenses through improper use of accessories such as a lens hoods, filters or camera extensions.

white balance A calibration facility on digital cameras that allows colour compensation to be made for light sources of different colour temperatures.

working distance The distance from the lens front to the subject.

Index

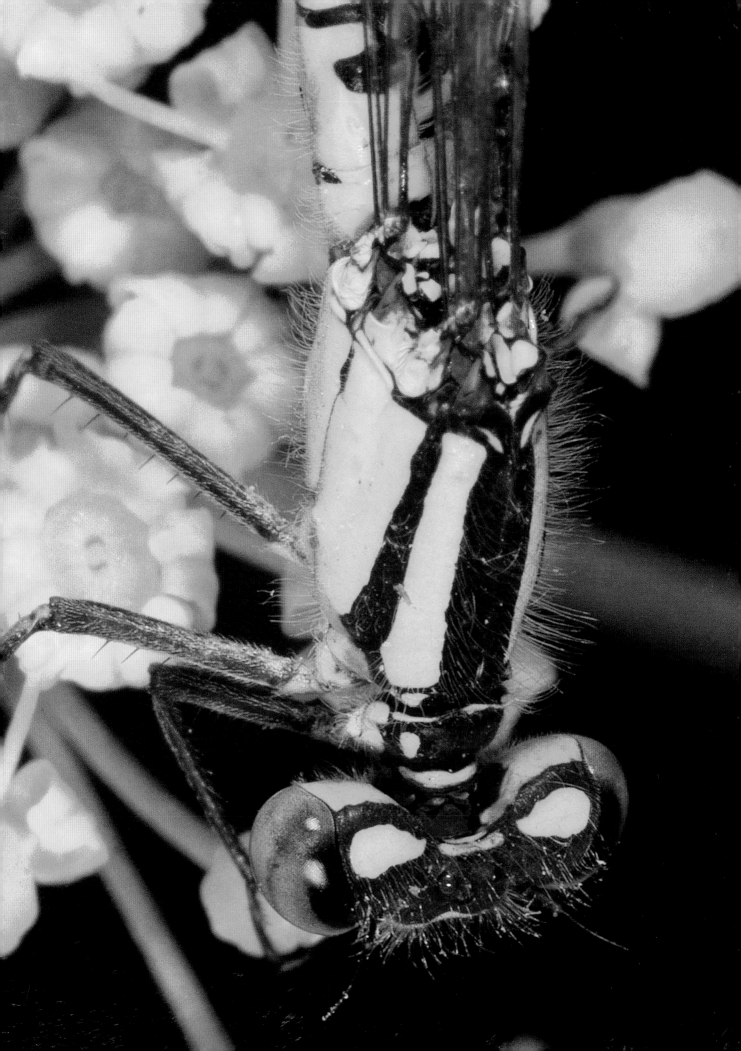

Author's Acknowledgments

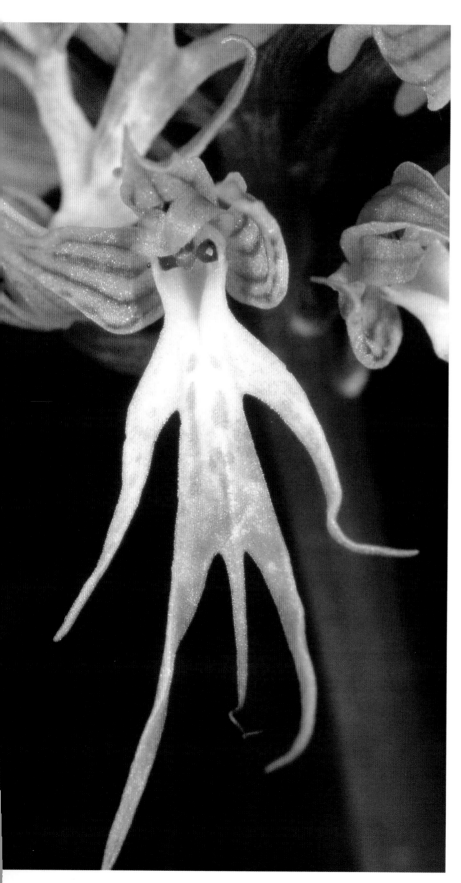

My grateful thanks goes to those who helped or encouraged me during the gestation period of this book.

Above all, my gratitude goes to my partner Lois Ferguson for her unstinting faith in me, for her ideas and skills in preparing the image sequences in the 'manipulation' section and her ability to organize me sensitively and subtly! My thanks go to my children Hannah and Rhodri, for their ceaseless encouragement and enthusiasm for their writer-father's projects.

Thanks for help with photographs go to Paul Naylor (www.marinephoto.co.uk) who very kindly let me use his superb marine pictures; to Toby and Vlasta at the Living Rainforest (www.livingrainforest.org) who enabled me take digital pictures in winter; to Karen Baker (www.mantisuk.com), who supplied me with both orchid and flower mantids to fulfil a long-held photographic ambition and Brian Darnton for microscope slides of foraminifera.

The following provided technical help and assistance and my thanks go out to them: Lynn Calver and Lynn Oliver of Nikon, UK, Peter and Chris Parks of Image Quest 3D, Graham Armitage at Sigma, UK, The Hawking Conservancy (www.hawkconservancy.org), Andover and to the many participants in the tours and courses we run who have become friends and whose enthusiasm and questions provided the impetus to write this book. And last, but not least, to Piers Spence and Nadia Naqib and the team at Quarto plc and to Sarah Hoggett for her deft touches with the text.

Paul Harcourt Davies' images and prints, together with details of his tours and courses can be found at (www.hiddenworlds.co.uk)